FREE WITHIN OURSELVES

We build our temples for tomorrow, strong as we know how,
and we stand on top of the mountain free within ourselves.

—Langston Hughes

FREE WITHIN OURSELVES

AFRICAN-AMERICAN ARTISTS IN THE COLLECTION OF THE NATIONAL MUSEUM OF AMERICAN ART

Regenia A. Perry

Introduction by Kinshasha Holman Conwill

National Museum of American Art, Smithsonian Institution, Washington, D.C.
in association with Pomegranate Artbooks, San Francisco

This publication is made possible through the generous support of the IBM Corporation.

Published on the occasion of the exhibition *Free Within Ourselves: African-American Art in the Collection of the National Museum of American Art,* curated by Lynda Roscoe Hartigan.

Tour Itinerary

Wadsworth Atheneum, Hartford, Connecticut
18 October 1992–10 January 1993

IBM Gallery of Science and Art, New York, New York
9 February–10 April 1993

Crocker Art Museum, Sacramento, California
5 November–30 December 1993

Memphis Brooks Museum of Art, Memphis, Tennessee
1 January–27 March 1994

The Columbus Museum, Columbus, Georgia
1 May –26 June 1994

First published in the United States of America by the National Museum of American Art, Smithsonian Institution, Washington, D.C., 20560, in association with Pomegranate Artbooks, Box 808022, Petaluma, California 94975.

Front cover: Lois Mailou Jones, *Les Fétiches* (see page 120)
Back cover: Jacob Lawrence, *The Library* (see pages 130–31)
Epigraph: Langston Hughes, "The Negro Artist and the Racial Mountain," *The Nation,* 23 June 1926, 692.

ISBN 1-56640-073-2 (cloth)
ISBN 1-56640-072-4 (paper)
Library of Congress Catalog number 92-14815

Perry, Regenia.
Free within ourselves : African-American artists in the collection of the National Museum of American Art/Regenia Perry : introduction by Kinshasha Holman Conwill.
p. cm.
Includes bibliographical references and index.
ISBN 1-56640-073-2.–ISBN 1-56640-072-4 (pbk.)
1. Afro-American artists–Biography. 2. Afro-American art–Washington (D.C.) 3. National Museum of American Art (U.S.)
I. Title.
N6538.N5P44 1992
704'.0396073'074753–dc20 92-14815
 CIP
Printed in Hong Kong by
South China Printing Company (1988) Limited

CONTENTS

FOREWORD AND ACKNOWLEDGMENTS

Several years ago, Nora Panzer, acting chief of the Office of Educational Programs, approached me about preparing a teacher curriculum packet containing biographical essays and slides on African-American artists in the NMAA's collections, intended for free distribution to schools in the Washington metropolitan area. Aware of the continued national interest in and need for such an undertaking, Dr. Elizabeth Broun, director of the NMAA, made the decision to expand this initial concept and publish the material as a book not only to serve as a full-color resource guide for educators but also to be made available for the general public.

It seems particularly appropriate that the NMAA should publish a book of this nature, since its collection of African-American art is one of the largest and most comprehensive in existence. The museum's nineteenth-century African-American holdings are especially strong due to the transfer of numerous works by Joshua Johnson, Robert Scott Duncanson, Edward Mitchell Bannister, Henry Ossawa Tanner, and Edmonia Lewis from the former Frederick Douglass Institute and Museum of African Art. When the New York-based Harmon Foundation closed its doors in the 1960s, the NMAA received hundreds of paintings by the African-American artist, William H. Johnson. In addition to its numerous works by African-American academic artists, the NMAA has a serious commitment to collecting works by self-taught artists to complement their recently acquired Herbert Waide Hemphill, Jr., Folk Art Collection.

The thirty-one artists included in this publication do not represent all of the African-American artists in the NMAA's collection. An attempt was made to include a representative cross section, geographically, chronologically, and stylistically, of African-American artists of the nineteenth and twentieth centuries, both academic and self-taught.

I am deeply indebted to a number of persons who assisted in the preparation of this book. I would like to extend my thanks to Nora Panzer, who conceived the original idea; Lynda Roscoe Hartigan, associate curator, who prepared the extensive bibliography, served as coordinator of the project, and provided many helpful suggestions; Richard Carter, editor, Office of Publications, who worked

tirelessly on the manuscript; Julia Beth Hackman, Educational Programs assistant, who researched photographs and quotations, and who typed and produced a large, and sometimes unwieldy manuscript; and to Erin Keever, intern in the Office of Educational Programs, who assisted in the research of photographs and quotations. Finally, I would like to thank Lois M. Fink, research curator of the Research and Scholars Center of the NMAA, who has served as my mentor and role model for a number of years; Virginia Mecklenburg, chief curator of the NMAA, and Elizabeth Broun, director of the NMAA, for their encouragement and enthusiastic support of this project in every stage of its development.

Regenia A. Perry
Professor of African and African-American Art History
Virginia Commonwealth University

PREFACE

How did the National Museum of American Art come to acquire its premier collection of African-American art? The story begins with late starts and happenstance, then good fortune and good friends, leading to perseverance and firm commitment. This book is testimony to that record and to my belief that this remarkable collection holds deep meanings for all Americans.

Remarkably, for 135 years after the founding of the federal art collections in 1829, no work by a black American was represented in the nation's holdings. Although blacks had played a crucial role in every aspect of American life—colonization, settlement, building of railroads and industry, wars, agricultural economy, and the growth of cities—the "mantle of culture" was represented in this museum and most others nationwide solely through the accomplishments of white artists.

In 1964, the museum's installation designer (and later deputy director), Harry Lowe, read an unusual newspaper story about James Hampton, a black veteran who worked as a janitor cleaning government buildings for the General Services Administration in Washington, D.C. Hampton had recently died, leaving a rented garage full of handmade ecclesiastical objects. Altars, bishop's chairs, offertory tables, crowns, plaques of scripture, and lecterns fashioned from cast-off furniture and government property, all covered with silver and gold foils, were found behind the garage doors—the private lifework of a soft-spoken man who would probably never have described himself as an artist, though in his writings he sometimes referred to himself as "St. James." Hampton had seen visions of Moses, the Virgin Mary, and Adam (who appeared to him on the day of President Truman's inauguration), and had rendered homage to his evangelical faith in his own way, without appeal to the institutions and societies intended to foster culture. Lowe, whose knowledge of Southern folk art had taught him to love the inventions of inspired people, was an eager advocate for the work. Shortly after Hampton's death, his lifework was purchased and placed on loan at the museum until its donation to the collection in 1970. A year later, all 180 foil-covered objects were installed in the museum. *Time* art critic Robert Hughes would later say that Hampton's *Throne of the Third Heaven* "may well be the finest work of visionary religious art by an American."

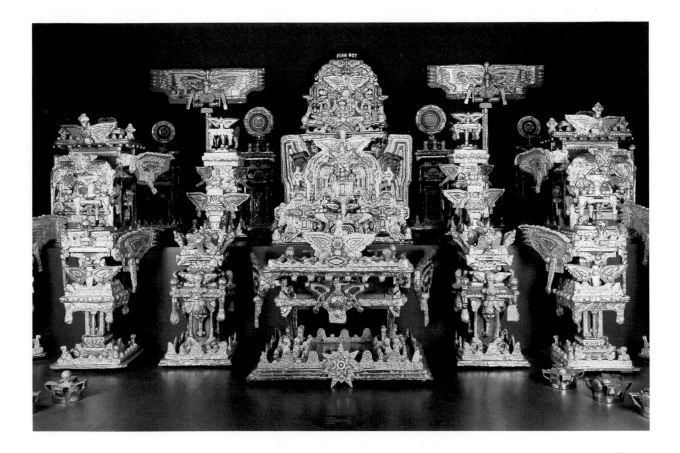

James Hampton,
*The Throne of the Third
Heaven of the Nations
Millenium General Assembly*,
detail, ca. 1950–64, gold and
silver tinfoil, Kraft paper, and
plastic over wood furniture,
paperboard and glass, 180
pieces in overall configura-
tion: 10 1/2 x 27 x 14 1/2 ft.
(partial view)

In 1966 IBM Corporation donated Sargent Johnson's African-inspired bronze
Mask as part of a larger gift. Three years later, IBM donated the works of two
more African Americans, Romare Bearden and Charles Sebree. There was no
indication then that these gifts constituted a momentous beginning, but in
retrospect, the seeds of the future were planted. It is with a sense of deep gratitude
that we acknowledge IBM's support for the publication of this book, which
documents the bountiful harvest that grew from those early donations.

Also in 1966, a last-ditch appeal to the museum came from the Harmon
Foundation, a philanthropic organization in New York City. The Harmon
Foundation had for forty years promoted the work of African-American art-
ists—"experimental, stimulative work" that could inspire others. In the course
of affairs, the foundation had amassed a major collection representing many
black artists and produced numerous exhibitions to bring them to the attention
of a broader audience. Throughout the period of the foundation's work,
however, the art establishment still considered all American art to be merely a
provincial off-shoot of Europe; most American art scholars and museums then
were more focused on breaking down this barrier than on eliminating biases
within the discipline of American art.

Joshua Johnson, *Portrait of Mrs. Barbara Baker Murphy (Wife of a Sea Captain)*, ca. 1810, oil on canvas, 21 3/4 x 17 5/8 in.

Edmonia Lewis, *Hagar*, 1875, carved marble, 52 5/8 x 15 1/4 x 17 in.

William H. Johnson, *Jitterbugs*, ca. 1944, oil on paperboard, 24 x 15 3/8 in.

Alma Thomas, *The Eclipse*, 1970, acrylic on canvas, 62 x 49 3/4 in.

When the dedicated director of the Harmon Foundation, Evelyn S. Brown, met with the museum's director, David Scott, the foundation's funds were depleted and it was facing immediate dissolution. The foundation was desperate to find a home for its collection "at a fairly early date," after futile attempts to place it in New York City. While it would be comforting to imagine that the nation's cultural institutions were competing for such a rare treasure, the truth is that the Smithsonian was the last hope for artworks that would otherwise be abandoned. The museum was suddenly endowed with a legacy that, in a single stroke, restored some small semblance of perspective on national culture.

Long before she turned to the Smithsonian, Evelyn S. Brown had already rescued collections, as when she had persuaded a New York court in the 1950s to transfer responsibility for William H. Johnson's lifework to the Harmon Foundation rather than see it destroyed for nonpayment of warehouse rental fees. The story of William H. Johnson, whose art today constitutes one of this museum's greatest treasures, serves as a parable for African-American artists. Johnson was a native of rural, segregated South Carolina, a migrant northward to urban New York, an expatriate to Europe escaping discrimination, who finally experienced a "homecoming" to Harlem and South Carolina in the 1930s and 1940s where he was inspired by the black cultural renaissance to make his best paintings. The recognition and patronage that would surely have accrued to an equally accomplished white artist was denied him. He spent the last twenty-three years of his life in an insane asylum on Long Island, dying in 1970 without knowing that his art would be permanently housed in a museum in the nation's capital and featured the following year in a retrospective exhibition and catalogue. As part of the agreement with the Harmon Foundation, the museum donated more than 120 of his paintings—about ten percent of the Johnson collection—to historically black colleges and universities, including Morgan State College, Hampton Institute, Tuskegee Institute, Fisk University, and Howard University, among others.

The year after the Johnson retrospective, in 1972, *Grey Night* by Washington's abstract painter Alma Thomas was purchased, leading to donations from the artist and several patrons, as well as a handsome bequest from Thomas, so that the museum now holds twenty-five paintings from all phases of her career. An exhibition and catalogue were subsequently prepared by curator Merry A. Foresta in 1981. Along with these developments, the museum had begun in the 1970s to host research fellows and interns of African-American descent who were eager to explore their heritage in greater depth.

In the early 1980s another momentous acquisition significantly restored the inadequate historical record of black artistic achievement. Again the lifelong commitment of individuals was decisive. Warren Robbins, a white collector and African art scholar, had for many years acquired both art from Africa and works by Americans of African descent, helping to document a crucial aesthetic

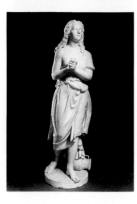

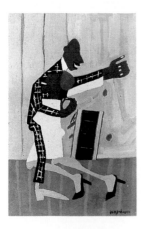

connection between sub-Saharan Africa and the black diaspora. Robbins worked from personal conviction and was aided significantly by Dr. David Driskell, a scholar who was seminal in creating the field of black art studies in the 1960s, building on the early work of such pioneers as James Herring and James Porter in the 1920s and 1930s. Warren Robbins' collection, amassed through purchases and donations from many concerned individuals, formed the core of Washington's first Museum of African Art. This museum was later incorporated into the Smithsonian Institution and rededicated solely to the art of Africa; in 1983, Robbins' substantial collection of more than two hundred African-American works—including large collections of work by nineteenth-century artists Joshua Johnson, Robert Scott Duncanson, Edmonia Lewis, Edward Mitchell Bannister, and Henry Ossawa Tanner—were transferred to the National Museum of American Art to take their place among the art of their compatriots.

For more than a century, American art collectors and professionals had focused mainly on an all-white roster of established masters, from colonial portraitists in New England through abstract expressionists, a canon that was firmly entrenched nationwide, leaving blacks and many other groups outside the mainstream. But when Robbins' African-American collections moved to the National Museum of American Art, the then-current director, Charles C. Eldredge, and the staff took a serious look at the museum's presentation of American art. The exciting new collection soon attracted the special attention of curator Lynda Roscoe Hartigan, who researched the artists and consulted black scholars and historians, discovering in the process many other painters and sculptors the museum aspired to collect. *Sharing Traditions: Five Black Artists in Nineteenth-Century America* (1985) was the resulting exhibition, presented in Washington and circulated to fifteen museums nationwide. To the artists, collectors, museum professionals, scholars, and audiences who helped and shared our excitement in this effort, we extend our gratitude.

New paths continue to appear. In 1986, the museum acquired more than four hundred works by self-taught artists from the huge holdings amassed by Herbert Waide Hemphill, Jr., including a whole group of artists never before collected by museums, many of them African Americans. Their inventiveness, unconstrained by conventions of the art world, is a new universe to explore. And as this book goes to press, we are embarking on another collecting initiative—the acquisition of work by African-American photographers, beginning with an in-depth commitment to the career of Roy DeCarava.

Art world hierarchies cannot be underestimated, and their role in limiting what we can see and understand must be acknowledged. They may appear disguised as "objective standards" or cloaked as the "historical record," when in fact they represent the conventions of cultural dominance. Had American society been free of racial bias, surely its museums would have long ago included

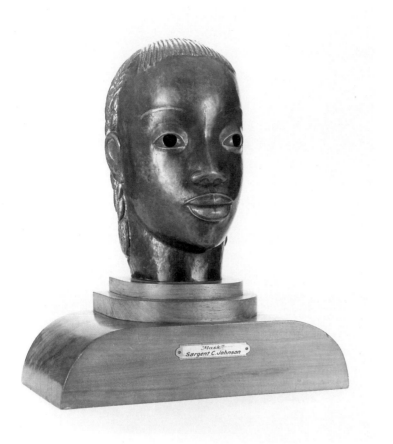

Sargent Johnson, *Mask*, ca. 1930–35, copper on wood base, 15 1/2 x 13 1/2 x 6 in.

professional staff reflecting the diversity of its people and the hierarchies would not have prevailed so long. But the gulf that separated black artists from predominantly white cultural institutions was a grand canyon that seemed unbridgeable for more than a century. The closed door confronting African-American museum professionals paralleled the exclusion of black artists, constituting a separate story of personal disappointment and institutional loss.

It can only increase our admiration for these artists and museum professionals to realize how much courage was required to persevere. But finally, the reasons for celebrating their achievements rest less on ideals of social justice than on the artworks they cherished—so rich, vibrant, and expressive that without them, the larger picture of American art is unacceptably compromised and impoverished. It is no longer possible to imagine a museum of American art without the work of these vital artists. Their accomplishments do not just diversify the record of American art; they redefine it. To take a single example, we must think again about the long-accepted notion that significant religious expression disappeared from American culture with the spread of Darwinism in the late nineteenth century; it clearly survives through the inspired work of artists as different as Henry Ossawa Tanner and James Hampton.

This book includes poignant and exhilarating histories, and many more await our attention. We have selected just thirty-one artists from the 105 represented in the museum's collections for inclusion here, a sampler meant to whet rather than satisfy the appetite for this important work. Our first goal is to spread the word about these remarkable artists to all those who care about our nation's art and history. Even more, however, we urge everyone to challenge the prevailing wisdom about American culture and open his or her eyes to the experience of all our artists. To the artists and to all those who respond to them, we dedicate this book.

This publication is a much-expanded version of a small pamphlet produced several years ago called *Free Within Ourselves.* Curator Lynda Roscoe Hartigan and museum educator Nora Panzer were responsible for that first general introduction to the museum's African-American collections, and their efforts were fundamental in conceiving and preparing this book. Nora Panzer consulted many people involved in art education nationwide to determine which materials would be most useful and she helped secure support for the project. She and Lynda Roscoe Hartigan also worked closely with scholar and author Regenia Perry to make an initial selection of the artists to be included and shape the texts documenting their work.

To Dr. Regenia Perry, we owe a special thanks. As our ambitions expanded from a small book to a larger one, she was always flexible and responsive, willing to take on more work to ensure that the publication would reach as many people as possible. In a separate acknowledgment, Dr. Perry notes her appreciation for all those who helped her in the preparation of her manuscript.

Chief curator Virginia Mecklenburg provided crucial curatorial assistance. As project director, curator Lynda Roscoe Hartigan offered scholarly guidance and carefully read the text several times. Publications chief Steve Dietz and his dedicated staff are responsible for the handsome presentation of the book and for arranging its wide distribution through Pomegranate Artbooks.

To accompany the publication, the National Museum of American Art has prepared an exhibition featuring artists represented in these pages. As this book appears, the exhibition begins a two-year tour which we hope will stimulate wider recognition of this great national collection.

Finally, I extend my most sincere gratitude to IBM Corporation for fully supporting this publication. IBM's contribution not only covers the cost of book production; it also allows the museum to distribute thousands of free copies to schools in the Washington, D.C., area, which we hope will encourage teachers to bring their students to see the artworks in person. IBM's longstanding support for the arts and education constitutes an inspiring example of corporate commitment and assistance to museums.

Elizabeth Broun
Director
National Museum of American Art

INTRODUCTION

The student of African-American art must be many things. First, he or she must be an archaeologist, willing to dig deeply under the rock and sift the sediment that represents history's and society's changing cycles of interest in the art of African Americans. The student must also be a person of great patience, a Job-like figure perhaps, willing to remain steadfast in the face of resistance, opposition or indifference. And finally, this student must be a visionary. Not unlike the self-taught African-American artists Sister Gertrude Morgan or James Hampton, he or she must be able to see the unseeable, think the unthought, imagine the unimagined.

In assembling its collection and this publication of African-American art, the National Museum of American Art has been an institutional archaeologist, Job-like in its determination and visionary in the realization of its desire to pursue an inclusive art history. The remarkable and inspiring story of the NMAA's steady acquisition, research, study, exhibition, publication, and appreciation of the art of black America is an example of a growing interest in American museums to expand their scope and missions to reflect more truly the rich diversity that is American art.

Why is this contribution so remarkable? I would like to suggest a number of reasons. First the care and attention given each artist in this book clearly demonstrates a respect for the work included that, while well deserved, is all too rare. Secondly, it is important because not only this generation, but future generations will be enriched by the knowledge and experience of the artists in this collection, each one unique, yet all united by a common struggle and all products of a common culture.

Indeed, a major contribution of this text is its ability to differentiate individual African-American artists from the shared history and traditions that shape so much of their work and their ability to negotiate the many arenas—national, international, academic, commercial, critical, popular—in which they operate. Reading both the facts and the between-the-lines emotions of the lives of this extraordinary group of artists is a vivid and moving experience.

What reader could fail to be stirred by Edward Mitchell Bannister's achieve-

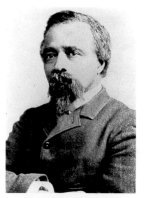

Edward Mitchell Bannister

Elizabeth Catlett

William Edmondson

Minnie Evans

ment of a first prize awarded at the Philadelphia Centennial Exposition of 1876, within a decade of the end of the Civil War? How many young people might be inspired by Elizabeth Catlett's five-decade pursuit of her career in both the United States and Mexico, with some of the leading art figures of her time, while becoming a major force in her own right? Inspiring in a different way are the art and life stories of visionary artists William Edmondson and Minnie Evans, standing as testaments to the urgency of the creative impulse and its insistence on expression, whatever the training and however modest the means of the creators. Much can also be learned from the very different expatriate experiences of several African-American artists, from Henry Ossawa Tanner and Edmonia Lewis in the nineteenth century, to Beauford Delaney, Hale Woodruff, Palmer Hayden, and Romare Bearden in the twentieth century.

Finally, this undertaking is so important because it will stimulate interest in the larger subject of African-American art. That subject has a lot to teach us all. For while there is no one monolithic African-American art, within the work of individual African-American artists one finds the embodiment of what it means to be an African American, in all its complexity and differences. Whether one learns the story of a largely figurative painter like Jacob Lawrence, whose renderings of historical and contemporary figures are at once jarring and seductively engaging, or a visionary sculptor like William Edmondson, whose modernist abstraction of form belies an absence of formal training, one learns each time a little more about the variety of human expression. The prevalence of musical reference in artists such as Romare Bearden and William H. Johnson, the interest in historical and political themes and figures in the work of Edmonia Lewis, Lois Mailou Jones, and Hale Woodruff, and the varied approaches to abstraction by Woodruff, Sam Gilliam, and Alma Thomas have something to tell us about influences, opportunities, and the singular vision of a particular artist. The role of ritual, faith, myth, folklore, modernism, and surrealism all have a place in the examination of this art. And the student who is willing to go further is in for some pleasant surprises and new insights into the sources and uses of art.

The exploration of African-American art in all its complexity has been undertaken for decades not only by the NMAA, but by numerous institutions throughout the United States, particularly those dedicated to the art and culture of black America and the African diaspora. In order to understand the context of the NMAA's work, it is important to speak of some of those other institutions.

Institutions like Howard University, Fisk University, Hampton University, the Schomburg Center for Research in Black Culture, The Studio Museum in Harlem, and the Museum of the National Center of Afro-American Artists have steadily built collections, nurtured scholars, educated and trained artists, and disseminated research and critical analysis of African-American art, some for as long as a century, most for at least a quarter of a century. Without these institutions and their educators, scholars, and artists—like Howard University's

Henry Ossawa Tanner

Edmonia Lewis

Beauford Delaney

Hale Woodruff

James A. Porter and James V. Herring; Fisk University's Aaron Douglas and David Driskell; Arturo Schomburg (the Afro-Puerto Rican bibliophile whose collection remains the leading archive on African-American culture in the world); Harlem Renaissance philosopher Alain Locke, and countless other students and scholars of this work—the efforts to bring this art to wider knowledge and recognition would not have been possible.

The painter Hale Woodruff is exemplary not only for his own contribution to abstraction, but for the years he spent teaching at both Atlanta University, where his annual competition for young artists brought them recognition and critical attention, and at New York University where he spent his last years. Other artist-teachers, such as Lois Mailou Jones, Elizabeth Catlett, and Jacob Lawrence, were both contributors to and beneficiaries of the nurturing cycle at traditionally black educational institutions where artistic training combined with handing the baton to the next generation of artists, art historians, curators, and critics. This knowledge, built over decades, has meant that the young have consistently been inspired to follow in the footsteps of their elders and have been urged on by the courage and vision of mentors who have pursued their careers despite modest public attention, little critical acclaim, or market success. Lessons then learned from the lives and experiences of Edward Mitchell Bannister, Edmonia Lewis, and Henry Ossawa Tanner, and taught by Hale Woodruff's generation to the generation of Jacob Lawrence have ultimately provided Richard Hunt, Fred Brown, and their peers with generations of shoulders to stand on, reaping the benefits of the cumulative knowledge and acceptance of African-American art and artists.

In addition to the support of institutions and elders, African-American artists through the years have been encouraged and helped by an ongoing (though hardly consistent or dependable) array of patronage from other sources. The enormous contribution of the Harmon Foundation from the Harlem Renaissance period to the 1960s is evident in the careers of numerous African-American artists, including a number documented in this book. Beginning in the 1930s the WPA was a lifeline for a number of African-American artists whose commissioned efforts under the program became an important part of their work. The postwar 1940s and 1950s were periods of heightened activity for African-American artists who were awarded fellowships, some exhibition opportunities, and travel abroad, particularly to Paris, where along with musicians, poets and writers, they received some of the acclaim and acceptance that eluded them at home. From the 1960s on, the civil rights movement and the black arts movement presaged a resurgence of interest in African-American art not seen since the Harlem Renaissance. Perhaps as important, that interest became institutionalized as African-American museums, galleries, and cultural centers burgeoned. Like the historically black colleges that preceded them, these institutions initially focused on the needs of the African-American community.

Palmer Hayden

Romare Bearden

William H. Johnson

Jacob Lawrence

Over time they developed into the principal resources for the study and collection of African-American art. In a shift that would have been hard to predict, the primacy of those institutions is being challenged by a growing movement towards cultural diversity. While the effect of this movement is much too recent to assess and the depth and sincerity of efforts to date too early to measure, its impact is already being felt. This publication is one of the positive aspects of that movement. Before discussing other such efforts, however, it is important to add a bit more context to the overall discussion.

Despite countless exhibitions, publications, seminars, and conferences, what makes efforts like this one so important and so urgent is that the art of African-American artists remains, nevertheless, underknown. An artist of the rank of Romare Bearden, in spite of major retrospectives and commercial success, is not as well known as Jackson Pollock or Jasper Johns. The same can be said of Jacob Lawrence, one of the greatest American artists of his generation. Unlike Bearden, Lawrence received early critical acclaim, yet, now in his midseventies, he is still far from a household name. Neither Lawrence's name nor Bearden's rings with the familiarity of a Frank Stella. Why is this? What can be done about it? What is the role of this publication in that effort?

The why is a bit difficult to answer, but just as the story of the NMAA's African-American collection is a story of starts, gaps, serendipity, and ultimately, commitment, such is the story and the requirement of others interested in such an undertaking. Such a standard is required because the exclusion of African-American artists is a longstanding and pervasive reality whose remedy is not a quick-fix but a comprehensive undertaking. For if one does not take the same kind of care, commitment, and deliberateness in the allocation of resources and mapping of a course of action, collections of African-American art will not be developed. There will always be other demands, funding needs, and daunting prospects of charting what for some will seem unfamiliar territory. As we approach the twenty-first century, however, such obstacles pale in light of our obligation to this and future generations to present a richer, more complete history of American artistic expression.

What can be done might be rephrased as what *is* being done. Because there are indeed positive aspects to the interest in cultural diversity, particularly if such efforts are approached with clear objectives and the expertise to match them. Certainly the interest in African-American art among museums in the United States has grown over the past ten years. Major exhibitions of the works of Jacob Lawrence, Romare Bearden, Robert Colescott, Betye and Alison Saar, Martin Puryear, and William H. Johnson (the latter recently organized by the NMAA) indicate the breadth and seriousness of that interest. Group shows and thematic exhibitions here and abroad now routinely not only include the works of African-American artists but also focus on their contributions. Acquisitions of African-American art from Brooklyn to Denver and from San Francisco to

Lois Mailou Jones

Sam Gilliam

Alma Thomas

James A. Porter

Atlanta have grown as well.

To a larger public in the last decade the emergence of artists as diverse as Betye Saar, Fred Brown, Melvin Edwards, Bob Thompson, Maren Hassinger, William T. Williams, Emilio Cruz, Alvin Loving, Tyrone Mitchell, Raymond Saunders, and Adrian Piper—as well as younger artists such as Lorna Simpson, Carrie Mae Weems, Fred Wilson, and Alison Saar—has meant that the "open secret" of the continuum of African-American artistic expression—once confined largely to the community of its origins—is now more widely revealed. And in that revelation, a new generation of curators, art historians, critics, artists, and informed citizens will be able to learn from the creativity and production of these remarkable artists.

This interest has not been confined to the work of formally trained African-American artists either. Recent and upcoming exhibitions of self-taught artists such as Nellie Mae Rowe, Horace Pippin, Elijah Pierce, and Thornton Dial mean that artists whose work was virtually unknown to all but an inner circle before the late 1970s and early 1980s will be more widely seen and appreciated.

As we look to the future of American art this publication's role comes into focus as well. The evidence presented here of the NMAA's ongoing and current commitment to the serious study of African-American art is noteworthy in and of itself. The plan for the dissemination of this book and the nationally touring companion exhibition are perhaps even more noteworthy. For it is in the effort to reach educators and young people (and one hopes, their parents) that the real power and impact of this undertaking lies. The young reader of this book is for all of us the true audience.

For all young people, this book promises the enjoyment and understanding of a fuller, richer American culture that includes all and embraces a vision as wide and deep as the human spirit. For the young reader, and for all readers, whether this volume is the beginning of a long relationship with African-American art or the continuation of an ongoing one, it presages an engaging odyssey that will open new territories of both knowledge and further inquiry. It is also hoped that further inquiry will not require the patience of Job (though perseverance is a good and necessary thing) to undertake the unearthing, rediscovery, and critical analysis of this important area of study. Rather, efforts like this book will have set the stage so that one will not be required to reinvent the wheel or start from scratch. In that way, more monographs on individual African-American artists will be written, more connections between the art of African Americans and their peers will be made, more research into iconography, style, and content, influence and influences will be drawn, and in short, the art of African-American artists will be given the same care and attention that their other American colleagues have received.

For in this endeavor we are all enriched, our worlds are made larger, our vision expanded. Because the more we learn about African-American artists, the more

Richard Hunt

Frederick Brown

Bob Thompson

we learn about ourselves as a country and as a culture. And that knowledge, particularly for the young, is as powerful as it is enriching. Artists of all backgrounds, historically and currently, serve to inspire, to move, to engage, to rouse, to push us to a greater discovery of what it is to be human, and to become aware what our world can be. And if ultimately that means future generations will have that enlarged vision, that greater degree of hope, that greater sense of possibility, then that can only be a good thing.

African-American art is an important part of the American legacy. It deserves greater resources, attention, and acknowledgment. This book and the African-American collection of the NMAA should stand as beacons for future archaeologists and visionaries of a world where all art and culture are valued as singular and precious.

Kinshasha Holman Conwill
Director, The Studio Museum in Harlem

FREE WITHIN OURSELVES

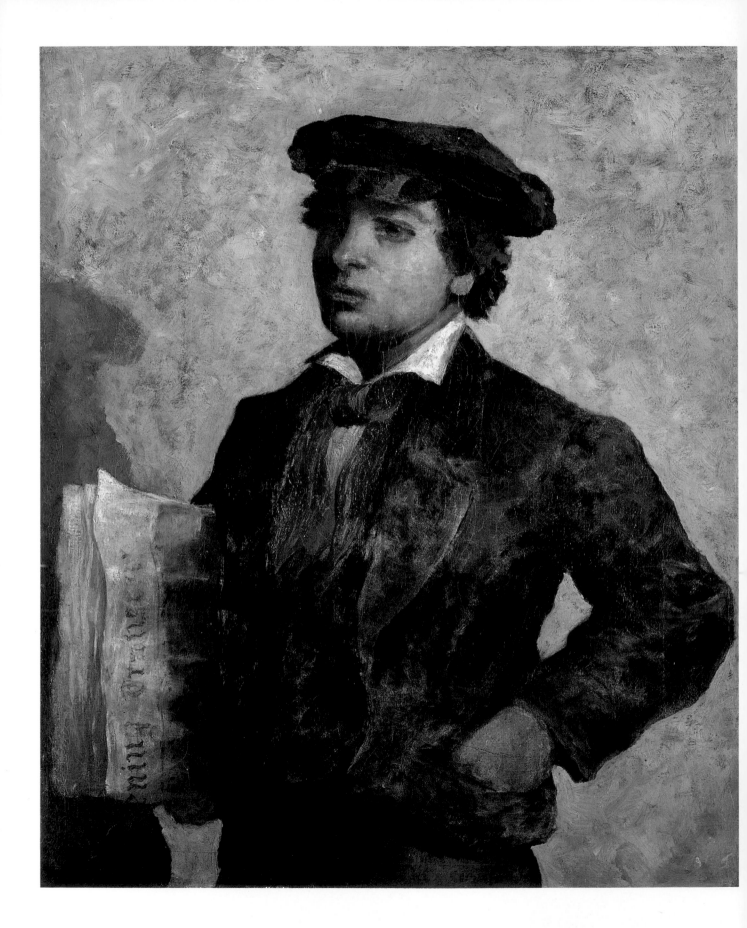

EDWARD MITCHELL BANNISTER

1828–1901

All that I would do I cannot—that is, all I could say in art—simply from lack of training, but with God's help I hope to deliver the message he entrusted to me.

Edward Mitchell Bannister's determination to become a successful artist was largely fueled by an inflammatory article he read in the *New York Herald* in 1867, that stated "the Negro seems to have an appreciation for art while being manifestly unable to produce it." Ironically, less than a decade later, in 1876, Bannister was the first African-American artist to receive a national award.

Bannister was born in November 1828 in St. Andrews, New Brunswick, Canada. His father was a native of Barbados, West Indies. The racial identity of Bannister's mother, Hannah Alexander Bannister, who lived in New Brunswick and whom Bannister credited with fostering his earliest artistic interests, is not known. Bannister's father apparently died early, and after the death of his mother in 1844 he lived with a white family in New Brunswick. Bannister left his foster home after several years and took a job at sea, as was customary for many young men from St. Andrews.

In 1848 Bannister moved to Boston where he held a variety of menial jobs before he became a barber and eventually learned to paint. Bannister painted in the Boston Studio Building, and also enrolled in several evening classes at Lowell Institute with the noted sculptor-anatomist Dr. William Rimmer. Only a few of Bannister's paintings from the 1850s and 1860s have survived, preventing a stylistic assessment of his early period in Boston. While Bannister lived in Boston he must have seen and been influenced by the Barbizon School-inspired paintings of William Morris Hunt who had studied in Europe and held numerous public exhibitions in Boston during the 1860s. American landscape painters were increasingly aware of the simple rustic motifs and pictorial poetry of

Newspaper Boy, 1869,
oil on canvas, 30 1/8 x 25 in.

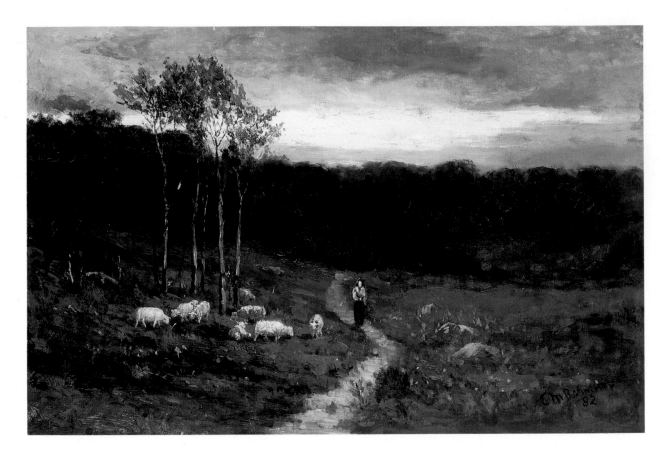

Woman Walking Down Path,
1882, oil on canvas, 20 x 30 in.

French Barbizon paintings by Jean-Baptiste Corot, Jean-François Millet, and Charles-François Daubigny in the midnineteenth century.

On June 10, 1857, Bannister married Christiana Cartreaux, a Narragansett Indian who was born in North Kingston, Rhode Island. The couple had no children. Christiana worked as a wigmaker and hairdresser in Boston, and her Rhode Island background might have prompted the Bannisters to move from Boston to Providence, Rhode Island, in 1870.

Since Bannister's artistic studies were limited, it is remarkable, indeed, that within five years after his arrival in Providence, one of Bannister's paintings was accepted in the Philadelphia Centennial Exposition of 1876. The painting, *Under the Oaks*, was selected for the first-prize bronze medal. Bannister related in considerable detail that the judges became indignant and originally wanted to "reconsider" the award upon discovering that Bannister was African American. The white competitors, however, upheld the decision and Bannister was awarded the bronze medal. The location of the painting has not been known since the turn of the century.

Following the Centennial Exposition, Bannister's reputation grew and numerous commissions enabled him to devote all his time to painting. He executed a large number of landscapes, most of which depict quiet, bucolic scenes

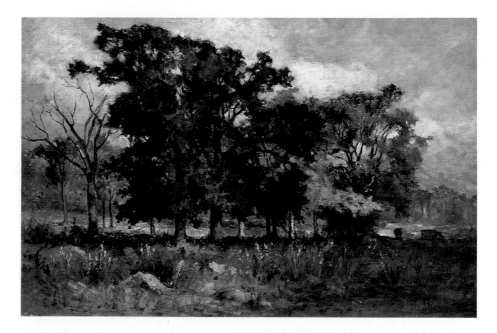

rendered in somber tones and thick impasto. While Bannister's initial influence probably stemmed from the Barbizon-inspired works of William Morris Hunt, his paintings are reflective of an artist who loved the quiet beauties of nature and represented them in a realistic manner. Bannister's middle-period landscapes of the 1870s were generally executed in broad masses of heavy impasto with few details. They also evoke a tranquil mood that became one of the hallmarks of Bannister's style. Later landscapes of the 1880s and 1890s employed a more gentle impasto and loosely applied broken color similar to impressionist techniques.

Many of Bannister's landscapes are small and have darkened considerably with age. His paintings contain no social or racial overtones, and the small figures seen frequently in his landscapes appear to be white. Although the majority of Bannister's paintings are landscapes, he also painted portraits, figure studies, religious scenes, seascapes, still lifes, and genre subjects. Bannister was attracted primarily to picturesque motifs including cottages, castles, cattle, dawns, sunsets, and small bodies of water, and he portrayed nature as a calm and submissive force in his works.

In spite of his limited training and experience, Bannister was among Providence's leading painters during the 1870s and 1880s. He was well liked and respected by his fellow citizens. On January 9, 1901, Bannister died while attending a prayer meeting at his church. Shortly after his death, the Providence Art Club mounted a memorial exhibition of 101 of Bannister's paintings owned by Providence collectors. Bannister's grave in North Burial Ground, Providence, is marked by a rough granite boulder ten feet high bearing a carving of a

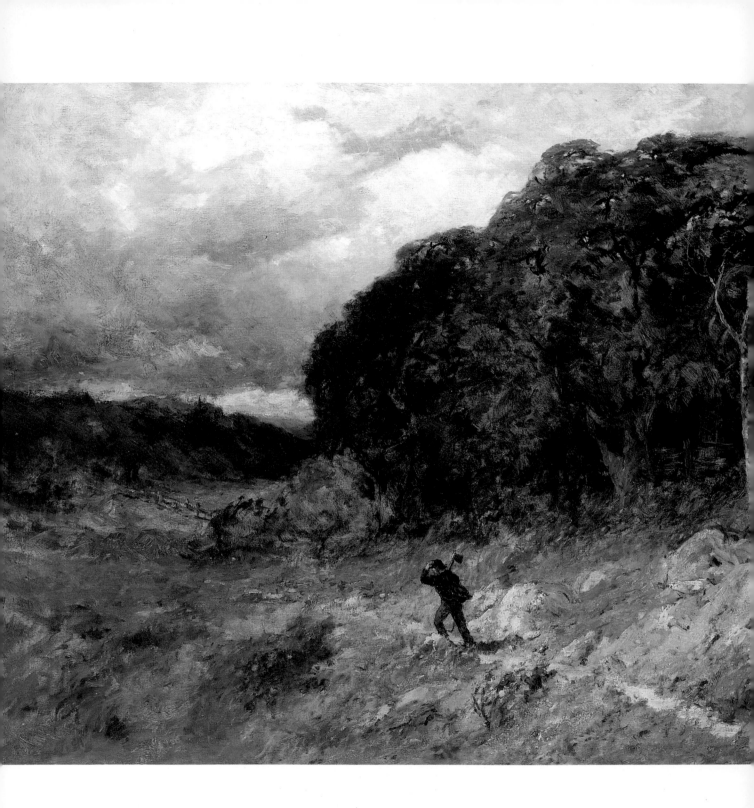

Approaching Storm, 1886,
oil on canvas, 40 1/4 x 60 in.

palette with the artist's name and a pipe. A bronze plaque also adorns the monument and is inscribed with a poem, which reads in part, "This pure and lofty soul . . . who, while he portrayed nature, walked with God." Edward M. Bannister was the only major African-American artist of the late nineteenth century who developed his talents without the benefit of European exposure.

APPROACHING STORM

In contrast to the tranquil mood that permeates the majority of Bannister's bucolic landscapes, *Approaching Storm* depicts a view of nature in opposition to the forces of an oncoming storm. Characteristic of Bannister's late landscapes of the 1880s, this painting was executed in loosely applied strokes of paint employing both brush and palette knife. The painting's dominant brown tones are highlighted by touches of sharp greens and yellows, which create electrifying accents across the painting's surface and increase its emotional impact.

The lone figure of a man with an axe is seen scurrying along a narrow path as he struggles to maintain his hat and balance against the wind. Although the figure is small, it is the focal point of the composition, and one of only several in which a figure plays a central role in Bannister's numerous landscapes. A large grove of trees with leafy boughs sway against the powerful wind, and ominous clouds roll across the horizon. The flickering yellows and gloomy clouds suggest thunder and lightning; one senses that a torrential downpour is imminent. *Approaching Storm* is one of Bannister's finest landscapes and perhaps the most emotionally charged of all his works. The painting is in the spirit and technique of the French Barbizon School. Bannister saw French Barbizon works in Boston and Providence as well as works by William Morris Hunt, the American so influenced by this style. His landscape paintings were the result of his keen observation and appreciation for the natural beauty of his New England environment.

Bannister's *Tree Landscape* of 1877, in contrast to *Approaching Storm*, is typical of his tranquil, poetic compositions. A large clump of trees and several grazing cattle dominate the painting's middle ground, and the basic composition is strikingly similar to a surviving sketch for his celebrated work, but now lost, *Under the Oaks* of 1876.

Newspaper Boy of 1869 is one of Bannister's few genre subjects. The name and racial identity of the subject are not identified in this work that was painted in Boston the year before Bannister moved to Providence. Newspaper boys and children of the streets were a popular subject of paintings in Europe and America at the time. Bannister's only surviving portrait is that of his wife, Christiana.

George W. Whitaker, "Reminiscences of Providence Artists," *Providence Magazine, The Board of Trade Journal* (Feb. 1914): 139.

ROMARE BEARDEN

1912–1988

It is not my aim to paint about the Negro in America in terms of propaganda . . . [but] the life of my people as I know it, passionately and dispassionately as Breughel. My intention is to reveal through pictorial complexities the life I know.

Romare Bearden, the only child of Richard Howard and Bessye Johnson Bearden, was born in 1912 in Charlotte, North Carolina, in the heart of Mecklenburg County. Shortly after his birth, Bearden's parents moved to New York City where his father worked as a sanitation inspector, and his mother became the New York editor of *The Chicago Defender* newspaper and the first president of the Negro Women's Democratic Association.

During the early 1920s the period of cultural flowering in the African-American community known as the Harlem Renaissance was in its formative stages. The Bearden apartment on West 131st Street in Harlem was a frequent gathering place for such intellectuals as W. E. B. Du Bois, Paul Robeson, and Countee Cullen, as well as artists Aaron Douglas and Charles Alston, and jazz musicians Fats Waller, Duke Ellington, and Andy Razaf. The Lincoln Theatre, Savoy Ballroom, and a number of other night spots were only a few blocks from the Bearden apartment, and Bearden became deeply immersed in jazz and the Blues as an adolescent.

In 1925, Bearden went to Pittsburgh where he lived with his maternal grandmother and graduated from Peabody High School in 1929. His grandmother operated a boarding house that catered largely to steel mill workers, many of whom had recently emigrated from the South. New York City, Charlotte, and Pittsburgh were the cities of Bearden's childhood, and each made an indelible impression on Bearden as an artist many decades later. His artistic interests were developed in Pittsburgh when his boyhood friend, Eugene Bailey, taught him how to draw. Following Bailey's death in 1925, Bearden's interest in art waned.

Bearden had not considered a profession as an artist when he enrolled in New

Family, 1988, collage on wood, 28 x 20 in.

York University in the early 1930s. He graduated in 1935 with a B.S. degree in mathematics. During his years at New York University, however, Bearden worked as a cartoonist for the university's humor magazine, *Medley*, did editorial drawings for the *Baltimore Afro-American*, and worked for *Colliers* and the *Saturday Evening Post*.

In 1935 Bearden decided to become a professional artist after a meeting of a group of African-American artists who later became the Harlem Artists Guild. In 1936 Bearden joined an informal group of black artists in Harlem, the "306" Group—named after the studio lofts at 306 West 141st Street where the group met. During the same year, Bearden enrolled at the Art Students League where he studied under German expressionist George Grosz. A strong influence, Grosz introduced Bearden to the works of Daumier, Goya, Breughel, and Köllwitz, as well as Ingres, Dürer, Holbein, and Poussin.

Bearden left the Art Students League after a year and a half, painted part-time, and found employment as a caseworker in the New York City Department of Social Services. By 1940 Bearden had begun to paint in tempera on brown paper. From 1942 to 1945, Bearden served in the army. After his discharge, he held his first one-man exhibition in a New York gallery—works from the "Passion of Christ" series—at the Samuel M. Kootz Gallery in 1945.

In 1950, Bearden decided to go to Paris and study philosophy part-time at the Sorbonne on the G.I. Bill. In Paris, Bearden met painter Georges Braque, sculptor Constantin Brancusi, and a number of French and American artists and writers living in Paris. He visited museums and galleries while traveling to Nice, Florence, Rome, and Venice. Having produced no paintings in Paris, Bearden returned to New York in 1951. He abandoned painting for two years while concentrating on songwriting, and a number of his songs were published. In 1952 Bearden resumed his caseworker duties, and two years later he married Nanette Rohan, a dancer and artist. During the mid-1950s, with the encouragement of his friends and wife, Bearden resumed painting, concentrating on oils and acrylics.

Very conscious of the evolution of his style, Bearden once stated that his early temperas of the 1930s were composed of closed forms with colors that were primarily earthy browns, blues, and greens. When he began painting watercolors he employed bright color patterns with bold black lines to delineate shapes. The next step included oils that were largely extensions of his watercolors. He enlarged his initial sketches as photostats, traced them on gessoed panel, and completed an oil painting with a thinned color as if it were a watercolor. Bearden's early interest in flat painting was largely inspired by Stuart Davis, whom he met in 1940. Davis was deeply influenced by jazz and helped Bearden visualize a relationship between painting and jazz.

At the height of abstract expressionism's popularity in New York, Bearden experimented with its techniques between the late 1950s and early 1960s. He

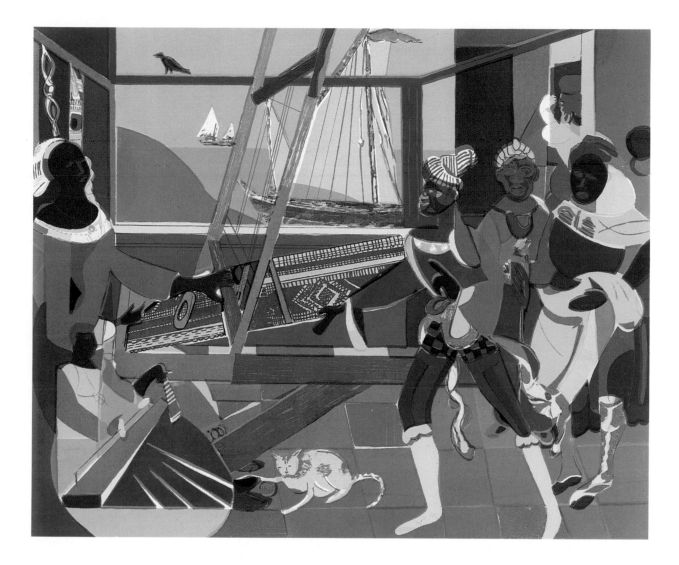

The Return of Ulysses,
serigraph on paper,
18 1/2 x 22 1/2 in.

produced a series of nonrepresentational paintings in which organic forms merge. Bearden, however, was never satisfied with abstract expressionism because he felt that it lacked a philosophy. Bearden subsequently began experimenting with a technique in which he painted broad areas of color on various thicknesses of rice paper and glued the papers on canvas, usually in several layers. He then tore sections of the paper away, upward and across the picture plane, until a motif emerged. Finally, he added more paper and painted additional elements to complete the painting.

The turbulent decade of the 1960s sparked the most important stage in Bearden's career. In 1963 a group of African-American artists in New York met in his studio to discuss how they could contribute to the civil rights movement. From this meeting the "Spiral" group was formed, and its members began to reassess their responsibilities as artists to society. One of the Spiral members

Golgotha, ca. 1945,
watercolor on charcoal
paper, 26 x 20 in.

suggested that Bearden enlarge his photomontages photographically. He experimented with this technique, but was not satisfied with the results. Arne Ekstrom, a New York art dealer, saw the rolled-up photostats in Bearden's studio and was so impressed that he encouraged Bearden to create a series of the works for an exhibition, entitled "Projections," at Ekstrom's gallery in October 1964. The following year, the Corcoran Gallery of Art in Washington, D.C., organized a second "Projections" show, Bearden's first one-man museum exhibition. The success of this series was such that he was able to support himself as a professional artist, and in 1966 Bearden gave up his job as a social worker.

The "Projections" series consists of monochromatic photomontages and photostats that Bearden called "Photo Projections." In these works, silhouettes of faces and hands have been cut from black-and-white photographs and then combined in carefully orchestrated designs. Scenes from African-American life in Charlotte, Harlem, and Pittsburgh mark Bearden's return to figurative painting. Stylistically, the scenes were inspired by African sculptures, Chinese calligraphy, and European painters as diverse as Bosch, Zurbarán, and Mondrian. Although Bearden never considered himself a propagandist, his dramatic "Projections" seemed artistically appropriate for the new black pride movement. These works brought Bearden unprecedented success and remain this prolific artist's most acclaimed efforts.

Between 1967 and 1969, Bearden produced some of his largest and most innovative works. Memories of Mecklenburg County, North Carolina, abound, reaffirming Bearden's roots in the rural South. Often incorporating life-size imagery, these paintings combine collage with acrylics, drawings and oils, mosaics of real textures, and black-and-white photographs. Bearden always insisted that his works were paintings, not collages, because he used the techniques and materials of collage to create the rhythms, surfaces, tones, and moods associated with painting.

During the 1970s and 1980s, Bearden refined his style and continued to emphasize subjects derived from African-American genre and myth. In 1977, an exhibition entitled "Romare Bearden, Odysseus" at Cordier and Ekstrom Gallery in New York, included paintings inspired by classical themes. Taken from the Homeric legends, these paintings incorporated larger and fewer collage elements, flat shapes of objects and people, and emphasized a single color such as blue or green. During the 1970s, motifs inspired by jazz and the Blues reappeared in Bearden's work; in 1977 an exhibition of monoprints, "Of the Blues," received critical acclaim. By the late 1970s, Bearden began to use more vibrant and intense colors in his paintings, perhaps as a direct result of numerous trips to St. Martin in the West Indies, which is his wife's family home. During the 1980s the impact of this environment can also be seen in Bearden's final works, a watercolor series of Caribbean landscapes, seascapes, and portraits.

Bearden was also a writer. His first book, *The Painter's Mind*, was co-written

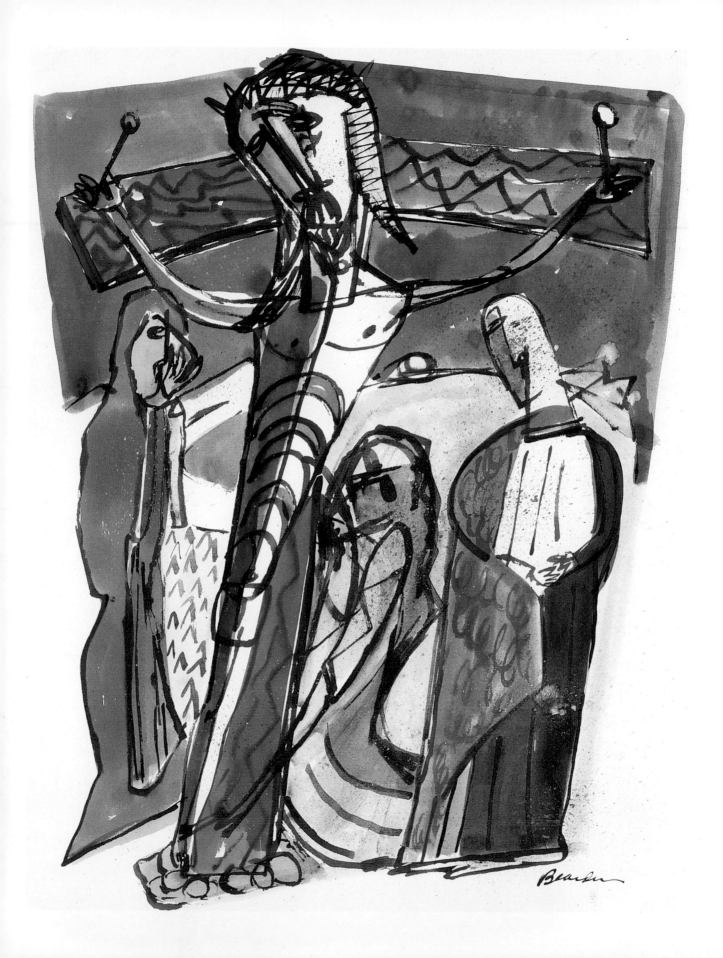

*Pepper Jelly Lady
(Presidential Portfolio)*, 1980,
color lithograph on paper,
25 15/16 x 21 3/16 in.

with the artist Carl Holty in 1969. He coauthored *Six Black Masters in American Art* in 1972 with Harry Henderson, and was working on a second book with Henderson, *A History of African American Artists*, at the time of his death. Bearden also organized several important exhibitions including "Contemporary Art of the American Negro" in Harlem in 1966 at what is now the site of the Studio Museum in Harlem, and in 1967, with art historian Carroll Greene, he organized "The Evolution of Afro-American Artists: 1800–1950" at City College in New York. Bearden received five honorary doctoral degrees, and was elected to membership in the American Academy of Arts and Letters and the National Institute of Arts and Letters in 1966. A year before his death in 1988, Bearden received the prestigious President's National Medal of the Arts.

PEPPER JELLY LADY

This lithograph depicts a Caribbean subject inspired by the artist's frequent trips to St. Martin over a period of twenty-five years. The vibrant colors in the central section are stylistically related to Bearden's works of the late 1960s and early 1970s, and to the majority of Bearden's Caribbean-inspired collage-paintings and watercolors.

Pepper jelly is a condiment used throughout the Caribbean, and vendors of this commodity are commonplace. Here the vendor appears at the entrance of a walled estate; a crowing cock announces her early arrival. The central part of the design reflects Bearden's superb ability to arrange flat overlapping shapes which, in this example, suggest a spatial depth not always seen in the artist's works. The train in the distant background reaffirms a journeying theme Bearden introduced in the mid-1960s. The print's wide border features line drawings incorporating such disparate themes as a church, a man beside a pot-bellied stove, a man in bib overalls, broad tropical fauna, Matisse-like imagery, a classical façade, and a seated couple inspired by a photograph of the artist's paternal great-grandparents on the porch of their home in Charlotte, North Carolina. The monochromatic linear motifs of the border provide an effective foil for the vibrant primary image. They reflect not only his childhood experiences in North Carolina, Pittsburgh, and New York, but European and Caribbean travels as well.

Golgotha, a watercolor of 1945, features bright colors bordered by black lines, as did many of his works during the 1940s. The design's effect is reminiscent of medieval stained glass, certainly appropriate to the "Passion of Christ," both the theme and title of a series Bearden produced in 1945. In this abstract composition, the figure of Christ on his cross is flanked by the two Marys and St. John the Apostle.

"Romare Bearden, The Human Condition" (New York: ACA Galleries, 1991), 2.

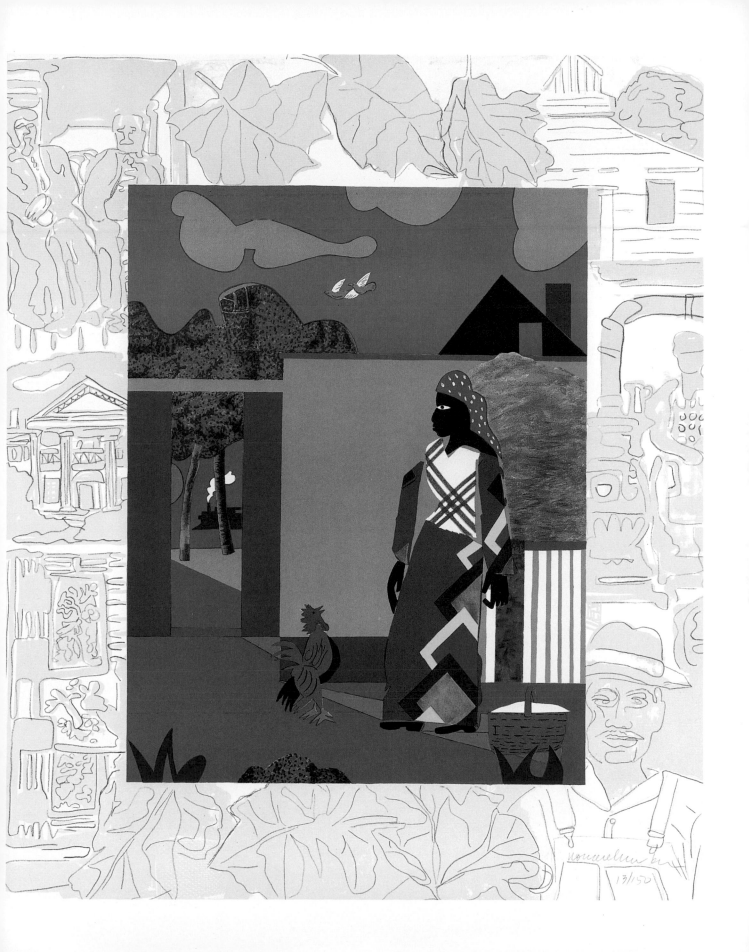

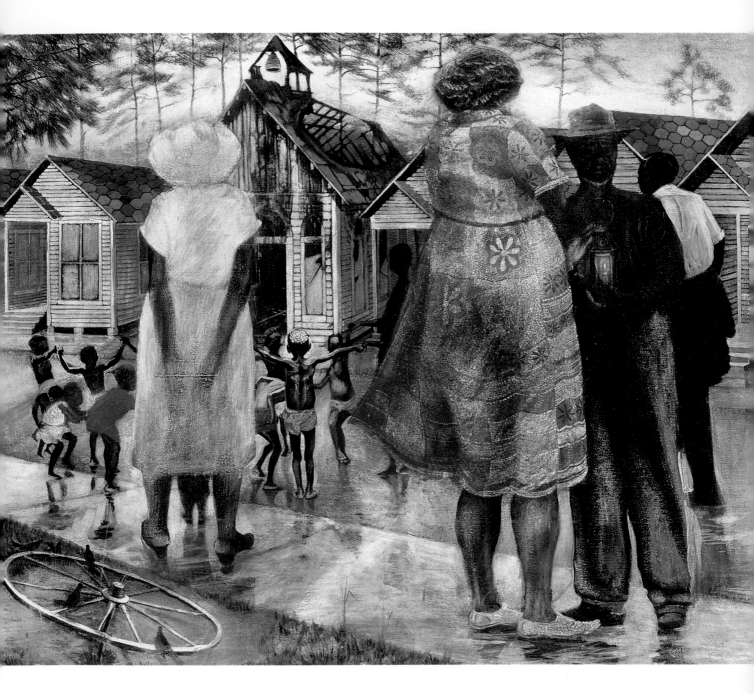

Shotgun, Third Ward #1, 1966,
oil on canvas, 30 x 48 in.

JOHN BIGGERS

———— born 1924 ————

I learned a long time ago that self-dignity and racial pride could be consciously approached through art.

Born in Gastonia, North Carolina, on April 13, 1924, John Biggers was the last of seven children of Paul and Cora Biggers. Biggers' father was a teacher, school principal, and shoemaker; his mother was a homemaker. When John Biggers arrived on the campus of Virginia's Hampton Institute (now Hampton University) in the fall of 1941 his goal was to become a plumber. During his freshman year at Hampton, however, Biggers enrolled in an art class taught by the dynamic educator Viktor Lowenfeld. It was a course that changed his life. Lowenfeld, an Austrian Jew who had moved to the United States to flee Nazi persecution, had gone to Hampton from Harvard University specifically to inspire young African-American students. In his intense instruction, Lowenfeld encouraged his students to explore the culture of their own people. He introduced his students to African sculpture as well as works by noted African-American artists, including Jacob Lawrence's widely acclaimed *Migration of the Negro* series. At Hampton, Biggers also studied under African-American painter Charles White and sculptor Elizabeth Catlett. These combined experiences awakened a desire in young Biggers to become an artist dedicated to depicting the lives of African-American people. While at Hampton Biggers also met his wife, Hazel, a fellow student whom he married in 1948.

When Viktor Lowenfeld left Hampton to assume a post in the art education department at Pennsylvania State University, he encouraged Biggers, his protégé, to follow. Biggers enrolled in Pennsylvania State University, where from 1946 to 1954 he earned bachelor's and master's degrees in art education as well as a doctorate. While there Biggers felt somewhat isolated during his early years on the predominantly white campus. During holidays and student teaching,

however, Biggers had an opportunity to observe and portray urban tenement life among African Americans in Philadelphia.

In 1949 Biggers accepted a position to establish an art department at the newly created Texas State University for Negroes in Houston. Rising to the challenge, Biggers succeeded in inspiring hundreds of young students during his tenure at the school, which was later named Texas Southern University. While working full-time as a teacher and administrator at Texas Southern, Biggers began establishing his reputation as a major African-American artist of the Southwest. One of his earliest large commissions in Texas was a set of illustrations to accompany a book entitled *Aunt Dicey Tales* by African-American Texan folklorist, J. Mason Brewer. From 1950 to 1956 Biggers painted four murals in African-American communities in Texas, which was the beginning of his interest in this category of painting. Each a major effort, the murals represented for Biggers the broadest methods of making his art accessible to the entire community. Since that time, Biggers has completed many other notable murals in the South and Southwest.

Unlike many African-American artists who made pilgrimages to Paris and other European cities to study, Biggers decided early in his career to visit the land of his ancestors. He made his first trip to West Africa in 1957 through a travel fellowship from UNESCO. His time was spent primarily in Ghana, Togo, Dahomey (now the Republic of Benin), and Nigeria where he was mesmerized by the colorful culture and life of African peoples. Biggers worked feverishly during his initial six-month stay, and produced an enormous body of drawings, paintings, and photographs. An important product of Biggers' African journey was the publication of a book, *Ananse, Web of Life in Africa*, in 1962. This book of drawings and writing records Biggers' African experience, and was one of the first books to be published by an African-American artist to reflect in narrative and visual terms the writer's kinship with the land of his ancestors.

Between 1969 and 1974 Biggers was severely ill and painted very little. Frustrated and in poor health, Biggers spent the majority of his time reflecting on his past experiences. In 1974 Biggers attended the exhibition, "African Art of the Dogon," at the Museum of Fine Arts in Houston, which reawakened his creative talents. He began creating new works that were more abstract, emphasizing the basic and eliminating the incidental. He began assembling his large and impressive collection of African art and surrounded himself with tools and crafts of African Americans, family quilts, and gourds—symbols that appear in Biggers' current works, as do anvils, cooking pots, washboards, and geometric quilt designs, reminiscent of Biggers' early years in North Carolina. Biggers has also developed a series of paintings depicting the characteristic "shotgun houses" of the Carolinas. Equally talented as a draftsman, lithographer, panel painter, and muralist, Biggers has been devoted to the portrayal of African-American culture in his work.

Following his retirement from Texas Southern University in 1983, Biggers entered a new phase of creative energy. Today, his career has come full-circle. In 1990 Biggers returned to his roots at Hampton University as artist-in-residence. There he served as model, mentor, and a source of inspiration for Hampton's students, and instilled in his students some of the same principles he gained there many years before. Recently, Biggers moved to his hometown of Gastonia, North Carolina, to live and work.

SHOTGUN, THIRD WARD #1

Shotgun, Third Ward depicts a scene from Houston's predominantly African-American Third Ward community where Biggers lived. Houston's Third Ward is an important historical black community still vital today. Painted shortly after almost five years of the artist's recuperation, the work is a fine example of Biggers' commitment to portraying African-American neighborhood scenes. *Shotgun, Third Ward* is a pivotal painting in the artist's career, as it is one of his earliest to employ three motifs that became ubiquitous symbols in his later works: the wheel, shotgun houses, and a lighted candle. This excerpt of Third Ward life depicts a church that burned in the neighborhood among a row of neatly arranged shotgun houses, and the reactions of some of the residents to that event.

The drama unfolds on a rain-drenched street under the setting sun near the church. Images of strong African-American women, which have appeared constantly in Biggers' art, appear as bold relief figures in the painting's foreground. Immediately behind the central female figure is an elderly African-American man holding a lighted candle in a glass that he shields with one hand. The candle symbolizes a ray of hope for the burned church, which will be restored and will continue to serve as a source of light and inspiration for the community. Characteristically, a group of small children who play and dance in the middle ground, seemingly oblivious to the recent tragedy, represent the next generation of Third Ward leaders.

Elton Fax, *Seventeen Black Artists* (New York: Dodd, Mead and Company, 1971), 282.

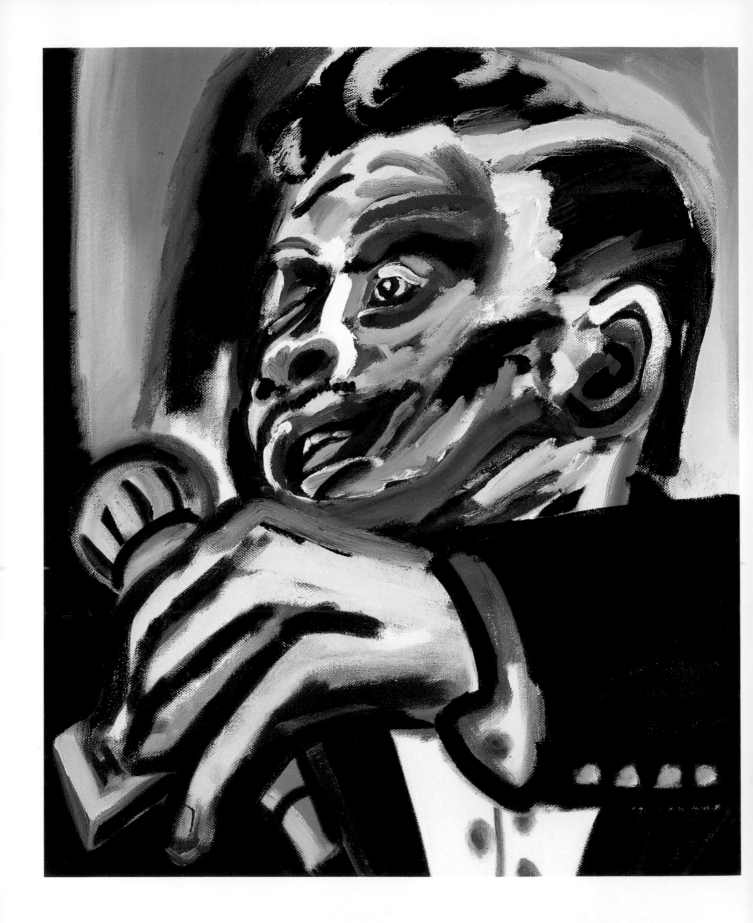

FREDERICK BROWN

—— born 1945 ——

I think my heritage has a great significance to the images I produce, but you can limit people with a name or a title to only serve one group. When you see my work, you can tell it is done by someone who is Black. But, I want to provide as many beautiful things to the world as I possibly can.

Frederick Brown's roots in his working-class neighborhood on Chicago's South Side contributed to his love of the Blues in the 1950s. Brown's father was friendly with many well-known Blues musicians, including Muddy Waters and Howlin' Wolf, and Jimmy Reed lived in the neighborhood. Brown studied art and psychology at Southern Illinois University, where he earned his B.A. degree in art. He taught for several years in Chicago and Carbondale, Illinois, and traveled to Europe in 1969. In 1970 he moved to New York's SoHo district to become a professional painter, but supported himself by teaching part-time at the Brooklyn Museum, York College, and the School of the Visual Arts.

Brown's paintings of the early 1970s were large, bold abstractions based on the abstract expressionist tradition of the art department at Southern Illinois University. In 1975 Brown met the noted American painter, Willem de Kooning. De Kooning encouraged Brown and Brown still affectionately refers to de Kooning as his "artistic godfather." Brown's large gestural paintings attracted widespread attention and by the mid-1980s were exhibited at the prestigious Marlborough Gallery in New York.

By the late 1970s and into the early 1980s, Brown gradually included figural elements, a change that coincided with his creation of some landscape paintings reminiscent of folk art. An airplane motif also appeared in Brown's works—a motif that the artist says represents a marking of time.

In the mid-1980s Brown began a series of paintings that immortalized the friends, mentors, and colleagues who had exerted the greatest influence on his life. One of the first paintings in this series was a monumental *Last Supper*,

Junior Wells, 1989,
oil on linen, 36 x 30 in.

41

Stagger Lee, 1983,
oil on canvas, 90 x 140 in.

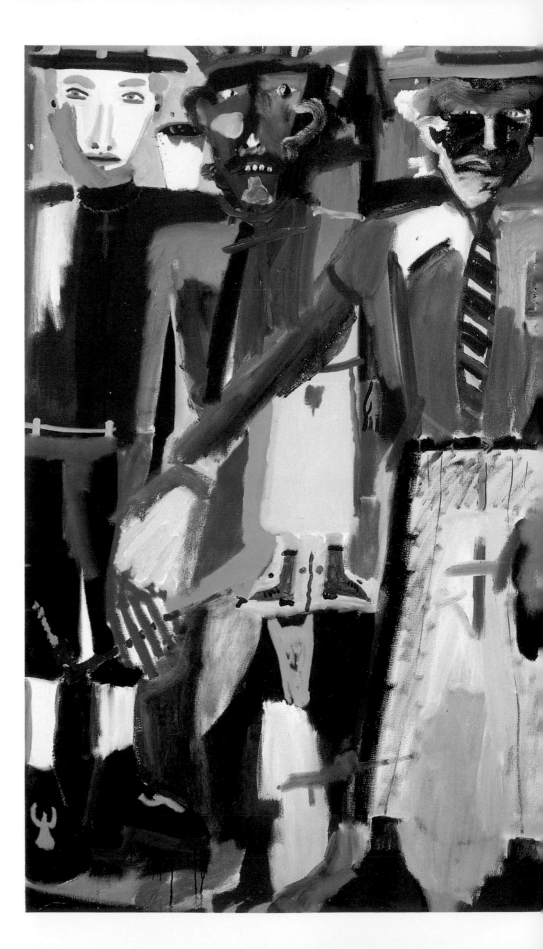

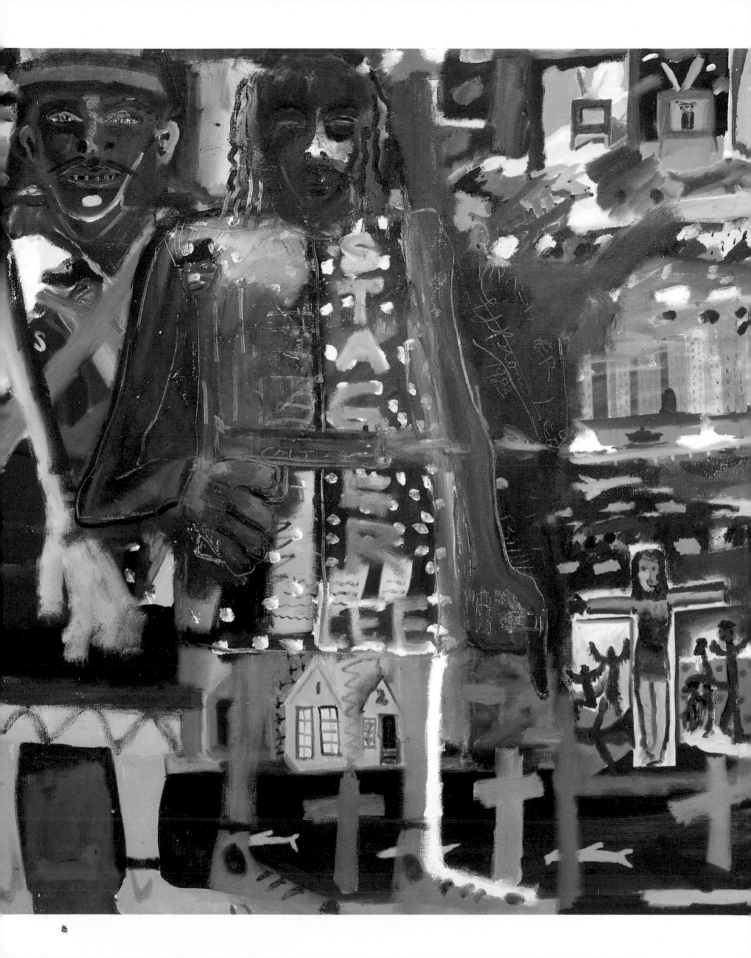

completed in 1984, which portrays twelve men who had sustained Brown both personally and professionally. He painted several other religious subjects, including *John the Baptist, David and Goliath,* and *The Ascension.* In his portraits of this period, Brown attached photographs of his subjects' faces to the canvas to produce a collage effect. In addition to portraits of single figures, Brown painted large-scale canvases filled with numerous characters both real and fictional, often disparate in their references.

Brown's background and long-standing interest in the Blues logically led to the next phase of his career. Shortly after his arrival in New York in 1970, he had collaborated with jazz giants Ornette Coleman and Anthony Braxton on a variety of multimedia projects. As in Chicago, music has always been a part of Brown's New York environment. For Brown, music and painting are one, and the Blues provides the stimulus and inspiration for painting late at night when he feels at the height of his creative powers. "After midnight, that's when the creative spirits are loose," Brown says.

Brown's meeting in 1969 with Chicago Bluesmen Earl Hooker and Magic Sam at a music festival in Denmark led to a suite of works twenty years later. Hooker and Magic Sam told Brown that they were more appreciated in Europe than in America, and Magic Sam predicted that after their deaths they would be quickly forgotten. Ironically, both men died shortly afterwards, and Brown vowed that he would do something to ensure that they would be remembered.

Two decades later, Brown felt ready to honor the pledge he had made in Denmark. He traveled to the Deep South to conduct research for a documentary on Blues singers. Since he had never spent any time in the South, he felt that it was important to visit the setting that gave birth to the Blues. Brown went to Clarksdale, Mississippi, where he visited the town's Delta Blues Museum. He talked with local Blues musicians and elderly black men who regaled him with stories about early Blues artists.

Returning to New York, Brown began a series of portraits of Blues musicians that he feels preserve the spirits of these artists. "Like the best painters," he states, "those musicians had the ability to strike the universal heart chord."

Brown's most recent series of paintings, completed in 1991, were conceived when Brown visited his four-year-old daughter in a New York hospital. The hospital's drab interior motivated him to paint something that would make children laugh. The result is a series of large colorful paintings and original silkscreens of clowns. He hopes to reproduce some of the designs as tapestries, ceramics, or prints for children's hospitals.

In 1988 Brown had a retrospective exhibition at the National Museum of the Chinese Revolution at Tiananmen Square in Beijing, China. Brown currently lives in New York and also maintains a studio in Arizona.

STAGGER LEE

Stagger Lee , completed in 1983, owes its genesis to the African-American cultural experience. The story of Stagger Lee is well known in African-American folklore and is immortalized by a Blues song in which Stagger Lee murders a man accused of stealing his hat. Although the story has many versions, Stagger Lee always emerges as a folk hero who is both feared and admired. In Brown's interpretation, Stagger Lee—his name is emblazoned on his jacket and he is shooting a pistol—is accompanied by his personal entourage, including a pilgrim, Native American Squanto, and a steel worker. All of the figures are placed close to the picture's front, and are executed in pulsating colors and loosely applied brushstrokes. In the background are images including a crucified Christ, several small empty crosses, television sets, airplanes, a group of skyscrapers, and a New York tavern. The result is a tapestry that weaves legend and fact and alludes to the complex and perhaps violent nature of American society.

Memphis-born Bluesman Amos "Junior" Wells was a popular figure in Chicago during the 1960s. A child prodigy, Wells obtained his first guitar at age twelve, and by age fourteen was playing with established Bluesmen. He began recording in the early 1950s, and in the 1960s was one of Chicago's major Blues figures. Wells earned a reputation as an innovative harmonica player who developed a style that reflected elements of the guitar.

In this portrait, Wells holds both his trademark harmonica and a microphone. The latter, seemingly disjointed from his body, cuts a powerful horizontal axis across the painting and serves as a spatial divider. The musician's head and hands have been enlarged and brought daringly close to the surface of the picture plane. The bold colors, rich impasto, and broad brushstrokes recall Brown's homage to German Expressionism and Willem de Kooning, while the masklike face speaks of his affinity for African art.

The painting pulsates with energy—bright yellows, reds, and greens are dispersed with bold strokes that suggest both form and vitality. In Chicago at the height of Wells's career, Brown met the performer and attended his performances. An intensely personal work for both artists, this portrait is also a timeless and universal symbol of all Blues musicians.

Eve M. Ferguson, "Art Sings the Blues," *The Washington Afro-American,* 26 Oct. 1991.

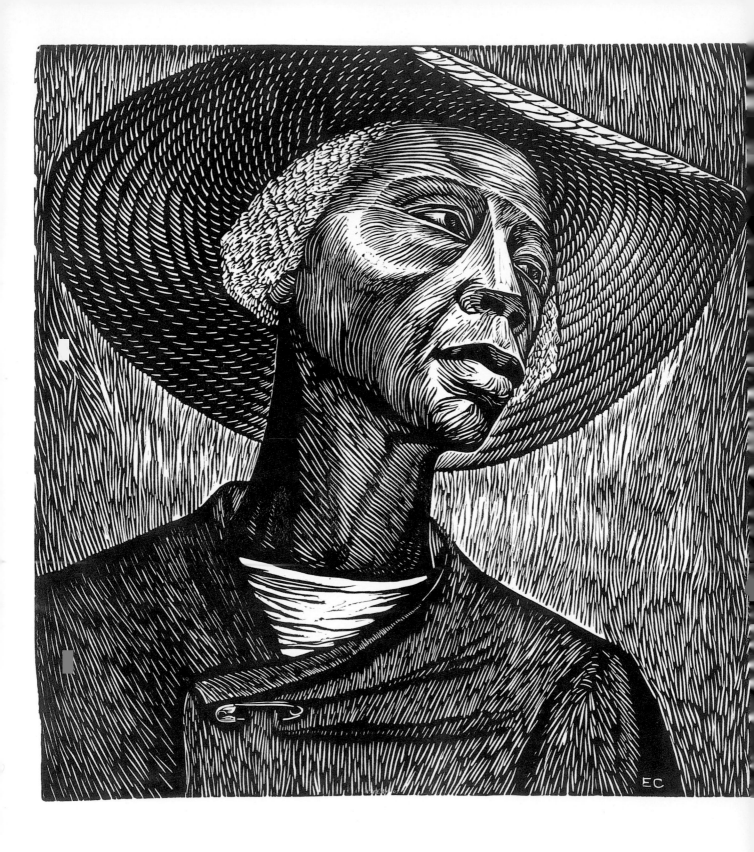

ELIZABETH CATLETT

——————— born 1915 ———————

I enjoy the beauty of materials, not only the beauty of forms. I love to see the grain of the wood assert itself in its own right and become integrated in the representation. I like to polish the stone to bring out its beauty.

Although she presently lives and works in Mexico, her adopted country, Elizabeth Catlett has devoted her entire artistic career to a socially conscious art that represents the struggles of African Americans. Catlett's sculptures and prints are well known in the United States and Mexico, where she taught sculpture at Mexico's National University for many years. Catlett was born in 1915 in a comfortable middle-class neighborhood in Washington, D.C. She attended public schools in the nation's capital and enrolled in the art department at Howard University, where she graduated with honors in 1936.

The desire for further study motivated Catlett to seek admittance to graduate school at the University of Iowa, where she studied with Grant Wood and emigré sculptor Ossip Zadkine. Catlett was the first student to complete the requirements for the University of Iowa's Master of Fine Arts degree in 1940. That same year, Catlett received the "first honor" in sculpture at the American Negro Exposition in Chicago.

In 1941 Catlett married Charles White, a fellow artist from Chicago with whom she had exhibited in a number of shows. During the same year, White received a Rosenwald Fellowship to travel and study in the South and to make sketches for a proposed mural at Hampton Institute (now Hampton University). Catlett accompanied her husband and experienced directly the racism of the time. She subsequently vowed to dedicate her art to black awareness. While Catlett and her husband were traveling in the South, Catlett taught art at Dillard University in Louisiana, Prairie View College in Texas, and at Hampton Institute with Viktor Lowenfeld. In 1942, White and Catlett returned to New York and studied at the Art Students League.

Sharecropper, 1970,
linoleum cut on paper,
17 13/16 x 16 15/16 in.

Singing Head, 1980,
black Mexican marble,
16 x 9 1/2 x 12 in.

During the early 1940s Catlett produced a number of sculptures depicting mother and child themes. These works were executed in a simple realistic style and shared a similar quiet strength with Catlett's works from her graduate school years. During the next decade Catlett's style moved toward abstraction, defined by smoothly rounded forms and gracefully elongated figures.

In 1946 Catlett received a Rosenwald Fellowship, and accompanied her husband to Mexico City where they studied painting, sculpture, and lithography. They became acquainted with the Mexican muralist David Alfaro Siqueiros, and lived in his house briefly. In 1947 Catlett and Charles White divorced and Catlett remained in Mexico City where she worked and developed a sense of identity with the city's residents. She began working with some of Mexico's most distinguished printmakers, and married the painter-engraver Francisco Mora. Elizabeth Catlett-Mora later became a naturalized citizen of Mexico. Today, she is regarded as one of Mexico's most celebrated artists. Though she has found warm acceptance in her adopted country, her African-American consciousness has inspired her to continue to produce sculptures and prints that deal with the struggles of African Americans.

SINGING HEAD

A splendid example of Catlett's simplified handling of forms and love of the stone medium, *Singing Head* is among her finest recent works. With its smoothly finished surfaces and elemental design, the work suggests contained exuberance. Throughout her lengthy and distinguished career, Catlett's sculptures have been characterized by an economy of form to create powerful expressions. In this example, light softly caresses the gently undulating surfaces and creates a quiet poetic song of great strength.

During the 1960s and 1970s Catlett created powerful black expressionistic sculptures and prints depicting African and militant themes. *Sharecropper* of 1970 is a fine example of Catlett's more realistic work in which the powerful, sculptural form of a strong, dignified African-American woman is executed in a style similar to her works from the 1940s when the artist was influenced by Mexican muralist David Siqueiros.

Raquel Tibol, "The Work of Elizabeth Catlett," *Los Universitarios* (Magazine of the National University of Mexico, Nov. 1975): 15–16; cited in Thalia Gouma-Peterson, "Elizabeth Catlett: The Power of Human Feeling and of Art," *Woman's Journal* 4: 1 (Spring/Summer 1983): 48.

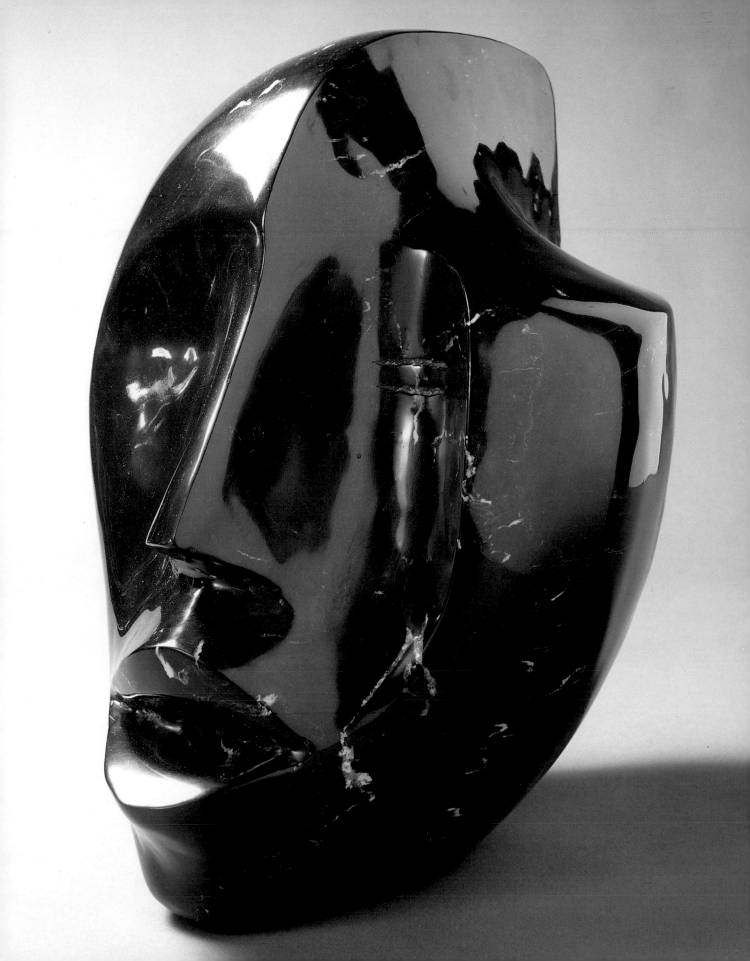

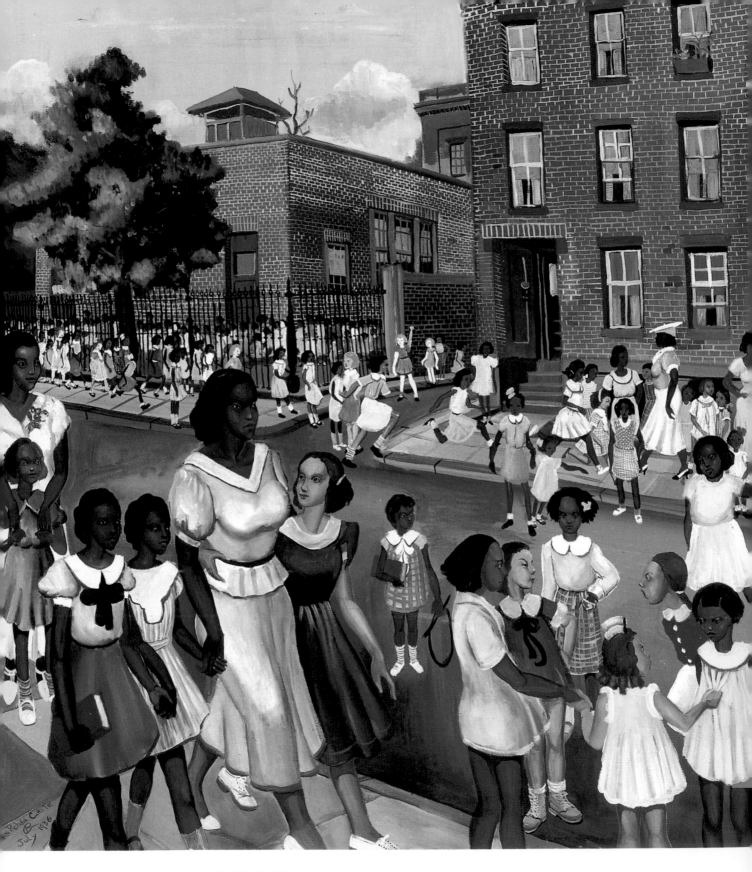

School's Out, 1936, oil on canvas, 30 1/4 x 36 1/8 in.

ALLAN ROHAN CRITE

—— born 1910 ——

Art like worship and study should be functional, serve a definite purpose and out of that purpose can come beauty of expression and all other decorative characteristics.[1]

Although he is best known for his religious illustrations, Allan Rohan Crite was a significant biographer of urban African-American life in Boston during the 1930s and 1940s. Crite was born in Plainfield, New Jersey, and moved to Boston during his youth and has lived there ever since. He studied at Boston University, the Massachusetts School of Art, the Boston Museum of Fine Arts School, and Harvard University, and was awarded degrees from the last two institutions. Crite has never married.

During the Depression years and into the 1940s when many African-American artists were engaged in mural projects, Crite developed a series of "neighborhood paintings" that were inspired by his Boston community's predominantly African-American Roxbury district. Crite has made the following statement concerning his neighborhood paintings:

> My intention in the neighborhood paintings and some drawings was to show aspects of life in the city with special reference to the use of the terminology "black" people and to present them in an ordinary light, persons enjoying the usual pleasures of life with its mixtures of both sorrow and joys . . . I was an artist-reporter, recording what I saw.[2]

During the late 1930s Crite began to concentrate primarily on religious themes. His productions were largely in pen and ink and lithography. Crite, a devout Episcopalian, views his religious themes from a contemporary perspective. His illustrations are nationally known, and he is the author of three books, *Were You There?* and *Three Spirituals* published by Harvard University, and *All Glory*, a meditation on the Prayer of Consecration in the Eucharistic Rite of the Episcopalian Church. Crite has painted murals and "Stations of the Cross" in various parishes in several states, and has also designed private devotional works

such as the Creed, Stations of the Cross, and parish bulletins that are furnished to churches in the United States and Mexico.

In 1937 Crite began a series of brush-and-ink drawings depicting three spirituals. This series was published in a large volume, *Three Spirituals From Earth to Heaven*, by Harvard University in 1948. The three songs selected by Crite are among the best loved of all African-American spirituals, "Nobody Knows the Trouble I See," "Swing Low, Sweet Chariot," and "Heaven." In Crite's highly individualistic approach he translated the text of the spirituals from a musical context to a visual one. The general theme treats the transition of man from the earthly sphere of his activities to his ultimate destination in heaven. During the time when many spirituals were conceived most African Americans were unable to read. Spirituals formed an oral tradition through which the lessons of the Bible were passed from generation to generation. The hymns are of two types, narrative and contemplative; narrative hymns tell stories from the Bible while contemplative hymns deal with lessons and ethical implications of the Bible in daily life.

The three hymns in Crite's illustrations are contemplative in nature. A human figure is used as the motif or melody figure in the first two hymns, and in the last spiritual the motif figures are first robes, then harps, and finally wings. The motif figures represent the melody, and the background represents the accompaniment. Small drawings on the left-hand pages of the book echo the character of the large illustrations and act as connecting links from phrase to phrase as the hymn progresses.

Crite's pen-and-brush drawings for *Three Spirituals* are probably the masterpieces among his religious works. From both an iconographical and technical point of view, the fresh and original treatment of each verse of the popular hymns was splendidly conceived. Crite's masterly handling of the brush-and-ink medium in which each line serves an expressive purpose reveals the talents of an artist with few peers among his generation. All of the figures in Crite's paintings and illustrations are represented as African Americans, and attest to his deeply instilled sense of racial pride.

SCHOOL'S OUT

School's Out is a classic example of the approach that earned Crite the title of "artist-reporter" in his Roxbury, Massachusetts, neighborhood during the 1930s and 1940s. Recording the people and architecture of Roxbury without social or political comment, Crite's paintings are also important visual documents of now-demolished buildings and fashion of the period. A joyous, carnival-like atmosphere characterizes this scene of young children emerging from a red brick schoolhouse surrounded by an iron fence. The children are joined by some of their mothers who have come to escort them home. The asphalt street, worn concrete sidewalk, and deteriorating bricks of the tenements in the background

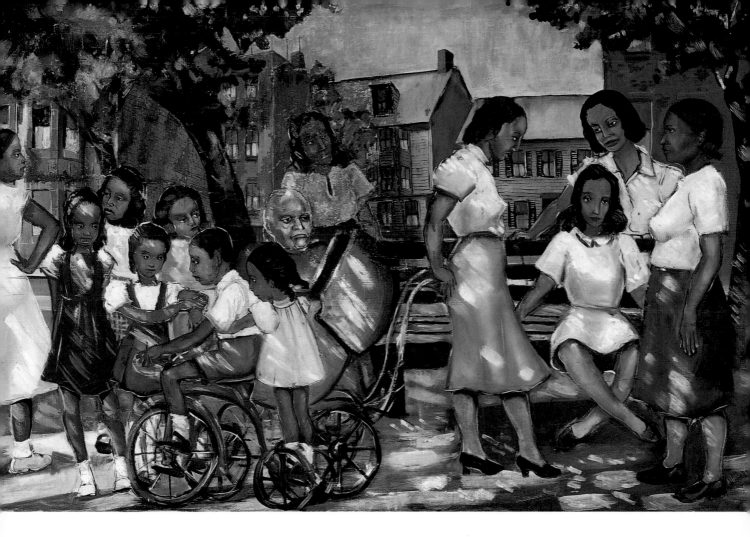

Shadow and Sunlight, 1941,
oil on board, 25 1/4 x 39 in.

have been recorded by Crite with great fidelity. Crite loves children and obviously delighted in depicting them here in many forms of activity and movement: laughing, waving, walking, running, talking, skipping, holding hands, and even involved in a small confrontation. One senses that this may be the last day of school, and the boundless energy of these girls, anticipating a long summer vacation, could not be contained. Although painted more than a half-century ago, Crite's theme of youngsters enjoying the end of another school year is universal, and as contemporary as the year in which it was painted.

His related painting entitled *Shadow and Sunlight* from 1941 depicts three generations of African Americans relaxing, playing, and basking in the sunlight of a neighborhood park in Roxbury. Light streams through the leaves of the trees and creates flickering patterns recalling in spirit the more abstract yet similar subjects of American impressionist Maurice Prendergast.

[1]Allan Crite, "The Artist Craftsman's Work on the Church," *Commentary on the 1950s,* Vertical File, Library, National Museum of American Art, Smithsonian Institution, Washington, D.C.

[2] Ibid.

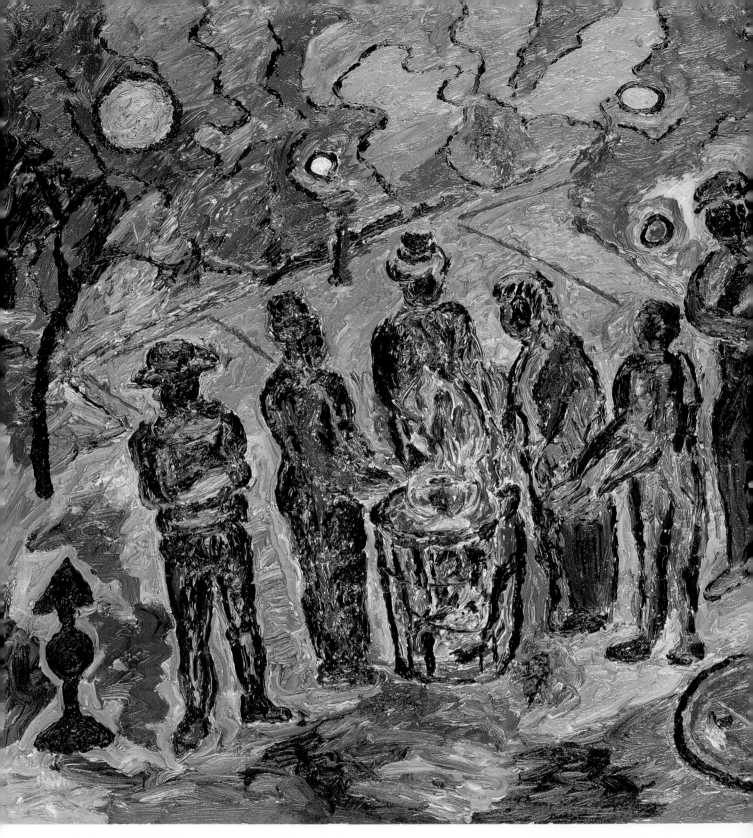

Can Fire in the Park, 1946,
oil on canvas, 24 x 30 in.

BEAUFORD DELANEY

1901–1979

The abstraction, ostensibly, is simply for me the penetration of something that is more profound in many ways than rigidity of a form. A form if it breathes some, if it has some enigma to it, it is also the enigma that is the abstract, I would think.

For more than three decades Beauford Delaney lived and worked in and around Paris where he earned the title "dean of American Negro painters living abroad." In 1945, when the writer Henry Miller published an article celebrating Delaney's art, he referred to his painter-friend as "the amazing and invariable" Beauford Delaney. Delaney was probably the most popular and best-known contemporary African-American artist then living abroad.

Delaney was born in Knoxville, Tennessee, in 1901 to a Baptist minister, Samuel Delaney, and his wife, Delia Johnson Delaney. Beauford, along with his younger brother, Joseph, showed remarkable skill in drawing during his childhood. Lloyd Branson, a local elderly white artist in Knoxville, gave lessons to Beauford, and encouraged him to study art in Boston. In 1924, when Delaney was sixteen, he moved to Boston and remained there for five years. Although he claimed to have been largely self-taught, Delaney attended classes at the Massachusetts Normal Art School and the South Boston School of Art, and enrolled in evening classes at the Copley Society. While working at various jobs to support himself, Delaney frequently visited the galleries at the Boston Museum of Fine Arts and the Isabella Stewart Gardner Museum. In Boston, he immersed himself in the art of the Old Masters, as well as nineteenth- and twentieth-century examples.

In 1929, Delaney moved to New York City; he lived first in Harlem and later moved to Greene Street in Greenwich Village. In 1930 Delaney held his first one-man show at the 135th Street branch of the New York Public Library, and in 1938 mounted a one-man exhibition at a gallery in Washington, D.C. Delaney's early works were primarily portraits executed in pastels, and he exhibited frequently

in the Harmon Foundation shows during the 1930s and 1940s. In 1948, by the time Delaney, along with Ellis Wilson, held an exhibition at the Artist's Gallery in New York, he figured prominently in art circles. His paintings of the late 1940s consisted largely of street scenes and interiors executed in a thick, impasto technique with broad areas of pure bright colors. While living in New York, Delaney met and sketched many prominent African Americans of that period. To support himself, Delaney taught art part-time at a progressive art school in Greenwich Village, and did custodial work at the Whitney Museum. Following Delaney's move from Harlem to Greene Street in Greenwich Village, he painted that street and neighborhood repeatedly. Greene Street became a symbol to Delaney as Mont St. Victoire had been to Paul Cézanne.

During the early 1950s, Delaney's paintings became progressively nonrepresentational. He retained a thick, impasto technique, but his style was more closely associated with the abstract expressionism of the New York School of painters. Delaney continued to develop his abstract expressionist style between 1950 and 1951, when he received a fellowship to the Yaddo Art Colony near Saratoga Springs, New York. Yaddo probably inspired Delaney to travel to Europe and visit the "new Rome," which was much talked about at Yaddo. A benefactor financed Delaney's first trip to Europe, and his plan was to visit Rome with a stop-over in Paris. Upon his arrival in Paris, however, Delaney was so enchanted with the city that he decided to settle there. Delaney lived in Paris for the remainder of his life.

The majority of Delaney's early paintings, which he left behind in his New York studio, have been lost. He is, however, represented in the collections of numerous artists, writers, and musicians with whom he associated during the 1930s and 1940s. Delaney was able to support himself financially in Paris through sales of his paintings, subscriptions from friends, and a grant from the National Council of the Arts in 1969. Three main forces contributed to the development of Delaney's style: the techniques of Vincent Van Gogh, the color of the Fauves, and the design principles of abstract expressionism. From his early pastel portraits in Boston and New York, to the street scenes of New York's Greenwich Village, and finally to the development of a nonrepresentational style, Delaney's works were never merely derivative of previous styles. His paintings possess a personal spontaneity that distinguishes him as one of the foremost abstract expressionists of his generation. By 1971 Delaney's heavy drinking and bohemian way of living had begun to take a physical and mental toll. He suffered an emotional breakdown. Not unlike William H. Johnson, Delaney was mentally incapacitated during his final years in Paris. He died on March 26, 1979, in an asylum, completely oblivious to his surroundings.

Can Fire in the Park, **detail**

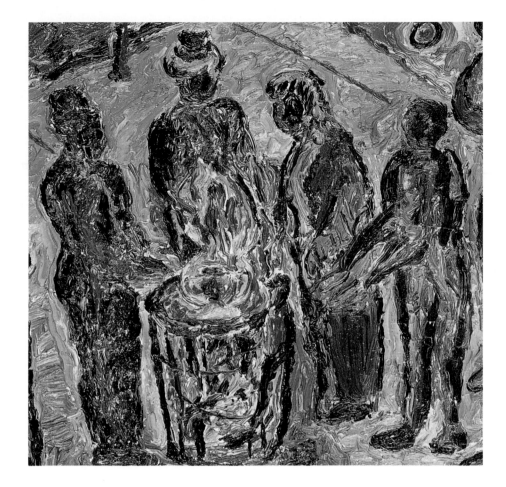

CAN FIRE IN THE PARK

Prior to moving to Paris in 1953, Delaney lived on Manhattan's Lower East Side, an environment from which he delighted in selecting subjects for his paintings. Here a group of "street people" hover around an open barrel from which the flames of a roaring fire emerge. The vibrant tones of blue, red, green, and yellow, and the black outlines punctuating his forms are characteristic of Delaney's distinctive style, influenced in part by his exposure to abstract expressionism.

Delaney's thickly applied paint and the use of vivid hues also recall the techniques of the French Fauves, who painted at the turn of the century. Indistinct, raceless, Delaney's street people strike an ironically poignant note for a contemporary audience while also recalling the tradition of can fires among the urban poor and homeless. The people in this painting shiver despite the roaring flames, and their figures, as well as the tipped-up landscape, are closely interwoven not only by emotional content but by the artist's use of color and texture as well.

Richard A. Long et al., *Beauford Delaney: A Retrospective* (New York: The Studio Museum in Harlem, 1978), n.p.

ROBERT SCOTT DUNCANSON

—————— 1821–1872 ——————

English landscapes were better than any in Europe, and the English are great in water color while the French are better historical painters than the English. I am disgusted with our Artists in Europe. They are mean Copiests. My trip to Europe has to some extent enabled me to judge of my own talent. Of all the landscapes I saw in Europe (and I saw thousands) I do not feel discouraged.

Robert Scott Duncanson was perhaps the most accomplished African-American painter in the United States from 1850 to 1860. He was born in Seneca County, New York, in 1821 to an African-American mother and Scottish-Canadian father, who sent his son to Canadian schools during his youth. In 1841 Duncanson and his mother moved to Mt. Healthy, Ohio, near Cincinnati. Little else is known about Duncanson's early life except that his second wife Phoebe was biracial, and the couple's only child, a son Mittie, was born in Cincinnati.

It is not known when or where Duncanson received his early artistic training, but by 1842 he had begun exhibiting in Cincinnati. In 1853 Duncanson made his first European trip, which was apparently financed by an abolitionist organization from Ohio. He visited England, France, and Italy, and may have traveled to Germany. In England, Duncanson was especially attracted to the landscapes of Claude Lorrain and J. M. W. Turner. Duncanson's trip to Europe probably did not last longer than a year as he returned to Cincinnati in 1854 and became the proprietor of a photography studio. But by the following year he had switched from photography to painting full time.

Duncanson's paintings may be divided into five categories: portraits, regional landscapes, landscapes inspired by literature, still lifes, and murals. The largest and most important commission in Duncanson's career was a series of murals he painted for abolitionist and political leader Nicholas Longworth between 1848 and 1850 for the main entrance of Belmont, his residence in Cincinnati. The Belmont murals consist of four over-door compositions and eight large landscape paintings executed in a *trompe l'oeil* style. Each panel is more than six

Pompeii, detail

by nine feet, and are the largest paintings among Duncanson's works.

Sometime in 1849 Duncanson established a studio in Detroit where he had been active as early as 1846. His artistic activities were favorably noted in both Cincinnati and Detroit where he worked throughout his career. Duncanson was also at one time associated with the prominent African-American photographer J. P. Ball in Cincinnati. Ball employed Duncanson to execute finished oil paintings from daguerreotypes.

Duncanson's finest paintings are the landscapes of his middle and late periods. These works define him as a Midwestern romantic, realist painter. Although he spent the greater portion of his active years in Cincinnati, he traveled widely north and west of Ohio and also to the upper ranges of the Mississippi River. In 1851 a Cincinnati patron financed his painting trip to New Hampshire and Vermont. Later William Miller, a miniaturist and friend of Duncanson, wrote that during a visit to Cincinnati, he observed that Duncanson was executing beautiful Italian landscapes from sketches he had made while traveling in Europe in 1853.

During the early 1860s Duncanson traveled north, painting and sketching in Minnesota and Vermont, and crossing into Canada. Duncanson's second trip to Europe, as well as his Canadian sojourn, were motivated by his increasing unhappiness in the United States and a supposed desire to leave. In 1861 or 1862 Duncanson went to Scotland. His name is not listed in the Cincinnati or Detroit city directories from 1864 to 1866, and it is likely that he wished to leave the United States during the Civil War.

By 1867 Duncanson had returned to this country and began exhibiting works directly inspired by his European travels. He made a final trip to Scotland in the years 1870 to 1871, and completed a number of paintings during his stay. Back in the United States by the summer of 1871, Duncanson exhibited his Scottish paintings with remarkable success. By all indications Duncanson's career was flourishing, and his paintings commanded up to five hundred dollars each, a very high sum for the time.

Unfortunately, when his career seemed brightest, he succumbed to emotional illness. His mental collapse occurred during the summer of 1872 while the artist was arranging an exhibition of his works in Detroit. He was hospitalized for three months at the Michigan State Retreat, and on December 21, 1872, he died. Duncanson's obituary in *The Detroit Tribune* of December 29, 1872, stated that, "He had acquired the idea that in all his artistic efforts he was aided by the spirits of the great masters." The problems of a biracial person in pre– and post–Civil War America, as well as his concern for his status as an artist, may have contributed to Duncanson's breakdown. So too may have Duncanson's seemingly irreconcilable conflicts between the romantic and realistic tendencies in his paintings. Perhaps it was the romantic realm in which Duncanson sought to escape from the harsh realities of prejudice.

POMPEII

During Duncanson's first trip to Europe in 1853 he visited the ancient Roman city of Pompeii, where ruins had been under excavation since the late 1740s. Duncanson completed at least two paintings entitled *Pompeii*, a vertical composition in 1855, and this smaller version in 1871, the year before his death. The ruins at Pompeii were a favorite subject among artists of the late eighteenth and early nineteenth centuries. That Duncanson was no exception is evident by the fact that he returned to the subject sixteen years after his earlier version.

Duncanson's late view of Pompeii is typical of his landscapes. Large forms are symmetrically balanced on either side of the painting and a body of water occupies the central space. This format may also be observed in *Mountain Pool* of 1870, which affords a more realistic view of nature and was based on Duncanson's travels in Ohio. In the Roman-inspired painting, the ruined capitals, columns, and toppled architectural fragments, strolling visitors, lush vegetation, and small idyllic village beyond the vessel-dotted sea were based more on Duncanson's imagination and Pompeiian wall paintings than reality.

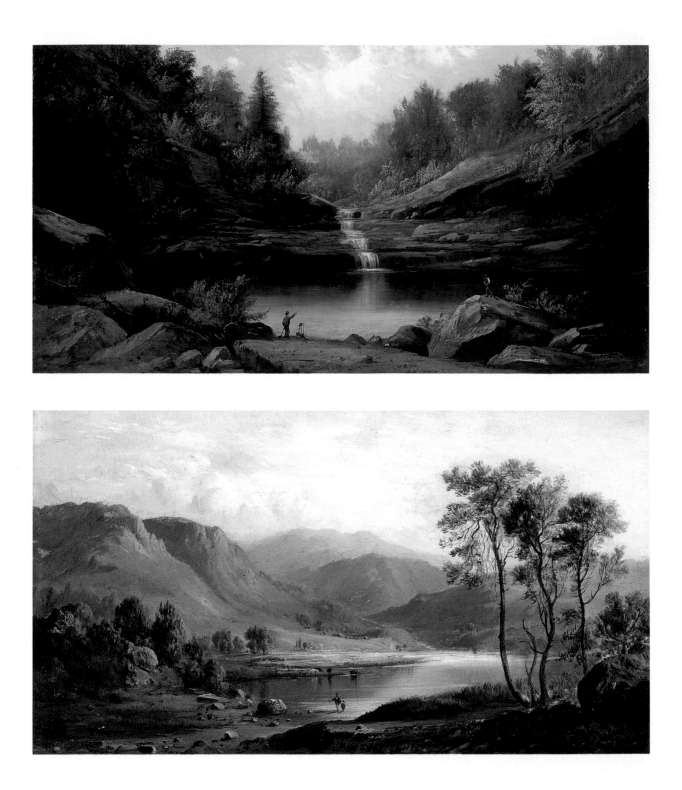

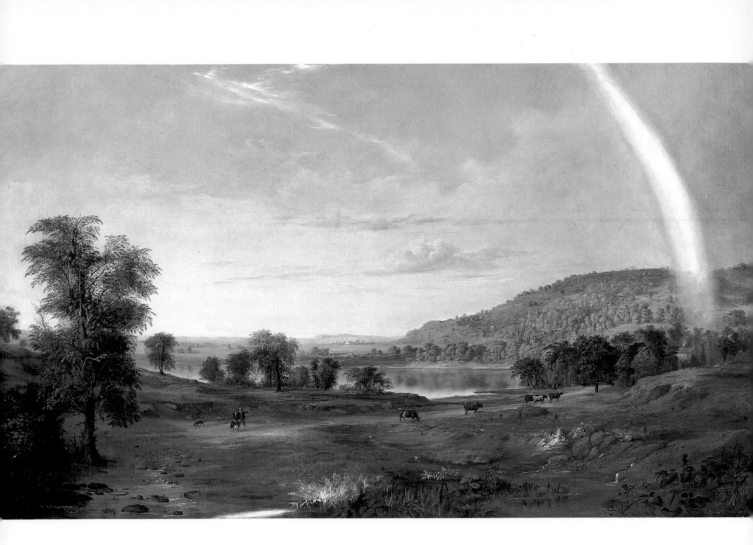

Mountain Pool, 1870,
oil on canvas, 11 1/4 x 20 in.

Loch Long, 1867,
oil on canvas, 7 x 12 in.

Landscape with Rainbow,
1859, oil on canvas,
30 1/8 x 52 1/4 in.

Light in this painting is soft, warm, and reminiscent of Venetian examples. Paint was applied in gentle strokes of fluid impasto and flecks of white highlights. The figures are minuscule in the vast landscape, and totally subjugated to the grandeur of nature.

A broad view of Mt. Vesuvius dominates the background. The gentle stream of smoke spurting from the volcano's summit serves as a constant reminder of the still potentially powerful force that destroyed Pompeii in 79 A.D. Romantic subjects of this nature provided an opportunity for Duncanson to combine realistic and imaginary themes, as well as unlimited avenues of expression for the inherently romantic tendencies in his paintings.

Letter from Duncanson to Junius R. Sloan, 22 Jan. 1854. Platt R. Spencer Collection, Newberry Library, Chicago, Ill.

WILLIAM EDMONDSON

ca. 1882–1951

I is just doing the Lord's work. I didn't know I was no artist till them folks come tole me I was. Every piece of work I got carved . . . is a message . . . a sermon, you might say. A preacher don't hardly get up in the pulpit but he don't preach some picture I got carved. You see, I got to do these things for my heavenly daddy whether folks buy them or not. He ain't never said nothing about pay for it.

The limestone carvings of William Edmondson were virtually unknown beyond his neighborhood in Nashville, Tennessee, until 1936. It was then that Louise Dahl-Wolfe, a New York photographer for *Harper's Bazaar*, saw his works while visiting friends in Nashville. Dahl-Wolfe took numerous photographs of the artist and his works, which she later showed to Alfred Barr, the director of the Museum of Modern Art in New York. Barr was so impressed with Edmondson's sculptures that he arranged an exhibition for the artist during the following year. In late 1937 the Museum of Modern Art mounted ten of Edmondson's sculptures, and he became the first African-American artist to have a solo exhibition there.

Edmondson was born around 1882 to George and Jane Edmondson in Nashville. The exact year of Edmondson's birth is uncertain—a fire had destroyed the family Bible in which it was recorded. During his early adulthood, Edmondson was employed in a variety of menial jobs and as an orderly at Baptist Hospital in Nashville for almost twenty-five years. Having never married, Edmondson shared the family home with his mother and unmarried sister. Following the deaths of his mother and sister and his retirement from the hospital, Edmondson worked at various part-time jobs, grew vegetables for sale, and lived alone for the remaining years of his life.

Around 1934 Edmondson became a religious convert. He said he was called to preach and cut tombstones to God's command. He attended the United Primitive Baptist Church in Nashville, and remained dedicated to his religion during the years following his conversion. Edmondson stated that God first appeared to him in a vision and ordered him to obtain a mallet and chisels. Around the same time, Edmondson discovered a pile of limestone that had been

Crucifixion, ca. 1932–37, carved limestone, 18 x 11 7/8 x 6 1/4 in.

Rabbit, ca. 1940, carved limestone, 12 5/8 x 5 x 8 in.

accidently dumped on his property and considered it a "gift from heaven." According to Edmondson's accounts, his inspiration was always divine. In a *Time* magazine article of November 1, 1937, Edmondson was quoted as follows:

This here stone n' all those out there in the yard—came from God. It's the work of Jesus speaking his mind in my mind. I must be one of His 'ciples. These here is mirkels I can do. Can't nobody do these but me. I can't help carving I just does it . . . Jesus has planted the seed of carving in me.

Edmondson began as a tombstone carver working in limestone, and he frequently provided tombstones for members of Nashville's African-American community. Later he progressed to carving figures. His sculptures are simple, rotund, emphatic forms ranging from one to three feet in height. The figures are roughly carved and forms are frequently suggested rather than articulated. He worked primarily in limestone, which was the only material he could acquire inexpensively or without cost. The quality of the limestone in Edmondson's figures varies greatly in color and texture—from a porous granular variety to a type almost as smooth as marble. The majority of the stones Edmondson obtained were rectangular blocks formerly used as sills, lintels, steps, and curbs.

Edmondson's career spanned a period of roughly fifteen years. Part of this time he worked under the auspices of the Works Progress Administration (W.P.A.), a government-sponsored artists' relief program. Unlike most W.P.A.-employed artists who were required to furnish some tangible evidence of their work, Edmondson was apparently not bound by any stipulations. He was free to create works of his choice, and his yard was cluttered with old stones and the images he created from them. These included tombstones, birds, doves, a delightful menagerie of animals comprising rabbits, squirrels, opossums, horses, tortoises, owls, lions, rams, and various other "critters" and reptiles. Edmondson's human figures included preachers, angels, choir girls, brides, nurses, teachers, boxers, comic-strip characters, and "courting gals on the carpet for husbands."

Most of Edmondson's sculptures are symbolic and were inspired by biblical passages. The frequent misspellings and omissions on his crudely lettered tombstones make evident the fact that Edmondson was barely literate. Edmondson's figure style is extremely simple—human faces are frequently curved forms with a few simple indentations denoting features. Feet are often without toes, arms without wrists, and legs without ankles. Textures are usually articulated in the hair of humans and fur of animals. Anatomical proportions are distorted in a manner that lends a vigorous and expressive effect to the pieces.

By 1947 Edmondson's health had begun to fail. He was stricken with cancer, which left him with scarcely enough energy to lift his tools. During the last few years of his life, he worked primarily with small blocks of limestone, and

occasionally chiseled inscriptions on tombstones commissioned by members of his church. The grass in his yard had grown tall around his figures and oddly shaped tombstones, creating a virtual forest of mysticism and symbolic figures.

On February 8, 1951, Edmondson died. He was buried in an unmarked grave in Mount Ararat Cemetery on the outskirts of Nashville. Cemetery records for Mount Ararat were subsequently destroyed by fire, and the exact location of Edmondson's grave is unknown. It is ironic that a man who devoted years to carving tombstones for others does not have one identifying his own grave. With a few tools and a forest of stone ranging from Bedford limestone to common fieldstone, Edmondson lived in harmony with his religious beliefs. His works are indeed "mirkels."

CRUCIFIXION

The crucified Christ is a theme that appears frequently in Edmondson's numerous limestone carvings. This example is typical of his rotund, neckless, and waistless figures. Christ's upraised arms are attached vertically, rather than horizontally, to the cross to conform to the perimeters of a block of stone with its cubic character still evident. A mass of curly hair frames Christ's round face. Facial features are merely suggested by tiny indentations for the eyes and mouth and a slight projection for the nose. While the fingers of Christ's hands—attached palm-side to the cross—are delineated, toes are absent from the ankleless feet.

Edmondson scrupulously avoided nudity in his work, which he deemed inconsistent with his spiritual beliefs, and some of his crucified Christ figures wear T-strap briefs. In the *Crucifixion*, Edmondson side-stepped the issue of nudity by consciously omitting any references to sexual characteristics. The naiveté of the artist is apparent in the figure's large head, inaccurate anatomical proportions and scale relationships, and the simplistic manner of the carving. These characteristics, coupled with the artist's strong religious convictions and sincerity of purpose, are the contributing factors to the sculpture's enormous appeal.

Among the countless species of "critters" and "varmints" that populated the menagerie in Edmondson's yard is this small, charmingly conceived, toylike rabbit. Shown seated on its haunches with slightly rounded proportions, it, like the majority of Edmondson's sculptures, is very reflective of the shape of the limestone block from which it was carved.

Edmond L. Fuller, *Visions in Stone: The Sculpture of William Edmondson* (Pittsburgh: The University of Pittsburgh Press, 1973), 12, 22.

MINNIE EVANS

— 1890–1987 —

I have no imagination. I never plan a drawing, they just happen. In a dream it was shown to me what I have to do, of paintings. The whole entire horizon all the way across the whole earth was out together like this with pictures. All over my yard, up all the sides of trees and everywhere were pictures.

The paintings and drawings of Minnie Evans depict scenes from the artist's private dream world. But even to the artist herself, this dream world was not entirely comprehensible. Evans was born in 1890, the only child of Joseph and Ella Kelley, farmers who lived in rural Pender County, North Carolina, near Wilmington. Evans' parents moved to Wilmington during her early childhood, and she attended school there through the sixth grade. She married Julius Evans of Wilmington and had three sons.

Evans traced her background to a maternal ancestor who was brought to the United States from Trinidad as a slave. There are elements in Evans' art that invite comparison to Caribbean folk art forms, though the artist only once traveled outside her native North Carolina. The bright colors and floral motifs that appear in her paintings were most likely inspired by trees and flowers, especially azaleas, at Airlie Gardens in Wilmington, where Evans worked as the gatekeeper for many years.

"My whole life has been dreams...sometimes day visions...they would take advantage of me," Evans once said. She also recalled that in 1944 a fortune teller informed her that she was "wrapped completely in color," and that she had "something of all nations."

The dream world of Minnie Evans received its earliest visual manifestations on Good Friday 1925 when she completed two small pen-and-ink drawings on paper dominated by concentric circles and semi-circles against a background of unidentifiable linear motifs. Evans always placed a good deal of significance on these early drawings.

Evans' first paintings were done entirely in wax crayons and resemble an

Design Made at Airlie Garden, detail

exercise employing every color in a gigantic box of Crayolas. The colors included greens shaded from light to deep, purples from mauve to pink, rose, and royal, and full ranges of reds, blues, and yellows with a sparing use of black and white. Evans' complex designs reveal an unaccountable presence of Caribbean, East Indian, Chinese, and Western elements in color and subject matter. Her own explanation of her work was that "this art that I have put out has come from the nations I suppose might have been destroyed before the flood. . . . No one knows anything abut them, but God has given it to me to bring [them] back into the world."

The central motif in many of Evans' paintings is a human face surrounded by curvilinear and spiral plant and animal forms and eyes merging with foliate patterns. She equated eyes with the omniscience of God and the concept of the eye as the window of the soul. The figures in her designs are sometimes portraits of ancient wise men and women who peopled her visions, ancestral visitors from some spiritual order, or angels, demons, and chimerical creatures. Evans' paintings are essentially religious in inspiration, and represent a world in which God, man, and nature are synonymous; God is frequently represented as a winged figure with a wide multicolored collar and rainbow halo. He is surrounded by a proliferation of butterflies, eyes, trees, plants, and floral forms in a garden paradise of brilliant colors contained within a cartouchelike frame of curvilinear rhythms.

The paintings and colored drawings of Minnie Evans are surrealistic without intellectualism or self-consciousness. They are the works of a visionary who equated God with nature, color with His divine presence, and dreams and visions with reality. The world as revealed through Evans' psychic revelations is a sacred province of complex visionary forms, angels, demons, hybrid plants, animals, and the all-seeing eye of God.

"Something told me to draw or die," Evans stated. "It was shown to me what I should do." The fact that her paintings "just happened to her" confirms that they are manifestations of an order of things unknown except to the artist herself. The art of Minnie Evans is a refreshing phenomenon—a lost world revealed through a subconscious that even she did not understand. Evans stated, "When I get through with them [the paintings] I have to look at them like everybody else. They are just as strange to me as they are to anybody else."

Evans died in Wilmington, North Carolina, in 1987.

DESIGN MADE AT AIRLIE GARDEN

Design Made at Airlie Garden is a splendid example of the collage-paintings Evans began creating around 1966. She constructed these by cutting out her earlier wax crayon designs, pasting them to a cardboard background or canvas board, and using them in combination with oils and watercolors to create expansive mixed-media compositions. Evans' later collage-paintings, as in this

Design Made at Airlie Garden,
1967, oil and mixed media on
canvas mounted on paper-
board, 19 7/8 x 23 7/8 in.

example, incorporated as many as three wax crayon designs in a roughly pyramidal grouping on a rectangular background. The remaining space was filled with multicolored floral, plant, and hybrid forms of the artist's dream world.

Most of Evans' paintings are similar yet no two are identical. Reflecting the many colors of the flowers of the botanical gardens where she worked, her paintings shimmer with the complexity of Byzantine mosaics. And like Byzantine mosaics, Evans' works embody a common religious intent and express the omnipotence of God.

Nina Howell Starr, "The Lost World of Minnie Evans," *The Bennington Review* vol. III, no. 2 (Summer 1969): 41.

SAM GILLIAM

———— Born 1933 ————

I am a better artist today in that I am obviously a better teacher. Whether I am teaching or making art, the process is fundamentally the same: I am creating.

For the past twenty-five years, Sam Gilliam has been internationally recognized as the foremost contemporary African-American Color Field painter. He is most widely known for the large color-stained canvases he draped and suspended from walls and ceilings during the late 1960s and early 1970s. Since that time Gilliam's style has undergone a number of phases, and he continues to explore new avenues of artistic expression.

Born in Tupelo, Mississippi, in 1933, Gilliam was the seventh of eight children of Sam and Estery Gilliam. Shortly after his birth, the Gilliams moved to Louisville, Kentucky, where the artist spent his childhood. Gilliam's father worked on the railroad, and his mother was a homemaker for the large family. Gilliam began painting by the time he was in elementary school, and recalls important encouragement from his fifth-grade art teacher and a special art program at Louisville's Madison Junior High School. In 1951 Gilliam graduated from Central High School in Louisville. He attended the University of Louisville and graduated with a bachelor of arts degree in fine arts in 1955. During that same year he enrolled in graduate school at the University of Louisville, and also had his first solo exhibition at the same institution. Gilliam served in the United States Army from 1956 to 1958. He returned to Louisville following his discharge, and completed his master of arts degree in fine arts at the University of Louisville in 1961.

Gilliam initially taught art for a year in the Louisville public schools. In 1962 he married Dorothy Butler, a Louisville native and a well-known journalist. That same year, Gilliam moved to Washington, D.C., where he has lived ever since.

The background for Gilliam's art was the 1950s, which witnessed the emergence of abstract expressionism and the New York School followed by Color

Art Ramp Angle Brown,
1978, acrylic and oil enamel
on canvas and nylon,
242 1/4 x 35 7/8 in.

April 4, 1969, acrylic on canvas, 110 x 179 3/4 in.

Field Painting. Although these developments were later to play major roles in Gilliam's style, he had no direct exposure to these movements during his years at the University of Louisville. His teachers in Louisville were influenced more by the emotionally charged art of the German Expressionists of the first half of this century. Gilliam's paintings and drawings from graduate school in the late 1950s until his first one-man exhibition in Washington in 1963 were primarily figural abstractions employing bold, dark colors of a brooding nature reminiscent of the works of German Expressionist Emil Nolde. An important contemporary influence whom Gilliam acknowledges during that period was Nathan Oliveira, a California figurative expressionist who held an exhibition in Louisville. Two other early influences were the fluidly luminous watercolors of Paul Klee, and the works of the German Expressionist group Die Brücke (The Bridge).

Although not an organized or self-conscious movement, one of the most important developments in abstract art to emerge following abstract expressionism occurred in Washington, D.C., and is most often designated the "Washington Color School." Artists identified with this movement include Morris Louis, Kenneth Noland, Thomas Downing, Paul Reed, Anne Truitt, and Gene Davis. The general course of this style developed from the more painterly abstractions of the 1950s to totally nonrepresentational, expansive, simplified works of clear bright colors through the 1960s. Morris Louis had died and Kenneth Noland had moved to New York by the time Gilliam arrived in Washington in 1962. Their

In Celebration, 1987,
serigraph on paper,
30 1/2 x 38 1/4 in.

G.D.S., 1978, serigraph on paper, 25 15/16 x 24 1/8 in.

works were well known in Washington, however, and in 1963 Gilliam met Thomas Downing who introduced him to Washington's realm of color art. At that point Gilliam decided to relinquish his earlier, brooding style in favor of nonrepresentational art. His earliest Washington works were large, clean-edged paintings with flatly applied areas of color within the stylistic idiom of Washington Color Field Painting. Following that phase, Gilliam created early abstractions of diagonal stripes on square fields. During this time Gilliam experimented by taping and pouring colors, folding and staining canvases, and literally folding a still-wet canvas against itself to imprint vertical, angular, and axial forms.

Around 1965 Gilliam became the first painter to introduce the idea of the unsupported canvas. Partially inspired by women hanging laundry on clotheslines he observed from the window of his Washington studio, Gilliam abandoned the frame and stretcher, and began to drape and suspend large areas of paint-stained canvas. This innovative and improvisational technique was phenomenally successful and of widespread influence. Gilliam received numerous public and private commissions for his draped canvases, earning him the title "father of the draped canvas." These paintings were sometimes suspended from ceilings, arranged on walls, or on floors. They represent a third dimension in painting, and impart a sculptural quality. Though installed by the artist, Gilliam's draped canvases could be rearranged at will, and he has frequently embellished these works with metal, rocks, and wooden beams. One of the largest and final works of Gilliam's "draped" series was *Seahorses* of 1975 for the Philadelphia Museum of Art. This six-part work involved several hundred feet of paint-stained canvas, and was commissioned for the exterior walls of two adjacent wings of the museum.

While at the height of his popularity as the creator of draped canvases, in 1975, Gilliam suddenly discontinued producing them and began creating dynamic geometric collages influenced by musicians Miles Davis and John Coltrane. By 1977 Gilliam was producing "Black Paintings," similar in technique to the collage paintings, but in predominantly black hues. In 1979 Gilliam's "Wild Goose Chase" series was inaugurated and featured slanted edges and designs reminiscent of quilt patterns.

Gilliam's method of paint application changed dramatically during the 1980s. His former technique of staining and saturating wet canvases was replaced by a method in which multiple layers of thick acrylic paint and gels are scumbled, spattered, and built up on the canvas in a rich impasto. Gilliam's "quilted" paintings of the 1980s involved cutting geometric shapes from his thickly encrusted canvas surfaces, and rearranging them on nylon or canvas backgrounds in patterns reminiscent of African-American patchwork quilts the artist remembered from his childhood.

Gilliam's most recent works are textured paintings that incorporate or are juxtaposed with metal forms. A noted series of this type was the "D" series that

appeared in a one-man exhibition at the Corcoran Gallery of Art in 1983 and employed a metal D-shaped form at the bottom of each painting. Gilliam continues to produce new series, employs enamel as well as acrylic paints, and uses canvas, nylon, and awning materials in conjunction with aluminum and other metals. Gilliam's ability to move beyond the aesthetic of Washington Color Field Painting has assured his prominence as an exciting and innovative contemporary painter.

An outstanding creator of public art, Gilliam frequently works on a monumental scale and has received numerous major public commissions around the country. He is also one of the few successful, self-supporting African-American artists who views the teaching of art as a mission. His love of teaching developed during the one year he spent in the Louisville public schools. He taught for nearly a decade in the Washington public schools, and then at the Maryland Institute, College of Art and the University of Maryland, and for several years at Carnegie Mellon University in Pittsburgh. In addition, Gilliam still devotes time to conducting workshops, participating in panels, and delivering lectures in this country and abroad. He is an eloquent and articulate spokesman for his work. Gilliam has received two National Endowment for the Arts awards, fellowships from the Washington Gallery of Modern Art and the Guggenheim Foundation, and an Honorary Doctorate of Humane Letters from his alma mater, the University of Louisville, in 1980.

OPEN CYLINDER

Gilliam's "Wild Goose Chase" series includes this two-part ensemble, called *Open Cylinder*, an example of his "quilted" paintings produced during the late 1970s. After cutting geometric shapes from his thickly layered canvases, Gilliam arranged and glued these shapes to a canvas background in random patterns reminiscent of the asymmetrical "crazy quilts" made by African-American quilters of the Deep South, and the irregular patterns of West African textiles. The geometric areas appear to float and shift across the two-dimensional surface, while each of the boldly textured areas complements the adjacent area. This complementary concept reaches a climax in the sections, side by side yet persuasive as an entity.

An earlier work of 1973, *Art Ramp Angle Brown*—a preliminary study for a GSA commission—is a dynamic combination of square segments of Gilliam's impasto-covered canvas and interwoven strips of nylon awning canvas. This evocative contrast of materials, textures, and colors (the commercial fabric's bright yellows and black and the grays, roses, and whites of Gilliam's canvas) as well as the three-dimensionality introduced by folding and draping several areas, contribute to the impact of this angular work.

Curtia James, "Working With His Seven-League Boots On," *American Visions* 4:1 (Feb. 1989): 27.

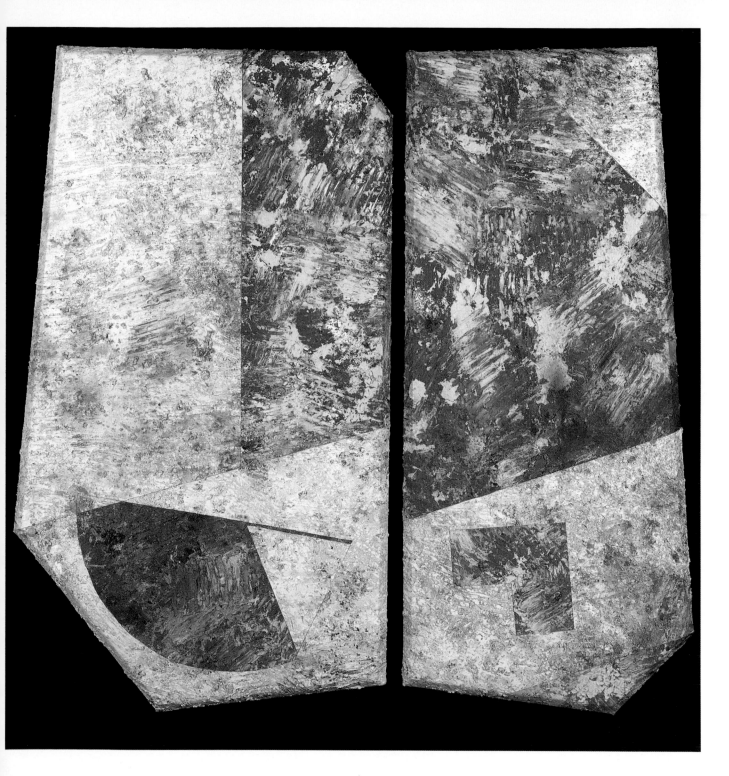

JAMES HAMPTON

————— 1909–1964 —————

That's my life. I'll finish it before I die.

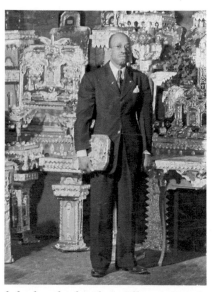

The artistic gifts of James Hampton were virtually unknown until shortly after his death. Hampton was born in the small rural community of Elloree, South Carolina. His father was an itinerant, self-proclaimed Baptist minister and gospel singer who deserted his wife and four young children to follow his calling.

When Hampton was around nineteen years old he moved to Washington, D.C., to join an older brother. From 1939 to 1942 Hampton worked as a short-order cook in several local cafes, and later joined the federal government labor force. Details concerning Hampton's educational background are sketchy. Presumably he attended the local schools in Elloree, South Carolina. On an application for federal employment in Washington, Hampton claimed to have attended an African-American high school in the District of Columbia through the tenth grade. There are no records, however, of Hampton's attendance at such a school.

In 1943 Hampton was inducted into the United States Army and served with the 385th Aviation Squadron in Texas, Hawaii, and the jungles of Saipan and Guam. His unit was noncombatant, and drew duties that consisted largely of carpentry and maintenance of air strips. Following his honorable discharge from the army in 1945, Hampton returned to Washington. In 1946 he was hired by the General Services Administration as a janitor. He remained in that position until his death.

Additional facts concerning Hampton's life are scarce. He never married, lived alone in a small apartment in a row house in northwest Washington, and was described as a small, bespectacled, soft-spoken recluse with few friends. James Hampton was totally dedicated to his "vision," a "vision" that almost

The Throne of the Third Heaven of the Nations Millenium General Assembly, detail

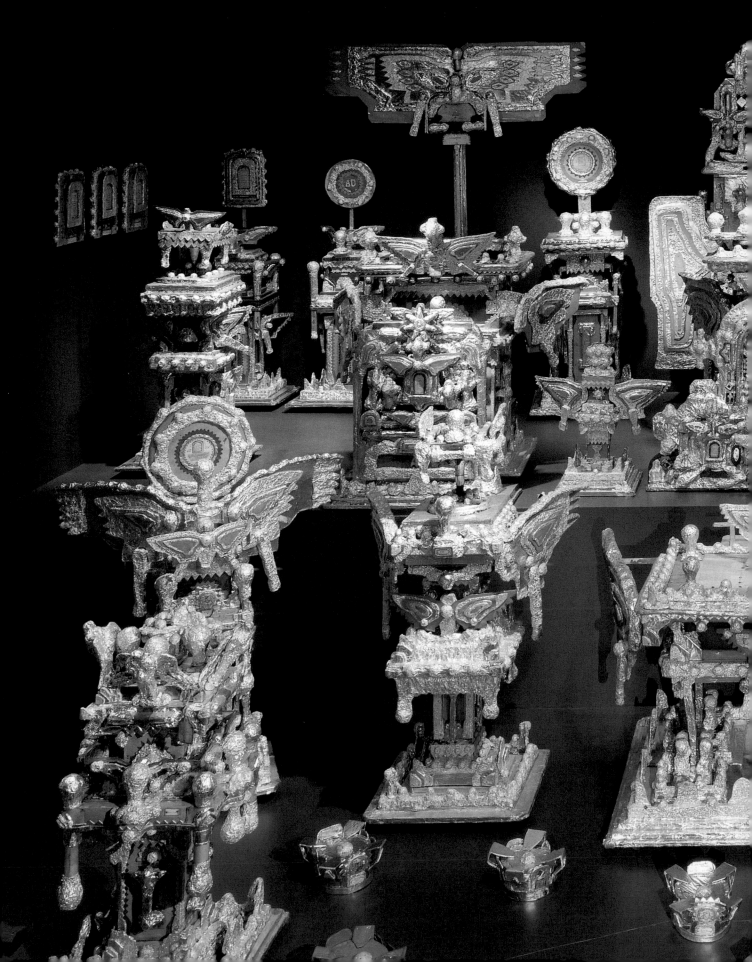

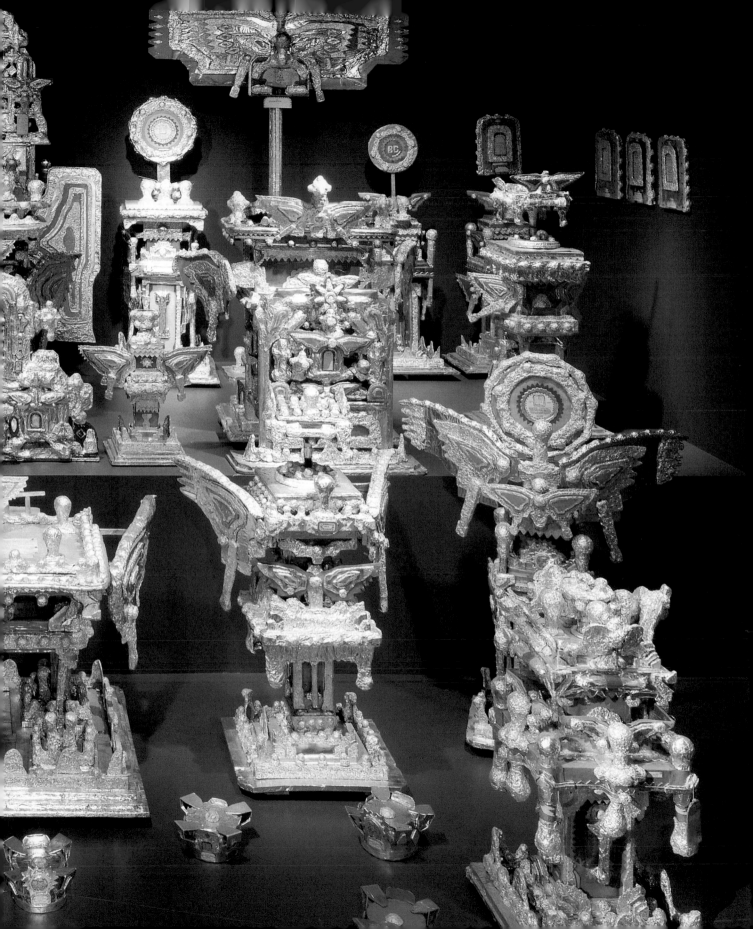

defies artistic classification yet produced an outstanding example of religious sculpture. In November 1964, Hampton died of cancer in Washington at the age of fifty-three.

THE THRONE OF THE THIRD HEAVEN

James Hampton's entire artistic output consists of a single work to which he assigned the remarkably lengthy title, *The Throne of the Third Heaven of the Nations Millenium General Assembly*, and on which he worked for over fourteen years. Hampton's *Throne* is his attempt to create a spiritual environment that could only have been constructed as the result of a passionate and highly personal religious faith.

Sometime during the early 1950s Hampton rented a drafty, unheated brick garage near his apartment in Washington, D.C., and transformed its drab interior into a heavenly vision. The construction consists of dozens of parts that comprise a central unit ten-feet tall, some twenty-seven by nearly fifteen feet in overall dimensions, and includes 180 separate glittering objects. The total work suggests a chancel complete with altar, a throne, offertory tables, pulpits, chairs, and hieratic and other obscure objects of Hampton's own invention. This religious monument was painstakingly constructed from old furniture, wooden planks and supports, cardboard cutouts, scraps of insulation board, discarded light bulbs, jelly glasses, hollow cardboard cylinders, Kraft paper, desk blotters, mirror fragments, electrical cables, and a variety of other "found objects," all scavenged from second-hand shops, federal office buildings, or the street. All of the surfaces of Hampton's great work were meticulously covered with various types of gold and silver tinfoil.

Hampton's *Throne* is totally symmetrical, and every object reflects the dedication of its maker. Massive wings sprout from almost all of its components; framed tablets originally lined the walls of the garage, and crowns and other complex foil decorations filled every available space of the assemblage. Every item has a relationship to the others and some bear a dedication to a saint, prophet, or other biblical character. On top of the large seven-foot central throne is a sign that reads "FEAR NOT." The entire complex was originally placed on a three-foot tall platform set stagelike against the rear wall of the garage. On the left side, inscriptions refer to the New Testament, Jesus, and divine grace; to the right, they refer to the Old Testament, Moses, and the Law.

The Throne of the Third Heaven of the Nations Millenium General Assembly is the result of Hampton's intense religious faith. In the churchlike environment that he created, Hampton apparently designated himself as "St. James," and a number of objects are labeled with inscriptions describing his visions:

"It is true that Adam the first man God created appeared in person on January 20, 1949 [. . .] this was on the day of President Truman's inauguration."

"It is true that on October 2, 1946, the Great Virgin Mary and the Star of

Bethlehem appeared over the nation's capital."

"This is true that the Great Moses, the giver of the Ten Commandments, appeared in Washington April 11, 1931."

An even more perplexing aspect of Hampton's efforts than his *Throne* and visions are wall tablets, a book, and other objects written by Hampton in an undecipherable script of his own devising. There is no evidence that Hampton had any assistance in constructing the *Throne*, so it may be assumed that it was his and his alone. Although no plans were found for the layout of Hampton's design, he carefully visualized the arrangement as he constructed it. He said that God told him what to do on a nightly basis.

In a search for the meaning of the *Throne* and Hampton's cryptic script, the New Testament Book of Revelation provides the best clues. Hampton attached labels to many of his objects that refer to the Millennium and the twentieth and twenty-first chapters of Revelation, which describe the first resurrection, the judgment of the dead before God, and the new heaven and earth. Hampton wrote on one of the pieces "the word millennium means the return of Christ and a part of the kingdom of God on earth."

Only a few works in the history of American folk art compare with Hampton's *Throne*. When light strikes its crinkled gold and silver foil-covered surfaces, the effect is dazzling and otherworldly. The *Throne* also prompts challenging psychological speculation. Perhaps it was Hampton's Baptist childhood that developed his passionate and private religious devotion. Few who were acquainted with the shy, retiring janitor suspected his secret artistic endeavors and fervent religious convictions. It is entirely possible that Hampton himself sat on the central throne of his glittering domain during private religious devotionals. These same driving forces must have inspired Hampton to create a type of personal hieroglyphics for which no translation will likely ever be found and probably records the innermost thoughts of his soul. It is a language that apparently originated and died with its author. Hence the personality of James Hampton remains an enigma wrapped in mystery, and provides innumerable avenues for speculation. But the *Throne* proclaims the intensity of his spiritual vision; for as he wrote: "Where there is no vision the People Perish."

Lynda Roscoe Hartigan, *The Throne of the Third Heaven of the Nations Millenium General Assembly* (Washington, D.C.: National Museum of American Art, Smithsonian Institution, 1987), essay originally published by the Museum of Fine Arts, Boston, for a 1976 exhibition of Hampton's work.

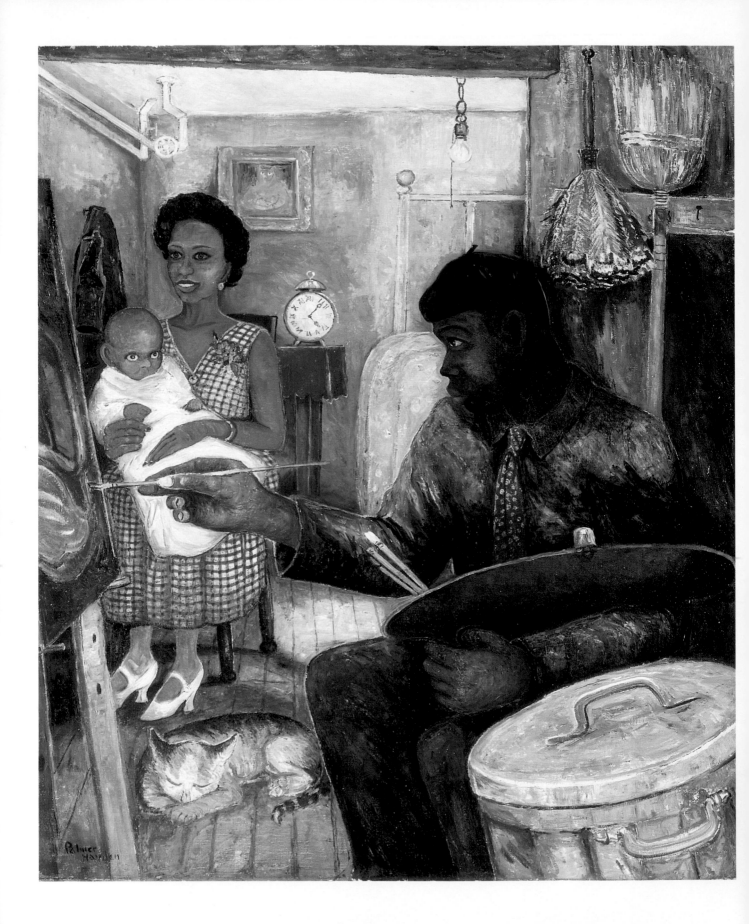

PALMER HAYDEN
1890–1973

I decided to paint to support my love of art, rather than have art support me.

Palmer Hayden was an artist whose association with the Harlem Renaissance was more spiritual than stylistic. Born on January 15, 1890, in Widewater, Virginia, to Nancy and John Hedgeman, Hayden was christened Peyton Cole Hedgeman but later changed his name to Palmer Hayden, the name he signed on all of his works. Hayden's interest in drawing began during his childhood. His first formal contact with art did not occur, however, until his enlistment in the army during World War I, when he enrolled in a drawing correspondence course. Hayden's military duty took him to West Point and the Philippines. Following his discharge from the army, Hayden moved to New York and worked part-time while studying art with Victor Perard at the Cooper Union School of Art.

During his early years Hayden also studied painting with Asa G. Randall at the Boothbay Art Colony in Maine in 1925. Hayden was awarded a working fellowship to Boothbay, and devoted most of his time to painting boats and marine subjects. His Boothbay period paintings were exhibited in New York in 1926 at the Civic Club and won two Harmon Foundation awards—the coveted gold medal and a cash prize of $400. With this money and a personal contribution from a patron, Hayden sailed for Paris in 1927, and studied in Brittany and in Paris at the École des Beaux Arts. Within a year Hayden had distinguished himself and mounted a one-man show at the Galerie Bernheim in Paris in November 1928. He also exhibited in group shows in Paris at the Salon des Tuileries in 1930 and the American Legion Exhibition in 1931. Hayden's portrayal of African-American subject matter in many of his paintings in the latter show was unusual in Paris at that time.

The Janitor Who Paints,
ca. 1937, oil on canvas,
39 1/8 x 32 7/8 in.

Hayden was in Paris during the final years of the Harlem Renaissance of the 1920s, but he had lived in New York during the formative years of that pivotal period. He knew Harlem Renaissance artists and shared their efforts, triumphs, and frustrations. Hayden maintained close contact with the Harmon Foundation while in the United States, and exhibited annually in the Harmon Foundation shows from 1928 to 1932 when he was in Paris.

Although Hayden received thorough academic training in New York, Maine, and Paris, his works always retained a flat naive character, which he developed independently during his youth. One of Hayden's best-known early works is *Fétiche et Fleurs* of 1926, which clearly linked Hayden with the African-Cubist tradition of Harlem and Paris. The small still-life composition depicts a vase of lilies, an ashtray, and a Gabonese Fang head on a table covered with a Kuba textile from Zaire. This painting was one of the earliest by an African-American artist to incorporate actual African imagery, and was awarded Mrs. John D. Rockefeller's prize for painting in the Harmon Show of 1933.

Following his return from Paris in 1932, Hayden worked on the United States Treasury Art Project and the W.P.A. Art Project from 1934 to 1940, and painted scenes of the New York waterfront and other local subjects. During the late 1930s Hayden developed a "consciously naive" style, which represented various aspects of African-American life. One of the first paintings that heralded Hayden's new style was *Midsummer Night in Harlem*, 1938, in which he effectively evoked the mood of Harlem's residents congregating outside to escape the heat inside the tenements. Despite the flat forms and stylized figures, the compositional arrangement and treatment of perspective reveal Hayden's academic training. African-American art historian James Porter apparently misunderstood Hayden's objectives when he criticized *Midsummer Night in Harlem* as a "talent gone astray," and compared the painting to "one of those billboards that once were plastered on public buildings to advertise black face minstrels." Hayden insisted, however, that he was not striving for satirical effects in his African-American folk paintings, but that he wanted to achieve a new type of expression.

In 1944 Hayden began painting the *Ballad of John Henry* series that would occupy him for the next ten years. The series comprises a group of twelve paintings depicting scenes from the life of the legendary African-American folk hero who inspired the ballad named after him. An exhibition of these paintings and others dealing with African-American folklore was held at the Countee Cullen Library in Harlem in 1952. Hayden was also represented in the large exhibition, "The Evolution of the Afro-American Artist," sponsored by the City University of New York, the Urban League, and the Harlem Cultural Council and presented in the fall of 1967 in the great hall of the City University. From the late 1960s until his death in 1973, Hayden continued to paint subjects based on African-American themes, but in a more cosmopolitan manner than his earlier works.

The Janitor Who Paints, detail

THE JANITOR WHO PAINTS

The Janitor Who Paints is among the most intriguing of Hayden's late "consciously naive" vignettes of African-American life. Hayden exhibited regularly in the Harmon Foundation shows and also worked as a janitor in the Harmon Foundation's office building. In this symbolic self-portrait, the painter is at work in his basement studio, surrounded by the tools of his dual professions, a palette, brushes and easel, and a garbage can, broom, and feather duster. The painter's studio is also his bedroom, and his bed, night table, alarm clock, and a framed picture of a cat are seen in the background.

The artist is painting a portrait of a young mother seated and holding her well-bundled baby with its curious hypnotic stare. Nothing seems amiss in the painting; the artist wears a shirt, tie, and beret, the attractive mother is clad in a checkered dress, and a cat sleeps peacefully on the floor. When this painting was x-rayed several years ago, however, the underpainting revealed some startling discoveries. The well-dressed, beret-wearing janitor-artist was originally painted as a ludicrous, bald man with a bean-shaped head; the baby was a grinning buffoon, and the mother was depicted as an unflattering servant. Ironically, the cat in the framed picture was painted over a portrait of Abraham Lincoln.

The present version, considerably more attractive and flattering, was undoubtedly altered by Hayden in response to widespread criticism of his works by his peers who felt that Hayden was caricaturing blacks for the amusement of whites.

Nora Holt, "Painter Palmer Hayden Symbolizes John Henry," *New York Times*, 1 Feb. 1947.

RICHARD HUNT

— born 1935 —

In some works it is my intention to develop the kind of forms Nature might create if only heat and steel were available to her.

For more than three decades Richard Hunt's status as the foremost African-American abstract sculptor and artist of public sculpture has remained unchallenged. Executed in welded and cast steel, aluminum, copper, and bronze, Hunt's abstract creations make frequent references to plant, human, and animal forms. Hunt prefers to be called a "Midwestern sculptor," and is one of the few well known African-American sculptors who still resides and works in his hometown.

Hunt was born on September 12, 1935, the younger of two children of Howard and Inez Henderson Hunt, a barber and a librarian respectively who lived on Chicago's predominantly black South Side. Both of Hunt's parents provided invaluable influences during his childhood. He acquired an early interest in politics from conversations he overheard while working in his father's barbershop. His mother instilled in him a love of reading and classical music, and took him to local black opera companies.

Hunt began drawing during his childhood, and enrolled in a summer program at the Junior School of the Art Institute of Chicago where he received his initial training in sculpture under Nelli Bar. In 1950 Hunt set up a studio in his bedroom, and began to model in clay. One of his earliest influences was the work of Julio González in an exhibition, "Sculpture of the Twentieth Century," held at the Art Institute of Chicago in 1953. Within two years Hunt had taught himself to master the welded-metal technique. Hunt's career at the Art Institute was outstanding. He was awarded the prestigious Logan, Palmer, and Campana prizes, and the James N. Raymond Foreign Traveling Fellowship in 1957, which permitted him to visit England, France, Spain, and Italy. Hunt was a Guggenheim Fellow in 1962, a Cassandra Foundation Fellow in 1970, and a Tamarind Fellow

"The greatest obstacle to being heroic is the doubt whether one may not be going to prove one's self a fool; the truest heroism, is to resist the doubt; and the profoundest wisdom, to know when it ought to be resisted, and when to be obeyed." from the series, Great Ideas, 1975, chromed steel, cut, formed and welded, 32 x 50 5/8 x 33 3/4 in.

Study for Richmond Cycle,
1977, soldered, bolted, and
burnished copper with wood
edging, 19 x 60 3/4 x 24 3/4 in.

(awarded under the auspices of the Ford Foundation) in 1965. He has had numerous one-man and group exhibitions, has received a number of honorary degrees, and has served as Visiting Artist and Professor at many schools and universities. In 1969 Hunt became the first African-American sculptor to be honored with a retrospective exhibition at the Museum of Modern Art in New York.

More than thirty examples of Hunt's sculptures are located in and around Chicago's libraries, community centers, universities, apartment houses, and office buildings. An equal number may be seen elsewhere in the Midwest, South, New York, and Washington, D.C. Hunt's early works of the 1950s were more figural than the later examples, and frequently reflected classical themes. During the 1960s and early 1970s Hunt used automobile junkyards as his quarries, and transformed cast-off automobile bumpers and fenders into elegant abstract welded sculptures.

Untitled—Bones, ca. 1964–70,
lithograph on paper,
24 x 34 1/2 in.

The public sculptures of Richard Hunt undeniably bridge the gap between abstract art and the black experience in America, as is evident in such works as *Freedmen's Column* at Howard University and *I Have Been to the Mountain*, a memorial to Dr. Martin Luther King, Jr., in Memphis, Tennessee, where King was killed. Hunt's success and popularity as a sculptor of public pieces can be attributed to the universal appeal of his work and his remarkable ability to produce abstract works that are suggestive of themes and people of his immediate world.

STUDY FOR RICHMOND CYCLE

A study for a large-scale plaza piece in Richmond, California, this elegant sculpture is characteristic of Hunt's highly abstract forms that often suggest natural phenomena. Employing copper to create both the large and small abstract forms, the archlike effect of the larger design is beautifully complemented by the small form in which contours are more angular. Contrasts in texture and the play of light can be seen in the reflections this two-part sculpture casts on the smooth copper surface of the oblong base. The base also provides a near mirror image of the object. The work was commissioned by the General Services Administration.

Hunt is also an accomplished printmaker who prefers lithography. Many of his lithographs, such as *Untitled—Bones* of 1964–70, reflect the same elegant abstract forms seen in his metal sculptures. Some of his lithographs were studies for his outdoor pieces and smaller sculptures.

Exhibition flier, *Richard Hunt*, (Notre Dame, Indiana: University of Notre Dame Art Gallery, 1966).

JOSHUA JOHNSON

active 1795–1825

As a *self-taught genius*, deriving from nature and industry his knowledge of the Art; and having experienced many insuperable obstacles in the pursuit of his studies, it is highly gratifying to him to make assurances of his ability to execute all commands with an effect, and in a style, which must give satisfaction.

Joshua Johnson, or Johnston, the earliest documented professional African-American painter, was active in Baltimore during the late eighteenth and first quarter of the nineteenth century. His background, however, remains a mystery. The families and descendants of those whose portraits he painted claim that Johnson was a former slave. Whether Johnson was a slave or not is open to question since his name appears in the City Directory of Baltimore from 1796 to 1824, when the directory did not list slaves. Johnson's identity as an African American has been questioned as well. In editions of the directory in which an asterisk designated a person of color, there is no asterisk by Johnson's name. Johnson may have been biracial and fair enough to elude identification as an African American by publishers of the directory. In the directory of 1817, however, Johnson's name appears among the "free householders of Color" listed separately in the publication.

There appears to be no question about Johnson's occupation. In all the directories he is listed as a "limner" or "portrait painter," and seems to have had at least eight different addresses in Baltimore and neighboring Fells Point. Johnson's birthplace is unknown. It might have been Baltimore, or more likely the French West Indies from which he may have come to Baltimore as an indentured servant who eventually earned his freedom. The names of Johnson's wife Sarah and their three children, George, John, and Sarah, are recorded in Catholic church records in Baltimore. Land records indicate that Johnson was a property owner in Montgomery, Frederick, and Anne Arundel counties in Maryland after 1824. The land records establish the fact that Johnson was apparently financially successful in his profession.

Portrait of Adelia Ellender,
ca. 1803–05, oil on canvas,
26 1/4 x 21 1/8 in.

Portrait of Mrs. Barbara Baker Murphy (Wife of a Sea Captain), ca. 1810, oil on canvas, 21 3/4 x 17 5/8 in.

Portrait of Sea Captain John Murphy, ca. 1810, oil on canvas, 21 1/2 x 17 1/2 in.

Johnson's identity as an artist was first established by J. Hall Pleasants, former secretary of the Maryland Historical Society, in an article published in 1939. When a retrospective exhibition of Johnson's paintings was held at the Peale Museum in Baltimore nine years later, twenty-five portraits were included. Since that time more than eighty works have been attributed to Johnson. None of Johnson's portraits is actually dated and only one bears his signature. The majority of Johnson's portraits have been assigned dates on the basis of the ages of the sitters, from about 1795 to 1825, and most depict affluent residents of Baltimore. All of the sitters in Johnson's portraits are white with the exception of two unidentified African-American males.

Many of the portraits, though not all, attributed to Johnson are drawn in the same stiff manner, the faces of the sitters in three-quarter view and their gazes straightforward. The backgrounds are usually plain, although some include a tiled floor and an open casement with landscape beyond a curtain. Favorite "stock objects" in Johnson's portraits were letters, books, gloves, parasols, riding crops, dogs, flowers, and fruit. Johnson frequently seated his subjects on upholstered Sheraton chairs or settees studded with brass tacks; as a result he has been called the "brass tack" artist.

In an advertisement placed by Johnson in the Baltimore *Intelligencer* of December 19, 1798, the artist described himself as a "self-taught" genius. Pleasants suggested that as a student of painting, or, as a slave, Johnson might have received training from some member of the Peale family who dominated Baltimore's art scene during the period of Johnson's activities. Johnson's name does not appear, however, in any of the Peale family's voluminous archives. Johnson's style is closely related to that of Charles Peale Polk (1767–1822, a nephew of the family patriarch Charles Willson Peale) in their mutual fondness for thinly painted surfaces, variety of accessories, and attention to costume details. It is unlikely that Johnson was entirely self-taught. If he did not receive his training from some member of the Peale family, he was at least familiar with their work.

Johnson's *Intelligencer* advertisement also referred to his "having experienced many insuperable obstacles in the pursuit of his studies." It seems reasonable to assume that Johnson was making a veiled reference to his race, and alluded to the fact that he had suffered racial and professional discrimination, yet had overcome such odds to some extent. The date and circumstances of Johnson's death are unknown.

BARBARA BAKER MURPHY AND JOHN MURPHY

This pair of companion portraits is among a dozen portraits attributed to Johnson in which the sitters appear in feigned ovals, or a painted frame within a frame, in chest-length, three-quarter profile, close-up views. Both figures have tautly drawn lips, tendrilled forelocks, broad eyebrows and heavy-lidded, al-

mond-shaped eyes that stare directly at the observer. These paintings have been dated around 1810, Johnson's early period, when his figures generally reflected a strong modeling of form. Records indicate that Johnson also painted portraits of the Murphys' son and daughter, but the locations of these paintings are unknown.

The portrait of Mrs. Murphy was probably designed to hang to the left of that of her husband. Depicted against a charcoal gray background, she is wearing a silver-gray empire-style dress with sheer white organza yoke, collar, and matching bonnet—reflecting the period's fashionable apparel. Of particular interest is the unusual attention Johnson devoted to the details of the sitter's jewelry, dress drawstrings, and delicate patterns on the ruffles of her collar and cap. Repeating the color of her dress in the spandrels of the painting has provided a harmonizing effect.

Johnson's lack of formal training is apparent in the incorrect placement and proportioning of Mrs. Murphy's left arm and shoulder. His attempts at modeling the figure were not entirely unsuccessful, and the source of light is inconsistent in his works. Paintings attributed to Johnson from the 1820s and 1830s reveal a marked flatness of the bodies in contrast to the slightly modeled faces of the subjects.

Captain John Murphy of Baltimore, a sailor originally from Ireland, is depicted against a reddish brown background, in which the gradation of tonal values suggest only a limited amount of depth. Again, Johnson devoted considerable attention to the details of the sea captain's coat, notably its delicately rendered gold buttons and his white shirt and sheet-white scarf. By contrast, his efforts to model the sea captain's figure are notably less ambitious. The portrait of Captain Murphy is one of at least five portraits of sea captains attributed to Johnson, no doubt indicative of the fact that such portraits were often commissioned in the event they did not return from their voyages. Family correspondence indicates that Captain John Murphy died at sea during a battle between his Baltimore schooner, the *Grampus*, and a British sloop-of-war, in the Canary Islands in November 1813, around three years after this portrait was painted.

Advertisement, "Portrait Painting," *Baltimore Intelligencer*, 19 Dec. 1798.

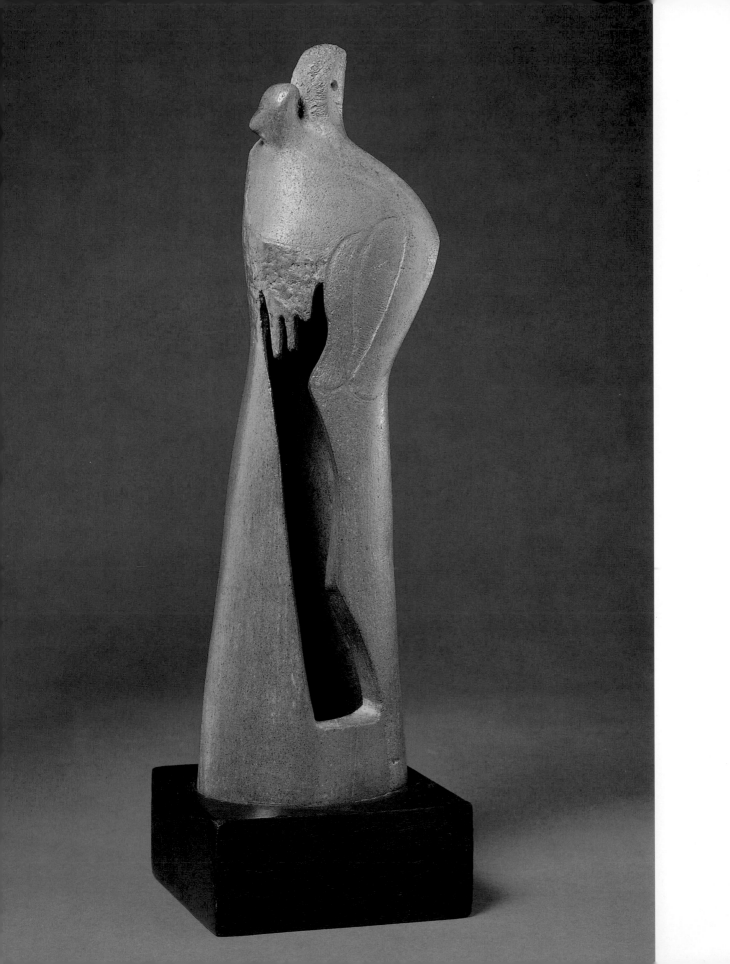

SARGENT JOHNSON

1887–1967

It is the pure American Negro I am concerned with, aiming to show the natural beauty and dignity in that characteristic lip and that characteristic hair, bearing and manner; and I wish to show that beauty not so much to the white man as to the Negro himself.

Born in Boston on October 7, 1887, Sargent Johnson was the third of six children of Anderson and Lizzie Jackson Johnson. Anderson Johnson was of Swedish ancestry, and his wife was Cherokee and African American. All of the children were fair enough in complexion to be considered white, and several of Johnson's sisters preferred to live in white society. Sargent, however, was insistent upon identifying with his African-American heritage throughout his life.

The Johnson children were orphaned by the deaths of their father in 1897 and their mother in 1902. The children spent their early years in Washington, D.C., with an uncle, Sherman William Jackson, a high school principal whose wife was May Howard Jackson, a noted sculptress who specialized in portrait busts of African Americans. It was probably while young Sargent was living with his aunt that he developed his earliest interest in sculpture.

After living in the Jackson home in Washington, the young Johnson children were sent to live with their maternal grandparents in Alexandria, Virginia. From there they were sent to boarding schools. The boys went to the Sisters of Charity in Worcester, Massachusetts, and the girls to a Catholic school in Pennsylvania for Indian and African-American girls. While at the Sisters of Charity, Sargent was sent to a public school where he studied music, art, and mechanical drawing. He was later sent to Boston to music school, but soon became more interested in art. He enrolled in the Worcester Art School where he received his first formal art training. From Boston, Johnson went to Chicago where he lived with relatives for a brief time before deciding to move to the West Coast. Johnson arrived in the San Francisco area in 1915, during the time of the Panama Pacific International Exposition, which impressed him greatly.

Untitled, ca. 1940, terra cotta, 10 1/2 x 3 1/4 x 2 3/8 in.

The same year Johnson arrived in San Francisco, he met and married Pearl Lawson, an African American from Georgia who had moved to the Bay Area. The couple had one child, Pearl Adele, who was born in 1923. The couple separated in 1936 and shortly afterwards Mrs. Johnson was hospitalized at Stockton State Hospital, where she died in 1964.

Johnson worked at various jobs during his first years in San Francisco but also attended two art schools, the A. W. Best School of Art and the California School of Fine Arts. Johnson was enrolled at the latter school from 1919 to 1923 and from 1940 to 1942. He studied first under the well-known sculptor Ralph Stackpole for two years, and for a year with Beniamino Bufano. Johnson's student work at the California School of Fine Arts was awarded first prizes in 1921 and 1922.

In 1925 Johnson came to the attention of the Harmon Foundation. During the following year he began exhibiting in the foundation's exhibitions and was represented regularly from 1926 to 1935. Johnson won numerous awards in the Harmon Foundation shows, including the Robert C. Ogden prize in 1933 for the most outstanding work in the exhibition. In 1930 and 1931, the Harmon exhibition was shown at the Oakland Municipal Art Gallery and Johnson was represented in both shows, and was the only California artist to be included. Johnson's works of the 1920s consisted primarily of small, smoothly finished ceramic heads that were primarily of children and were greatly influenced by the style of Bufano.

The 1930s were the most productive decade in Johnson's career. His figure style retained the basic simplicity of his earlier works. He became more interested, however, in stylization of forms and experimented with a variety of mediums—terra cotta, wood, beaten copper, marble, terrazzo, porcelain, etchings, and gouache drawings. Johnson's earliest interest in African art became manifest around 1930 when he executed several copper masks based on African prototypes.

The W.P.A. Federal Art Project provided a number of opportunities for Johnson during the late 1930s in the Bay Area. Johnson's first large W.P.A. project was an organ screen carved of redwood in low relief for the California School of the Blind in Berkeley. The eighteen-by-twenty-four-foot panel was completed in 1937 and installed in the school's chapel. In 1939 he undertook another W.P.A. project, decorating the interior of the San Francisco Maritime Museum in Aquatic Park.

For the Golden Gate International Exposition held on the newly created Treasure Island in San Francisco in 1939, Johnson completed his largest figures. He designed two eight-foot-high cast stone figures, which were displayed around the fountain in the Court of Pacifica. Johnson's figures depict two Incas seated on llamas and are distinctly East Indian in inspiration. They are known as the "happy Incas playing the Piper of Pan," and are among Johnson's finest

works. He also designed three figures symbolizing industry, home life, and agriculture for the Alameda-Contra Costa Building at the Exposition.

A final group of works from Johnson's mature period was an animal series depicting a camel, burro, grasshopper, duck, hippopotamus, and squirrel. Each of the figures was twenty-six-by-twenty-four inches and cast in gray and green

Mask, ca. 1930–35,
copper on wood base,
15 1/2 x 13 1/2 x 6 in.

terrazzo. These animals were part of a project for a child-care center playground in San Francisco, and comprise some of Johnson's most delightful works.

One of Johnson's favorite activities during the late 1950s and 1960s was collecting diorite rocks from the seashore near Big Sur, California. Diorite became one of Johnson's preferred materials in addition to cast stone and terra cotta. Johnson's last sculptures, completed in 1965 and 1966, were made of diorite and displayed a completely abstract style and simplicity.

Johnson moved a number of times in the final fifteen years of his life. Following an illness in 1965, Johnson finally settled in a small hotel room in downtown San Francisco. In October 1967 Johnson died there of a heart attack. During his long and distinguished career he never ceased to grow as an artist and to keep abreast of contemporary techniques. His works were influenced by Cubism as well as the art of West Africa, Latin America, and Mexico. Gifted with the remarkable ability to combine those influences with his own style, Johnson created sculpture that reflects his own vitality and originality.

MASK

Johnson's interest in African themes developed around 1930 when he began producing two- and three-dimensional copper masks inspired by West African prototypes. The smoothly rounded forms that characterize his earlier terra-cotta portrait heads were also evident in the African mask series.

In this splendid example of a helmet mask, Johnson has depicted a young girl, perhaps an African princess, with elaborately braided hair that lies flat against her head. Her face expresses great serenity, and the figure's broad nose and full lips are handsomely complemented by the voids of her widely spaced eyes. The smoothly polished and rounded surfaces of the triple-tiered wooden base echo the mask's design and provide additional harmony.

Cast bronze heads from the ancient Nigerian cultures of Ife and Benin undoubtedly inspired this mask. Stylistically its features are more closely related to the naturalism of Benin examples than the realistic portrait heads from Ife. Although inspired by classic Nigerian models in bronze and terra cotta, Johnson's work is essentially original.

Johnson's consistent interest in curvilinear rhythms is also apparent in his two-dimensional works such as *Lenox Avenue*, a lithograph of 1938. In this design, a masklike head, seen in semiprofile, is the vortex of a cubist-inspired composition recalling the cultural metamorphosis of the Harlem Renaissance. A large piano keyboard, musical note, and other motifs merge with and overlap the head. These forms symbolize the coalescence of music and art in black America's cultural capital during the period of the Harlem Renaissance from 1920 to 1929 and the Great Depression of the 1930s.

San Francisco Chronicle, 6 Oct. 1935; cited in *Sargent Johnson: Retrospective* (Oakland: The Oakland Museum Art Division Special Gallery, 1971), 17.

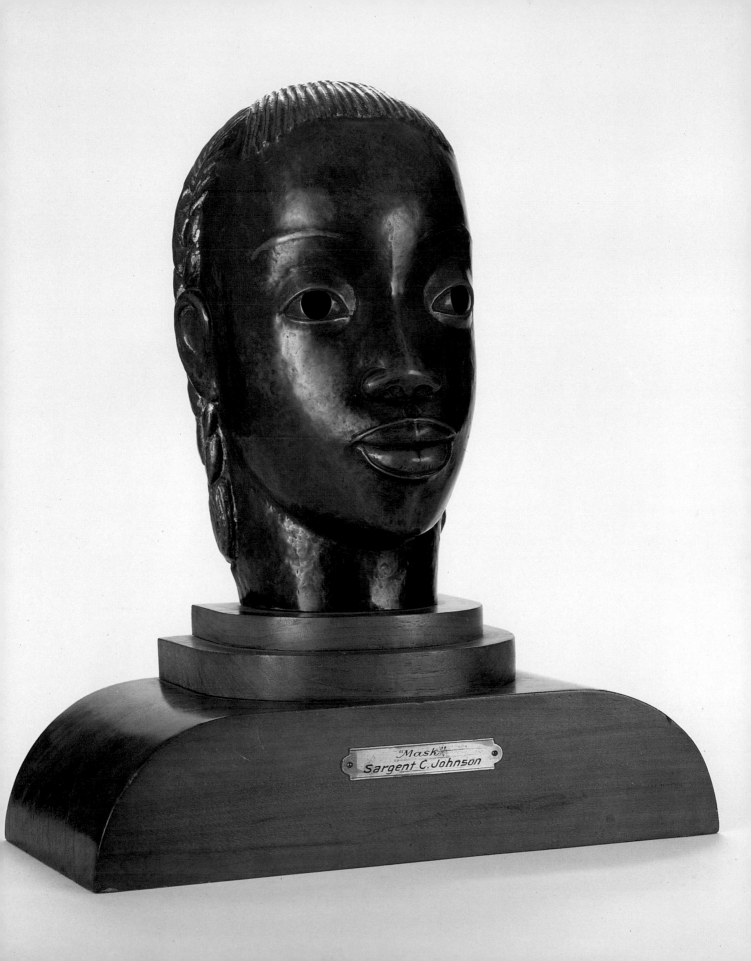

"Mask"
Sargent C. Johnson

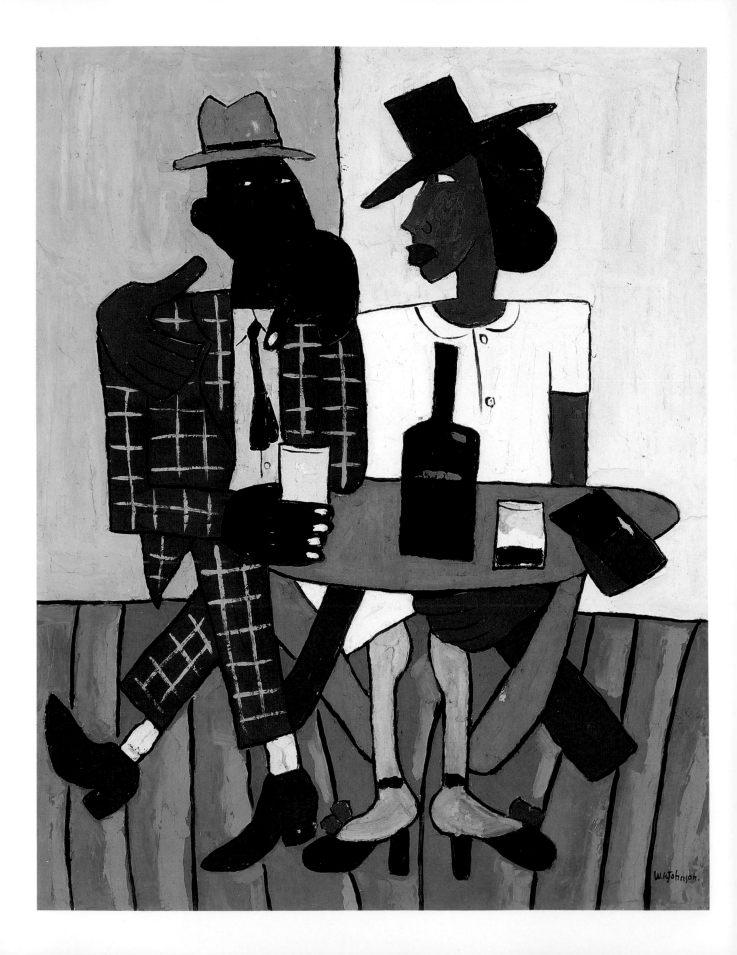

WILLIAM H. JOHNSON
1901–1970

And even if I have studied for many years and all over the world, . . . I have still been able to preserve the primitive in me. . . . My aim is to express in a natural way what I feel, what is in me, both rhythmically and spiritually, all that which in time has been saved up in my family of primitiveness and tradition, and which is now concentrated in me.

One of the most brilliant yet tragic careers of an early twentieth-century African-American artist was that of William H. Johnson. Originally from the Deep South, Johnson became a world traveler who absorbed the customs and cultures of New York, Europe, and North Africa. He completed hundreds of oils, watercolors, gouaches, pen-and-ink sketches, block prints, silk screens, and ceramics. Johnson's career also spanned a gamut of styles from the academic, through Impressionism, Cubism, Fauvism, and German Expressionism, to, finally, a "conscious naiveté."

Johnson was born on March 18, 1901, in Florence, South Carolina. The eldest of five children, he dropped out of school at an early age to help support his family. As a child he frequently copied cartoons from local newspapers, an activity that developed his ability to tell a story in witty pictures. Johnson left Florence around 1918 and moved to New York where he enrolled in the National Academy of Design and worked notably with the painter Charles Hawthorne. In 1926 Hawthorne raised funds to send Johnson abroad to study.

During the winter of 1926 Johnson traveled to France where he studied and painted in Paris, Moret-sur-Loing, and Cagnes-sur-Mer. From 1927 to 1929 he also visited Corsica, Nice, Belgium, and Denmark. Johnson's earliest works in Paris and Corsica were impressionistic landscapes and cityscapes. He quickly developed a short-hand technique that included only the essentials of design. In late 1929 Johnson returned to New York with a number of his French-Corsican paintings. He exhibited some of these works in the Harmon Foundation show of 1930 and received the coveted gold medal.

Cafe, ca. 1939–40, oil on fiberboard, 36 1/2 x 28 3/8 in.

Self-Portrait with Pipe, ca.
1937, oil on canvas, 35 x 28 in.

Harbor, Svolvær, Lofoten,
ca. 1937, oil on burlap,
26 x 35 1/4 in.

Following this success, Johnson returned to Europe and married a Danish textile artist, Holcha Krake, whom he had met in southern France. The newlywed Johnsons traveled across France and Belgium to Denmark where they settled in the small fishing village of Kerteminde, near his wife's home. The people of Kerteminde welcomed Johnson warmly and were fascinated by his paintings of gardens, old houses, and scenes of marine life.

In 1933 the Johnsons spent several months in North Africa where they delighted in the colorful Arabian bazaars and mosques, painted numerous portraits of the residents, worked in ceramics, and were taught age-old secrets of glazing and firing. The couple then traveled across Norway by bicycle. Johnson's paintings of that period capture the fresh atmosphere of spring with blossoming trees, the clear water of the deep fjords, and the blues of distant snow-capped mountains. Sailing next from Aalesund, Sweden, north to Tromsö, the two artists continued to paint and immerse themselves in the beauties of nature. They lived in Svolvær in the Lofoten Islands where Johnson painted and Holcha painted and wove her copy of the Baldishol Tapestry.

The threat of World War II prompted Johnson to return to the United States in 1938. In a pronounced and unexpected transition in his style, Johnson became interested in religious paintings and his subjects were almost exclusively African American. Using a palette of only four or five colors and painting frequently on burlap or plywood, Johnson developed a flat, "consciously naive" style. During the early 1940s, war activities, the Red Cross, and other related events interested Johnson and provided grist for his widely exhibited narrative paintings.

In January 1944 Johnson's wife Holcha died of cancer, an event that nearly shattered both his life and career. In June 1944 Johnson traveled to Florence, South Carolina, to visit his mother for the first time in fourteen years. There he painted a number of portraits of family and friends, as well as a series of paintings portraying seated women staring directly at the observer.

In 1945 Johnson began his final paintings—social, historical, and political panels including a series of narrative themes built around single subjects such as Booker T. Washington and John Brown. These paintings were exhibited only once in the United States. Late in 1946, still despondent over his wife's death, Johnson packed all of his art and returned to Denmark where he hoped to find peace among his wife's family in the country that he had grown to love. He exhibited his historical and political paintings in Copenhagen in March 1947, which was the last exhibition of his works held during his lifetime. "There is quite a bit of Matisse's worship of unrestricted colors in his pictures," wrote a Danish critic of Johnson's last show, "But where Matisse is an aesthetician, Johnson goes further and shows us the working people of the southern states, the Negroes and their leaders, and their entirely strangely colorful world. . . ."

Johnson, whose peculiar behavior had been noticed by close friends, became mentally ill shortly after his last show in Denmark. He was cared for temporarily in Denmark and later sent back to New York where he was hospitalized. On April 13, 1970, Johnson died at Central Islip State Hospital on Long Island, where he had spent the last twenty-three years of his life in obscurity, unable to produce any art. Today Johnson is considered one of the most important African-American artists of his generation.

GOING TO CHURCH

Paintings such as *Going to Church* reveal the degree to which Johnson abandoned academic traditions in favor of a folk or "consciously naive" style after 1938. Filled with predominantly African-American imagery, this scene depicts a cornerstone of rural black life in the South. Johnson's return to the United States had reawakened his appreciation of his heritage and prompted what may well have been an attempt to compensate for its almost total exclusion in his earlier works.

In *Going to Church*, a family of four, dressed in their Sunday best, people a scene undoubtedly inspired by Johnson's childhood in rural South Carolina. Sharp, strong colors, generously applied, help call attention to animals and figures that loom larger than the buildings and trees. Deliberately left flat and unmodeled, all of the forms appear to be stacked vertically rather than receding in space. Despite these various devices, Johnson's academic training and extensive European exposure remain evident. The perfect balance, syncopated color arrangement, elegant elongation, and repetitively paired motifs—cart wheels, fence posts, churchyard crosses—are design decisions not consciously

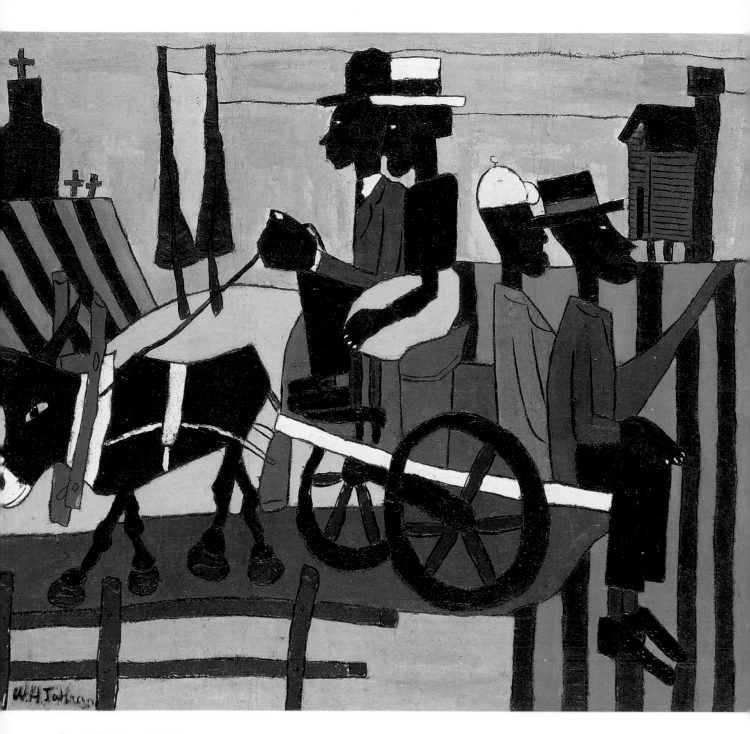

Going to Church, ca. 1940–41,
oil on burlap, 38 1/8 x 45 1/2 in.

Swing Low, Sweet Chariot, ca.
1944, oil on paperboard,
25 5/8 x 26 1/2 in.

*Dr. George Washington
Carver*, ca. 1945, oil on
fiberboard, 35 1/2 x 28 1/2 in.

sought by folk or self-taught artists.

Johnson's life-long exploration of expressionistic techniques had culminated in a style forceful because of its emphasis on contrast and simplification to the essential. Crucial to that evolution was his understanding of the modern European tradition of expressionist landscape painting. Pulsating color, subtle abstraction, and deliberate contrast combine in *Harbor, Svolvær, Lofoten* to capture Johnson's empathetic reading of the picturesque yet dramatic landscape of Norway's northern fjords. This magnificent scene is one of approximately twelve works devoted to the Lofoten Islands, which Johnson and his wife visited by boat and on foot in 1937.

Richard J. Powell, "In My Family of Primitiveness and Tradition: William H. Johnson's Jesus and the Three Marys," *American Art* 5:4 (Fall 1991): 21.

W.H.Johnson

FRANK JONES

—— 1900–1969 ——

I draw them as I see them.

Born around 1900 in Red River County, Texas, near Clarksville, Frank Jones spent twenty-eight of his sixty-nine years imprisoned in Texas for crimes he may not have committed. Details concerning Jones's early life are scant. His father deserted the family when Jones was three or four years old, and his mother abandoned him on a street corner when he was around five or six.

After Jones was abandoned by his mother, he was taken in by Willie Dean Baker, an elderly black woman who raised him with the assistance of a neighbor, Della Gray. Jones never attended school or learned to read and write. During young adulthood he worked at a variety of odd jobs around Clarksville and neighboring towns.

Jones vividly recalled that his mother told him that he had been born with a "veil" or "caul" (part of the fetal membrane) over his left eye. Jones's mother said that this veil would enable him to see spirits. The "spirit-veil" belief is widespread in African-American culture, and has its genesis in black West Africa. Children who are born with a veil over their eyes are believed to have the power to see and communicate with spirits, as well as the ability to foresee the future.

Jones saw his first spirit or "haint" when he was around nine years old. He continued to have supernatural visions for the rest of his life. He compared his "double-sightedness" to looking into a peephole and viewing the spirit world. Jones alternately referred to the spirits he saw as "haints," "devils," and "devil haints," but insisted that they were all the same. Assuming human, animal, bird, and inanimate forms, these devils were male or female and of many nationalities. For Jones their existence was real and universal, but to those who were not born with the veil they were invisible.

Indian House, ca. 1968–69, colored pencil on paper mounted on paperboard, 22 5/8 x 22 5/8 in.

Jones's supernatural powers were well known in his East Texas community, where his early life was spent uneventfully. His long history of imprisonment began in 1941 when he was accused of raping a young woman whom he had raised after finding her abandoned in 1935. The child's mother appeared six years later and demanded the child. According to Jones, when he refused to relinquish custody of the girl, the mother charged him with rape. Jones claimed he was innocent, but was convicted and served two years and two months in prison.

Around 1945 Jones married Audrey Culberson, who had two adult sons. In 1949 Jones's foster mother Della Gray was robbed and murdered. One of Jones's stepsons was convicted of the murder and implicated Jones as well. Although Jones vigorously denied any knowledge of the crime, he was found guilty and sentenced to life in prison. He served nine years of the sentence and was paroled. Jones returned to Clarksville and made plans to remarry. In 1960, however, a woman whom he hired to clean his house accused him of raping her. Jones denied the charge, and insisted that he had been "set-up" by the girl and a male neighbor who disliked him. Jones was returned to prison as a parole violator; the rest of his life was spent in prison.

Jones's "artistic" career began during his third confinement in prison and spanned only a period of five years, from about 1964 to his death in early 1969. He focused on creating drawings, in red and blue pencil on paper, that invariably reflect visions based on experiences within prison and communication with the "haints" and "devils" of his spirit world.

Jones's earliest drawings were done with materials he found around the prison recreation office where he was assigned to work. He used red and blue pencil stubs discarded by prison bookkeepers and inexpensive typing paper often retrieved from wastebaskets. Jones's works received their earliest recognition through a prison art show in 1964. Shortly afterwards, a Dallas art gallery began marketing his work, and supplied him with larger, higher-quality paper and additional colored pencils. Jones became increasingly prolific, and four months after his debut in the prison art show he held his first one-man show at the gallery. This exhibition was well received by the public, and drew considerable media coverage that resulted in a number of interviews with Jones by members of the press. As a consequence of his prison celebrity status, Jones's material existence improved considerably. Indeed, he enjoyed the media attention, as he had never had a single visitor or received a single piece of mail during the previous fifteen years. In addition, he was held in high esteem by his fellow inmates, and the income from the sale of his drawings allowed him to purchase a radio and wristwatch—the only two luxuries in his bleak prison life.

Although Jones was active artistically for only five years, his style underwent noticeable changes. His first drawings, completed in 1964, depict his character-istic "devil-houses," shown in multilevel architectural cross sections that reveal

Indian House, detail

a variety of figures representing the spirits Jones claimed he saw. The colors red and blue dominate his drawings and he continued to prefer them even after he was provided with an array of colors. For Jones, red and blue symbolized smoke and fire and Hell. The spiked shapes that Jones identified as horns create patterns and also suggest movement. His early drawings are frequently populated by figures identified as flying fish and elongated winged figures shown in profile.

As Jones became more confident and his gallery supplied him with better materials, his "mature" style emerged. These later drawings are characterized by architectural structures filled with grinning figures that hover above floors and are suspended from ceilings. Enclosing the frenzied figures serves to neutralize them, not unlike how actual prison walls serve to limit the behavior of inmates. Although Jones was tormented and taunted by the devils of his spirit world, he rendered them powerless by capturing them on paper and enclosing them in cell-like rooms. His representation of confined spirit people was also analogous to his life in prison.

The single motif that appears in the majority of Jones's drawings is a large clock. Clocks hold a special significance for prisoners. Terms such as "doing time" or "pulling time" are common prison jargon, coupled with the fact that prison routine is regimented and based on strict time schedules. Since prisoners lose their freedom, they are constantly preoccupied with the passing of time and the time of their eventual release. In Jones's earliest drawings empty circles appear at the top of his "spirit houses." Later these circles developed into clocks

with hands, indicating specific times; in some instances the clocks have multiple hands and appendages that spin off or orbit around them. These changes were probably related to Jones's continual requests for parole and its subsequent denial by state authorities. By the late 1960s, Jones was suffering from progressive liver disease, which was the ultimate cause of his death.

Jones's prison number, 114591, appears at the bottom of some of his drawings, placed there like a signature. Although a fellow inmate taught him to write his name, his spelling was inconsistent and he developed many curious variations.

Jones neither relinquished his dream of being released, nor wavered from his claim of innocence. As his health deteriorated, his artistic output remained constant. Early in February 1969 Jones's parole was finally granted. His health suddenly worsened, however, and he was admitted to the prison hospital. Two weeks later, on February 15, 1969, Jones died while still incarcerated. Funds from his drawings provided him with a dignified funeral, and his remains were returned to Clarksville for burial.

The drawings of Frank Jones provide valuable insight into the spiritual state and artistic vision of a remarkably talented man whose life was characterized by unfortunate events. If Jones found any consolation or avenues of escape from his prison confinement and the "devil-haints" who taunted him, it was through their capture and imprisonment in his "devil-houses." For as malevolent as they may have seemed, these "devil-haints" were Jones's constant companions and his most intimate acquaintances.

INDIAN HOUSE

One of several hundred works by Jones, this drawing is a splendid example of his late period. Probably completed the year before his death, this double-walled "Indian House" or "devil-house" is fully populated with creatures from Jones's spirit world. Joining the humanlike grinning "haints" or "devil-haints" are flying fishes and birdlike creatures, all of which are drawn in Jones's favorite red-and-blue color combinations. Most of the figures float freely in space, yet are confined in separate, cell-like geometric cubicles. They impart a restless energy to this work which is, in turn, stabilized by the straight edges that define the multistoried house. Two of the largest winged creatures have apparently escaped from their cells and perch jauntily on either side of the clock that appears in most of Jones's drawings. This clock bears a double set of numbers, and even the hands have sprouted a pair of wings. The clock's double numbers may be a reference to the "double time" Jones was serving.

Dee Steed, "The Devil in Contemporary Primitive Art," unpublished paper, n.d; cited in Lynn Adele, *Black History/Black Vision: The Visionary Image in Texas* (Austin: Archer M. Huntington Art Gallery, The University of Texas at Austin, 1989), 46.

Indian House, detail

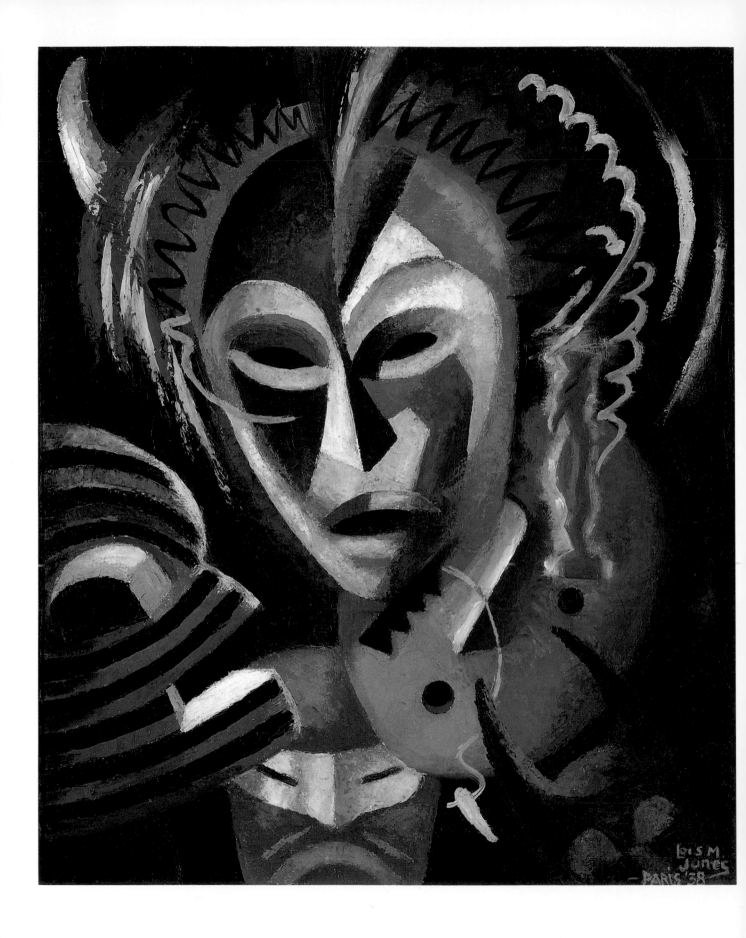

LOIS MAILOU JONES

——— born 1905 ———

Mine is a quiet exploration—a quest for new meanings in color, texture and design. Even though I sometimes portray scenes of poor and struggling people, it is a great joy to paint.

For more than fifty years, Lois Mailou Jones has enjoyed a consistently successful career as a painter, teacher, book illustrator, and textile designer. Her art spans three continents: North America, Europe, and Africa, and she has been represented in more than seventy group shows and mounted twenty one-woman exhibitions since 1937.

Jones was born in Boston in 1905, the second of two children of Thomas Vreeland and Caroline Dorinda Jones. Jones's father was the first African American to graduate from Boston's Suffolk Law School, and her mother was a beautician. Jones has recalled that her mother fostered her earliest artistic interests and that her teachers in the Boston public schools were encouraging. Jones's initial professional aspirations were to pursue a career in social work. It was, however, the offer of a scholarship for the vocational drawing classes at the Boston Museum School of Fine Arts that spurred Jones to a permanent career in art. Initially for one year, her scholarship was extended to six years, based on Jones's outstanding achievements, and when she graduated in 1927 she was also awarded a teacher's certificate. She has received diplomas from the Boston Normal Art School and Designer's School in Boston. She has also studied art at Harvard University and Columbia University.

Jones's first experience with racial prejudice occurred in 1927 when she applied for a graduate assistantship at the Boston Museum School of Fine Arts. Her application was flatly rejected and she was advised to travel to the South and help African Americans living there. After briefly considering moving to New York City, Jones was recruited in 1928 by Palmer Memorial Institute, a private African-American boarding school in Sedalia, North Carolina, to head its art

Les Fétiches, 1938,
oil on linen, 21 x 25 1/2 in.

department. After two years in North Carolina where she experienced the frustrations and indignities of segregation first-hand, Jones left Palmer Memorial and joined the faculty of the Fine Arts Department at Howard University in Washington, D.C. She remained at Howard as professor of design and watercolor painting for forty-seven years until her retirement in 1977.

Jones's long career may be divided into four phases: the African-inspired works of the early 1930s, French landscapes, cityscapes, and figure studies from 1937 to 1951, Haitian scenes of the 1950s and 1960s, and the works of the past several decades that reflect a return to African themes. Her formal artistic career began in 1930 when she joined the faculty at Howard University. The racial discrimination that she experienced in Boston and North Carolina, as well as the climate and aftermath of the Harlem Renaissance, motivated the depiction of African and African-American themes in Jones's early paintings. She became associated with the Harmon Foundation shortly after moving to Washington, and was a frequent participant in its exhibitions during the 1930s.

In 1937 Jones received a General Education Board Foreign Fellowship to study in France. She went to Paris in 1937 where she studied painting at the Académie Julian, lived among the French, learned to speak French fluently, and painted views of Paris and surrounding areas. Since her first trip to France, Jones has felt a spiritual affinity for the French people and their nation. She explains that France provided her with the first feeling of absolute freedom to live and eat wherever she chose. Her admiration for France and its people was so profound that she returned to Paris each year, except during World War II, for more than twenty years after her first trip. In 1952, a book of more than one hundred reproductions of her French paintings, *Lois Mailou Jones Peintures 1937–1951*, was published in Paris. Jones was the only African-American female painter of the 1930s and 1940s to achieve fame abroad, and the earliest whose subjects extend beyond the realm of portraiture.

Jones's third period was also formed outside the United States in Haiti where she discovered a second spiritual home. She first went to the capital, Port-au-Prince, in 1954 when the Haitian government invited her to visit and paint the country's landscape and its people. The trip lasted ten weeks and in that time Jones developed a love for Haiti's warm climate, its beautiful scenery, and its colorful, deeply religious people. She also conducted painting classes at the Centre d'Art and the Foyer des Artes Plastiques. In recognition, the government of Haiti made her a chevalier of the National Order of Honor and Merit.

Haiti acquired even more meaning for Jones following her marriage to Louis Vergniaud Pierre-Noel, a prominent Haitian artist. Jones and Pierre-Noel first met in 1934 when they were graduate students at Columbia University. For almost twenty years they corresponded before they eventually married in the south of France in 1953. Jones and her husband lived in Washington, D.C., Martha's Vineyard, and in Pierre-Noel's hometown, Port-au-Prince. They had

no children. His death in 1982 ended their twenty-nine year marriage.

Jones's numerous oils and watercolors inspired by Haiti are probably her most widely known works. In them her affinity for bright colors, her understanding of Cubism's basic principles, and her search for a distinctly personal style reached an apogee.

Jones's return to African themes in her work of the past several decades coincided with the black expressionistic movement in the United States during the 1960s. Skillfully integrating aspects of African masks, figures, and textiles into her vibrant paintings, Jones continues to produce exciting new works at an astonishing rate of speed, even in her late eighties.

In 1945 James Lane, curator of painting at the National Gallery of Art in Washington, said of Jones's work, "God's gift to Lois Jones is a beautiful sense of color. Like a singer who always sings true, this well-trained painter—and she has studied under Philip Hale, Jonas Lie, and the Académie Julian—shows true harmony in her oils. But that is not God's only gift: He has given her a sense of structure and design (which she uses in her textile patterns) that carries the color to victory, for unorganized color alone could not possibly do the trick. Her work, from her earliest still lifes and her prize-winning portrait *French Mother*, has, one sees, been responsive to light and the joyousness of light, but where the fine cityscapes of her Paris period were charming and gray, the landscapes, the portraits, and the still lifes from Martha's Vineyard are clarion and colorful. It is all, in the best sense of the word, happy art." It is extraordinary that nearly fifty years later, Jones's paintings, currently inspired by African themes, are still highly reflective of Lane's description.

LES FÉTICHES

Jones was one of the first female African-American painters to depict African imagery in her work. While in Paris during her fellowship period she completed a number of paintings with African themes, including *Les Fétiches*, which she considers her first major painting in this vein. Skillfully juxtaposed are five African masks, a white pendant charm, and a standing, red anthropomorphic figure. Rendered in monochromatic tones and boldly silhouetted against a dark background, the faithful representation of the artifacts is a result of Jones's first-hand study of African masks and ritualistic objects as well as those from other non-Western civilizations since the 1920s. A keynote work of her career, *Les Fétiches* is a poetic synthesis of the spirit and meaning of Jones's ancestry.

In contrast, *Jardin du Luxembourg* is a typical example of Jones's landscapes and cityscapes completed in France during the late 1940s under the influence of post-Impressionism. While this painting reveals a familiarity with the works of Paul Cézanne and Maurice Utrillo, Jones's composition, light, and color are very much her own. Broad, freely applied brush strokes convey the light that pervades the entire composition and the painting's bright colors are in harmony with the

Jardin du Luxembourg,
ca. 1948, oil on canvas,
23 3/4 x 28 3/4 in.

impressionist tradition. Jones's concern for form is decidedly Cézannesque, and is achieved through color relationships rather than modeling in light and shade. The scores of paintings Jones completed in France during the 1930s and 1940s, including those done in the United States from her French sketchbooks, established her reputation as an artist internationally.

Jones's view of the gardens of the Luxembourg Palace also includes a view of the palace and the twin towers of Nôtre Dame in the background. The scene was captured during the afternoon of a sunny day, and visitors to the park may be seen reading, strolling, or merely relaxing among the lush greenery, flowers, and cascading fountain of the palace's formal gardens.

Samella S. Lewis and Ruth G. Waddy, *Black Artists on Art* (Los Angeles: Contemporary Crafts Publishers, 1969), 1:97.

JACOB LAWRENCE

———— born 1917 ————

If at times my productions do not express the conventionally beautiful, there is always an effort to express the universal beauty of man's continuous struggle to lift his social position and to add dimension to his spiritual being.

The most widely acclaimed African-American artist of this century, and one of only several whose works are included in standard survey books on American art, Jacob Lawrence has enjoyed a successful career for more than fifty years. Lawrence's paintings portray the lives and struggles of African Americans, and have found wide audiences due to their abstract, colorful style and universality of subject matter. By the time he was thirty years old, Lawrence had been labeled as the "foremost Negro artist," and since that time his career has been a series of extraordinary accomplishments. Moreover, Lawrence is one of the few painters of his generation who grew up in a black community, was taught primarily by black artists, and was influenced by black people.

Lawrence was born on September 17, 1917, in Atlantic City, New Jersey. He was the eldest child of Jacob and Rosa Lee Lawrence. The senior Lawrence worked as a railroad cook and in 1919 moved his family to Easton, Pennsylvania, where he sought work as a coal miner. Lawrence's parents separated when he was seven, and in 1924 his mother moved her children first to Philadelphia and then to Harlem when Jacob was twelve years old. He enrolled in Public School 89 located at 135th Street and Lenox Avenue, and at the Utopia Children's Center, a settlement house that provided an after-school program in arts and crafts for Harlem children. The center was operated at that time by painter Charles Alston who immediately recognized young Lawrence's talents.

Shortly after he began attending classes at Utopia Children's Center, Lawrence developed an interest in drawing simple geometric patterns and making diorama-type paintings from corrugated cardboard boxes. Following his graduation from P.S. 89, Lawrence enrolled in Commerce High School on West 65th

Dreams No. 2, 1965, tempera on fiberboard, 35 3/4 x 24 in.

Street and painted intermittently on his own. As the Depression became more
acute, Lawrence's mother lost her job and the family had to go on welfare.
Lawrence dropped out of high school before his junior year to find odd jobs to
help support his family. He enrolled in the Civilian Conservation Corps, a New
Deal jobs program, and was sent to upstate New York. There he planted trees,

drained swamps, and built dams. When Lawrence returned to Harlem he became associated with the Harlem Community Art Center directed by sculptor Augusta Savage, and began painting his earliest Harlem scenes.

Lawrence enjoyed playing pool at the Harlem Y.M.C.A., where he met "Professor" Seifert, a black, self-styled lecturer and historian who had collected a large library of African and African-American literature. Seifert encouraged Lawrence to visit the Schomburg Library in Harlem to read everything he could about African and African-American culture. He also invited Lawrence to use his personal library, and to visit the Museum of Modern Art's exhibition of African art in 1935.

As the Depression continued, circumstances remained financially difficult for Lawrence and his family. Through the persistence of Augusta Savage, Lawrence was assigned to an easel project with the W.P.A., and still under the influence of Seifert, Lawrence became interested in the life of Toussaint L'Ouverture, the black revolutionary and founder of the Republic of Haiti. Lawrence felt that a single painting would not depict L'Ouverture's numerous achievements, and decided to produce a series of paintings on the general's life. Lawrence is known primarily for his series of panels on the lives of important African Americans in history and scenes of African-American life. His series of paintings include: *The Life of Toussaint L'Ouverture*, 1937, (forty-one panels), *The Life of Frederick Douglass*, 1938, (forty panels), *The Life of Harriet Tubman*, 1939, (thirty-one panels), *The Migration of the Negro*, 1940–41, (sixty panels), *The Life of John Brown*, 1941, (twenty-two panels), *Harlem*, 1942, (thirty panels), *War*, 1946–47, (fourteen panels), *The South*, 1947, (ten panels), *Hospital*, 1949–50, (eleven panels), *Struggle—History of the American People*, 1953–55, (thirty panels completed, sixty projected).

Lawrence's best-known series is *The Migration of the Negro*, executed in 1940 and 1941. The panels portray the migration of over a million African Americans from the South to industrial cities in the North between 1910 and 1940. These panels, as well as others by Lawrence, are linked together by descriptive phrases, color, and design. In November 1941 Lawrence's *Migration* series was exhibited at the prestigious Downtown Gallery in New York. This show received wide acclaim, and at the age of twenty-four Lawrence became the first African-American artist to be represented by a downtown "mainstream" gallery. During the same month *Fortune* magazine published a lengthy article about Lawrence, and illustrated twenty-six of the series' sixty panels. In 1943 the Downtown Gallery exhibited Lawrence's *Harlem* series, which was lauded by some critics as being even more successful than the *Migration* panels.

In 1937 Lawrence obtained a scholarship to the American Artists School in New York. At about the same time, he was also the recipient of a Rosenwald Grant for three consecutive years. In 1943 Lawrence joined the U.S. Coast Guard and was assigned to troop ships that sailed to Italy and India. After his discharge

The Library, 1960, tempera
on fiberboard, 24 x 29 7/8 in.

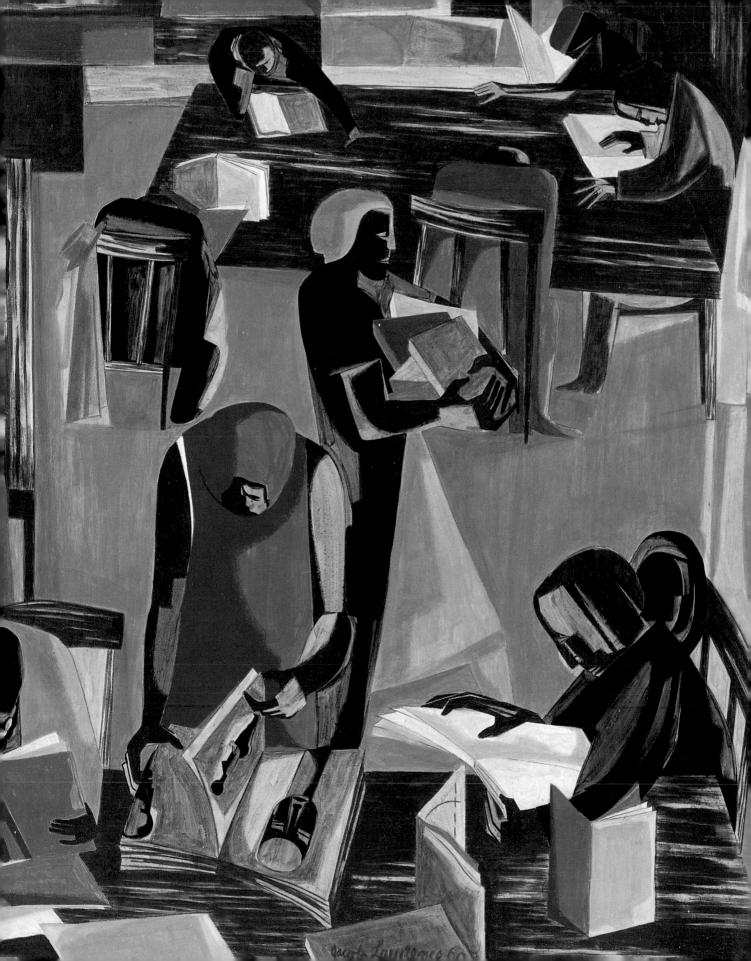

in 1945, Lawrence returned to painting the history of African-American people. In the summer of 1947 Lawrence taught at the innovative Black Mountain College in North Carolina at the invitation of painter Josef Albers.

During the late 1940s Lawrence was the most celebrated African-American painter in America. Young, gifted, and personable, Lawrence presented the image of the black artist who had truly "arrived." Lawrence was, however, somewhat overwhelmed by his own success, and deeply concerned that some of his equally talented black artist friends had not achieved a similar success. As a consequence, Lawrence became deeply depressed, and in July 1949 voluntarily entered Hillside Hospital in Queens, New York, to receive treatment. He completed the *Hospital* series while at Hillside.

Following his discharge from the hospital in 1950, Lawrence resumed painting with renewed enthusiasm. In 1960 he was honored with a retrospective exhibition and monograph prepared by The American Federation of Arts. He also traveled to Africa twice during the 1960s and lived primarily in Nigeria. Lawrence taught for a number of years at the Art Students League in New York, and over the years has also served on the faculties of Brandeis University, the New School for Social Research, California State College at Hayward, the Pratt Institute, and the University of Washington, Seattle, where he is currently Professor Emeritus of Art. In 1974 the Whitney Museum of American Art in New York held a major retrospective of Lawrence's work that toured nationally, and in December 1983 Lawrence was elected to the American Academy of Arts and Letters. The most recent retrospective of Lawrence's paintings was organized by the Seattle Art Museum in 1986, and was accompanied by a major catalogue. Lawrence met his wife Gwendolyn Knight, a fellow artist, when he was a teenager. They were married in 1941, and their close and mutually supportive relationship has been an important factor in Lawrence's career.

THE LIBRARY

In this view of a library filled with African-American readers, Lawrence no doubt recalls his Harlem childhood during which he spent many hours in the local library and developed a love for books. *The Library* is typical of Lawrence's stylized figurative manner. All of the people in the room are engrossed in reading or examining illustrations with the exception of the standing figure in black who carries an armload of books. Arranged in Lawrence's characteristically flattened space, the angular figures in the foreground provide a bold horizontal emphasis, connecting the middle and background spaces filled with readers seated at tables with tops in tipped-up perspective. Reducing the figures' scale effectively suggests depth in this basically two-dimensional painting, and the emphatic horizontal and diagonal lines are balanced by the two elongated vertical figures who move in and across the picture's surface.

Dreams No. 2 of 1965 demonstrates the degree to which Lawrence has

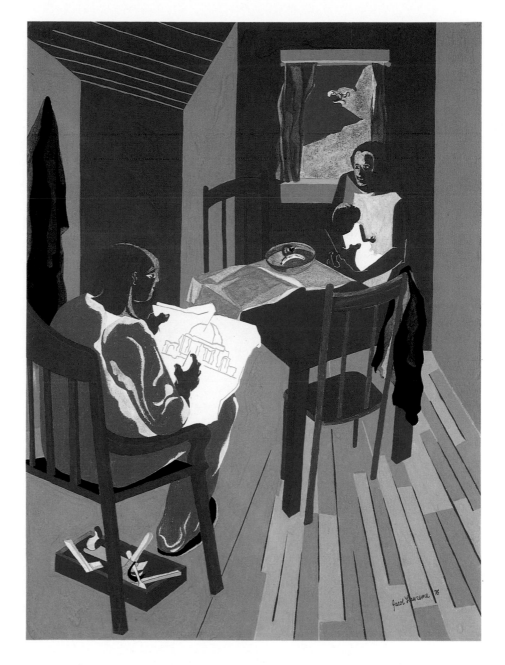

sustained a consistent style. Here, a woman, wearing a nightgown and seated in a darkened room, visually experiences the subjects of her dreams through two open windows. The sheer curtain panels lend a semitransparent appearance to the dream-world figures in sharp contrast to the more lucid figure of the dreamer.

Ellen Harkins Wheat, *Jacob Lawrence: The Frederick Douglass and Harriet Tubman Series of 1938–40* (Hampton, Va.: Hampton University Museum; Seattle: in association with University of Washington Press, 1991), n.p.

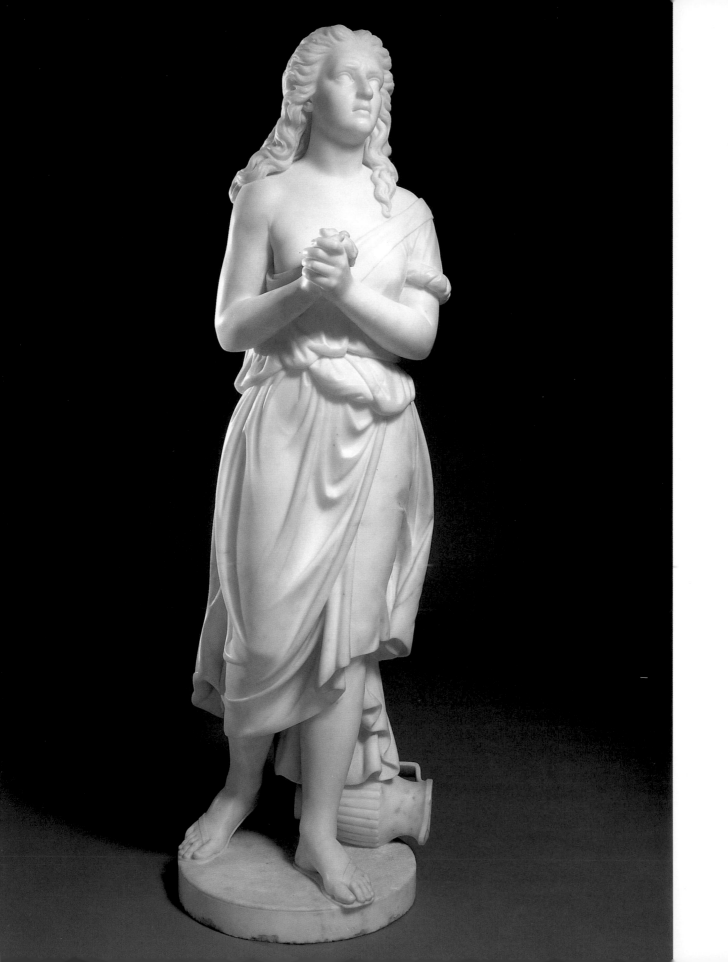

EDMONIA LEWIS

—— ca. 1843–after 1911 ——

There is nothing so beautiful as the free forest. To catch a fish when you are hungry, cut the boughs of a tree, make a fire to roast it, and eat it in the open air, is the greatest of all luxuries. I would not stay a week pent up in cities, if it were not for my passion for art.

Edmonia Lewis, the first professional African-American sculptor, was born in Ohio or New York in 1843 or 1845. Her father was a free African-American and her mother a Chippewa Indian. Orphaned before she was five, Lewis lived with her mother's nomadic tribe until she was twelve years old. Lewis's older brother, Sunrise, left the Chippewas and moved to California where he became a gold miner. He financed his sister's early schooling in Albany, and also helped her to attend Oberlin College in Ohio in 1859. While at Oberlin she shed her Chippewa name "Wildfire" and took the name Mary Edmonia Lewis. Her career at Oberlin ended abruptly when she was accused of poisoning two of her white roommates. Lewis was acquitted of the charge, though she had to endure not only a highly publicized trial but also a severe beating by white vigilantes. Subsequently accused of stealing art supplies, she was not permitted to graduate from Oberlin.

Lewis left Oberlin in 1863 and, again through her brother's encouragement and financial assistance, moved to Boston. There she met the portrait sculptor Edward Brackett under whose direction she began her limited sculptural studies. She was determined to become a sculptor. With a minimum of training, exposure, and experience, Lewis began producing medallion portraits of well-known abolitionists such as William Lloyd Garrison, Charles Sumner, and Wendell Phillips. With sales of her portrait busts of abolitionist John Brown and Colonel Robert Gould Shaw, the Boston hero and white leader of the celebrated all-African-American 54th Regiment of the Civil War, Lewis was able to finance her first trip to Europe in 1865.

After traveling to London, Paris, and Florence, Lewis decided to settle in Rome

Hagar, 1875, carved marble, 52 5/8 x 15 1/4 x 17 in.

where she rented a studio near the Piazza Barberini during the winter of 1865 and 1866. When Lewis arrived in Rome, sculptors favored the neoclassical style that was marked by a lofty idealism and Greco-Roman resources. She quickly learned Italian and became acquainted with two prominent white Americans living in Rome, the actress Charlotte Cushman and the sculptor Harriet Hosmer. A number of other American sculptors lived in Rome at this time because of the availability of fine white marble and the many Italian stonecarvers who were adept at transferring a sculptor's plaster models into finished marble products. Lewis was unique among sculptors of her generation in Rome as she rarely employed Italian workmen, and completed most of her work without assistance. Her motivation was probably twofold: lack of money and fear of the loss of originality in her work.

Unfortunately, most of Lewis's sculptures have not survived. Portrait busts of abolitionists and patrons such as Anna Quincy Waterston, and subjects depicting her dual African-American and Native American ancestry were her specialty. Lewis also completed several mythological subjects or "fancy pieces" such as *Asleep*, *Awake*, and *Poor Cupid*, and at least three religious subjects, including a lost *Adoration of the Magi* of 1883, and copies of Italian Renaissance sculpture.

Her *Moses*, copied after Michelangelo, is an example of Lewis's imitative talents; the sensitively carved *Hagar* (also known as *Hagar in the Wilderness*) is probably the masterpiece among her known surviving works. In the Old Testament, Hagar—Egyptian maidservant to Abraham's wife Sarah—was the mother of Abraham's first son Ishmael. The jealous Sarah cast Hagar into the wilderness after the birth of Sarah's son Isaac. In Lewis's sculpture Egypt represents black Africa, and Hagar is a symbol of courage and the mother of a long line of African kings. That Lewis depicted ethnic and humanitarian subject matter greatly distinguished her from other neoclassical sculptors.

Newspaper accounts reveal that Lewis returned to the United States in 1872 to attend an exhibition of her works at the San Francisco Art Association. The San Francisco *Pacific Appeal* reported that Lewis was in the United States again in October 1875, and made a brief appearance at a concert held in St. Paul, Minnesota. After 1875, facts concerning the remainder of Lewis's life as well as the date and place of death are obscure and conflicting. She never married, had no children, and was last reported living in Rome in 1911.

OLD ARROW MAKER

Lewis made at least three copies of this sculpture, one of the few surviving examples of her work depicting American Indian subjects. Inspired by memories of her childhood among the Chippewas in upstate New York, *Old Arrow Maker* (also known as *Old Arrow Maker and His Daughter*) is a compact grouping of two figures seated on a round base with a fawn lying near their feet. Both

Anna Quincy Waterston, ca.
1866, carved marble,
11 7/8 x 7 1/4 x 5 1/8 in.

figures wear traditional American Indian attire, and are engaged in making moccasins and arrowheads; as a child Lewis herself made moccasins. Although the young woman's features reflect typical neoclassical idealism, those of the older man portray strong ethnological characteristics. The coarse-textured material of their apparel is yet another of Lewis's deviations from the usually smooth, finished surfaces of neoclassical sculptures.

Lewis greatly admired the poetry of Henry Wadsworth Longfellow, and was especially attracted to his epic poem, *The Song of Hiawatha*. Lewis completed at least three figural groups inspired by the poem: *The Wooing of Hiawatha*, *The Marriage of Hiawatha and Minnehaha*, and *The Departure of Hiawatha and Minnehaha*. While in Rome in 1869, Longfellow visited Lewis's studio where he sat for a portrait and probably saw the sculptures his poem inspired. Until recently the only surviving known work from Lewis's *Hiawatha and Minnehaha* series was a pair of small busts of the young lovers, which were probably studies for the figurative groups. In 1991, however, Lewis's *Marriage of Hiawatha and Minnehaha* was rediscovered.

Edmonia Lewis, quoted in "Letter From L. Maria Child," *National Anti-Slavery Standard*, 27 Feb. 1864.

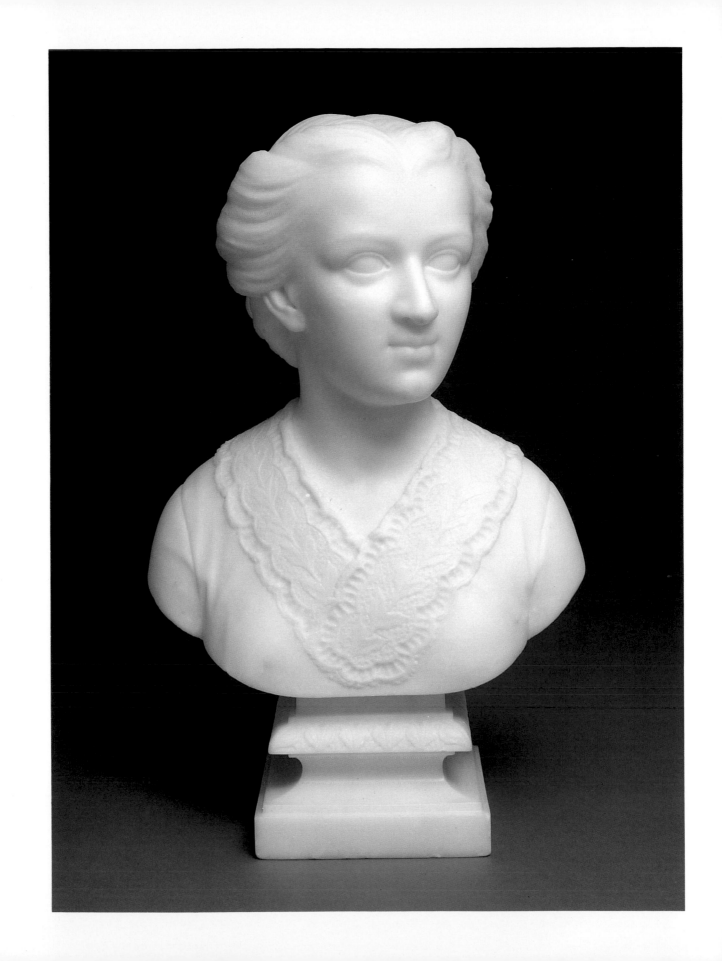

Let's Make A Record
SISTER GERTRUDE MORGAN

SIDE ONE
1. Let Us Make A Record
2. Way In The Middle of The Air
3. I Got The New World In My View
4. If You Live Like Jesus Told
5. He Wrote The Revelation
6. Take The Lord Along With You
7. The Gift of God Is Eternal Life

SIDE TWO
1. Power
2. I was Heard From The Wound In His Side
3. Take My Hand, Lead Me On
4. I Am The Living Bread
5. New Jerusalem
6. Gods Word Will Never Pass Away
7. Power

Recorded Live In The Prayer Room New Orleans, La.

Recorded by Ivan Sharrock
Produced by E. Borenstein
511 Royal Street, New Orleans, La.

Jesus the lord is salvation a deliverence from evil Exod 14:13. come on in my Room—come on in the Prayer lord Jesus come on in my Room. Rom 6:10

HOLY BIBLE BOOK DIVINE PRECIOUS TREASURE THOU ART MINE.

STEREO LB1

True Believer Records

Sister Gertrude morgan, Everlasting Gospel Prayer

SISTER GERTRUDE MORGAN

——— 1900–1980 ———

I guess my paintings spread the word; they represent something. They get me a living, of course, and help out the mission here. . . . I am a missionary of Christ before I'm an artist. Give all the fame to some other artist. I work for the Lord. Now don't forget to give Him credit.

A former street preacher who became an artist, poet, and musician, Gertrude Morgan painted biblical themes to illustrate her gospel teachings. Born on April 7, 1900, in Lafayette, Alabama, Morgan moved to New Orleans during the late 1930s following a separation from her "earthly" husband. In New Orleans she became affiliated with the "Holiness and Sanctified" denomination, a loosely organized religious group that praised God through music and dancing. Morgan adopted the title "Sister" during the early 1940s when she became associated with two other street missionaries, Mother Margaret Parker and Sister Cora Williams. As a result of contributions and offerings from their combined street preaching, the three women purchased land, built a chapel, and opened a child-care center in the Gentilly section of New Orleans. For more than twelve years they furnished food and shelter to orphans, runaways, and children of working mothers. The center was destroyed by a hurricane in 1965. After the center closed, Morgan moved to St. Bernard Parish and became the nurse-companion of an elderly woman who owned the tiny house that later became Morgan's "Everlasting Gospel Mission."

In 1965 Morgan had a vision of the Holy Ghost that revealed she was the chosen bride of God. After that, Morgan wore only white to symbolize her spiritual marriage—a crisp nurse's uniform, nurse's oxfords, white stockings, and a small peaked cap perched on her mixed gray hair.

Sister Gertrude Morgan worked with any available materials at hand when the "spirit" moved her—cardboard, window shades, styrofoam trays, plastic utensils, jelly glasses, blocks of wood, lamp shades, picture frames, her guitar case, and even the back of a "For Sale" sign placed in her yard by a real estate agent.

Let's Make a Record, ca. 1978, tempera, acrylic and pencil on paperboard album cover with long-playing record, 12 3/8 x 12 1/2 in. and 11 7/8 in. (diam.)

Jesus Is My Airplane, ca. 1970, tempera, ball-point pen and ink, and pencil on paper, 18 x 26 3/8 in.

us ned straight

Kingdom of God. a close (hebrew. 12:7.8

God. 3D chap pung since nt Kingdom study of all the passage, Relating to the kingdom
tin the Kingdom of God will shew that it is Regarded Both as
thats all Right, a present possession and as a future inherita-
nce

Psalm 22:28,
Psalm 45.6

Psalm 45.11

Isa 24:23

Come in my Room, Come on in the Prayer Room, ca. 1970, tempera, acrylic, ball-point pen, and pencil on paperboard, 12 1/8 x 23 in. (irregular)

She freely intermingled acrylics, poster paint, watercolors, wax crayons, and ball-point pen. An integral part of her composition, Morgan's calligraphy was used to convey important messages or to denote specific scriptures that she illustrated. Though as a child she drew designs on the ground with sticks, and later drew pencil designs and painted on paper, she did not begin to paint seriously until 1956.

The majority of Morgan's paintings are religious. She painted scores of self-portraits, depicting her before and after her mystical marriage, wearing black and white, respectively. God is always depicted as white in Sister Gertrude's paintings, and she is represented as an African American. Morgan always signed but never dated her works, and used the designations "Jesus" and "God" interchangeably in her paintings. Her prodigious output may be divided into early, middle, and late periods as dictated by style, medium, and content.

After 1970 Morgan painted scenes almost exclusively inspired by the Book of Revelation, which deals with the Second Coming of Christ. Her favorite theme depicts the New Jerusalem as described in Revelation: "And, I, John, saw the holy city, New Jerusalem, coming down from God out of heaven, prepared as a bride adorned for her husband." Morgan's "New Jerusalem" paintings invariably include a large multistory building shown in cross section to reveal empty chambers, Christ preparing for His marriage to Sister Gertrude, the wedding ceremony, and finally the bridal couple relaxing on a terrace. Morgan also completed a group of large friezelike, narrative paintings that she called "charters" and illustrated with consecutive chapters from the Book of Revelation.

Sister Gertrude also created a group of hand-made, painted fans that she gave to friends and handed out during sessions in her all-white Prayer Room. The fans were made of oblong strips of cardboard, stitched together and painted on both sides. Visitors to Sister Gertrude's tiny mission were ushered into her

Prayer Room where she alternately preached and sang her prayer songs.

Gertrude Morgan's paintings and painted objects express her vivid imagination, innate sense of color and composition, and fervent religiosity. Like many self-taught artists, whether white or black, Sister Gertrude Morgan's fundamentalist and pentecostal beliefs were central to her art. During the summer of 1980 Sister Gertrude died peacefully in her sleep. She left no known survivors.

JESUS IS MY AIRPLANE

One of Sister Gertrude Morgan's favorite subjects was an open airplane in which she and Jesus are flying as wife and husband. In *Jesus Is My Airplane*, Morgan and Jesus look down on mankind and warn of the wages of sin. In this delightful version, the airplane (with Jesus as the pilot) appears to have departed from a distant, multistoried temple in heaven and is surrounded by angels and attendants. Sister Gertrude Morgan is seen standing between Jesus and God.

The airplane hovers like a giant bird above a city. The celestial and the terrestrial realms are clearly divided, and one of Morgan's original poems appears like skywriting from the airplane:

> *Jesus is my air*
> *Plane, you hold*
> *the world in your hand, you*
> *Guide me through the land*
> *Jesus is my air Plane I*
> *say Jesus is my air*
> *Plane We're striving for*
> *that Promise land. Come*
> *on, Join our Band let's make*
> *it in that Kingdom land.*

The anecdotal composition is well balanced, despite the absence of perspective, and the calligraphic messages are harmoniously integrated into the overall design. Motivated by her intensely personal religious beliefs, this painting reveals her desire to create visual aids for her missionary teachings.

Morgan frequently portrayed the all-white Prayer Room in her tiny Everlasting Gospel Mission. Only her cloth-covered table, a piano, and a few chairs furnished this starkly bare room. In *Come in My Prayer Room, Come on in the Prayer Room*, a cross section of her inner sanctum, Morgan is seated at her table; nearby are her piano and several of her favorite paintings, *New Jerusalem* and *The Eye of God*. An exterior and an interior door lead to Morgan's sanctuary, and in a metaphorical comparison, Christ knocks on yet another door, providing a dual invitation into God's holy kingdom.

"Sister Gertrude," *The New Orleans States-Item*, 1 Sept. 1973.

KEITH MORRISON

———— born 1942 ————

I wrestle with ideological tensions between African and European values in my work (as I do as a person). I have resigned myself to this continual ideological conflict in myself, because I believe that it reflects an issue which is preliminary to the amalgamation of cultures which will bring about a true world culture of ideas in the Twenty First Century.

As a child, Keith Morrison drew and painted constantly and dreamed of becoming an artist. Born in Jamaica, Morrison was profoundly influenced by African and Caribbean cultures—influences that were later manifested in his art.

Before graduating from high school in Jamaica, Morrison applied to a number of art schools in Great Britain and the United States. Although he initially wanted to study in Italy, his family wanted him to study in England. A compromise was reached, and Morrison came to the United States. He enrolled in the School of The Art Institute of Chicago where he studied between 1959 and 1965, and earned both bachelor's and master's degrees in art.

After receiving his master's degree, Morrison taught in the public schools of Gary, Indiana. Two years later, Morrison began his career as a university professor, and since that time has taught at Fisk University, DePaul University, the University of Illinois, the University of Chicago, the University of Maryland, Maryland Institute, College of Art, and the University of Michigan, Ann Arbor. Since 1988, he has served as chairman of the art department at the University of Maryland.

While at the Art Institute's school, Morrison received a thorough background in abstract expressionism, and was probably most influenced by the hard-edged abstract paintings of Ellsworth Kelly. Shortly thereafter, Morrison produced his first series of paintings—large, black-and-white, hard-edged abstractions. Although these works were well received and highly acclaimed, they did not satisfy his inner longing to create paintings that more specifically reflected the rich and colorful culture of his homeland. In general, Morrison's black-and-white canvases were generally conventional abstract expressionist works. To the artist,

Zombie Jamboree, 1988, oil
on canvas, 62 x 69 1/8 in.

however, they were works of black pride, and an identification with the struggles of African Americans during the civil rights movement of the 1960s. Although Morrison grew up in comfortable middle class circumstances in Jamaica and did not come to the United States until he was seventeen, he experienced racial and professional discrimination following his arrival in this country.

Around 1975, Morrison abandoned his abstract expressionist style and began to create figural paintings treating African and Caribbean themes. He did not exhibit any of these paintings until the early 1980s. Since that time, Morrison has produced primarily figural works featuring themes that deal with his dual cultural background. His subjects depict lush tropical foliage and colors, and real and imaginary animals and masked dancers. These symbolic paintings vibrate with energy and are haunting in their enigmatic imagery. His subjects are drawn from stories he heard as a child, and the superstitions and voodoo ceremonies of his native environment. Other paintings are celebratory, and reminiscent of the Afro-Caribbean festivals so prominent in that culture. In these works themes of life, death, and rebirth abound.

In addition to his painting and teaching activities, Morrison is a printmaker, writer, critic, and curator. He has organized a number of important exhibitions, and is the author of the well-known exhibition catalogue, *Art in Washington and its Afro-American Presence: 1940–1970.*

ZOMBIE JAMBOREE

This painting was inspired by stories about voodoo ceremonies that Morrison heard as a child in Jamaica. In the center, three large animals, which appear to be communicating with each other, are seated in front of a pond at dusk. Though the painting's colors are vibrant, its scene is eerie and symbols of death abound. Small crosses mark graves, a mummified form rises apparitionally above the pond, and a spotted serpent hovers above. A transparent figure of a man is discernible in the pond, which is filled with dismembered parts of animals and people.

Morrison has always been fascinated by ponds at dusk, from which evil spirits emerge according to legend. In *Zombie Jamboree*, the figure wearing white was based in part on *Hamlet*'s tragic heroine Ophelia, and in part by that powerful evocation of nature, Igor Stravinsky's *Rite of Spring*. The image of ghosts dancing across a pond in Benjamin Britten's opera, *The Turn of the Screw*, also influenced this painting, Morrison has said. The enigmatic floating figure recalls an event from the artist's childhood. An adult friend of the Morrison family was drowned—or committed suicide—in a pond at dusk, and this event has left an indelible imprint on the artist. In addition, the rising mummified figure is symbolic of death and resurrection, and is an image that appears in several of his works of the same period.

Zombie Jamboree, detail

Morrison's African heritage can be seen in the upper section of the painting in which small dancing figures wearing African masks are joined by a skeletal form. These figures reinforce the voodoo themes of the work, which celebrate both the agony of death and the joy of resurrection.

Alternative Museum, *Keith Morrison: Recent Painting* (New York: Athens Printing Company, 1990), 3.

JAMES A. PORTER

1905–1971

You can't help painting when you're in Africa—the skies, the red earth, the verdure and the dress of the people—all of them reinforce one's feeling for color.

James A. Porter, born in Baltimore in 1905, was the first African-American art historian. His 1943 book, *Modern Negro Art*, was the earliest comprehensive treatment of African-American art and remains a classic in its field. He attended public schools in the District of Columbia and later graduated from Howard University in 1927. He became an art instructor at the university and chairman of its art department, a position he retained until his death. Porter attended graduate school at Columbia University and the Art Students League in New York

where he studied with the painter Dimitri Romanowsky. During the summer of 1935 Porter used a fellowship from the Institute of International Education to study medieval archaeology at the Institut d'Art et d'Archéologie at the Sorbonne in Paris. After completing his studies in Paris, Porter received a stipend from the Rockefeller Foundation for extensive travel in Belgium, Holland, Germany, and Italy. Porter stated that the purpose of his trip was "To make a first-hand study of certain collections of African Negro arts and crafts housed in important museums of ethnography. . . ."

On a leave of absence from Howard University, during the school year 1945 and 1946, Porter again received financial support from the Rockefeller Foundation to visit cultural facilities in Cuba and Haiti. In 1955 he was appointed a fellow of the Belgium-American Art Seminar, and pursued further studies in the history of Flemish and Dutch art of the sixteenth, seventeenth, and eighteenth centuries while in Belgium. Porter's final educational trip abroad—to West Africa in 1963—was sponsored by a grant from the *Evening Star*, a Washington, D.C., newspaper. There he conducted research for a book on West African architecture, and completed a series of twenty-five paintings dealing with West

Colonial Soldier, detail

African themes. These paintings were exhibited in the Gallery of Art at Howard University following his return.

Primarily an educator and writer, Porter was also an artist and completed a number of important drawings and paintings. Charcoal drawings from an early sketchbook reveal that he was a sensitive draftsman. It was in the areas of portrait painting, figure studies, and still lifes, however, that he excelled; his most successful works were oil portraits of family and friends. He also completed a group of paintings depicting scenes and local residents during his trips to Haiti and Cuba.

In 1966 Porter was honored by President Lyndon B. Johnson on the twenty-fifth anniversary of the founding of the National Gallery of Art as "one of America's most outstanding men of the arts." James Porter, remembered for his significant role in establishing the art department and gallery at Howard University, his pioneering research, and writings in the field of African-American art history, served most importantly as a teacher and mentor to generations of students.

Porter's works were shown frequently in group exhibitions throughout his career. In 1940 he was represented in the American Negro Exposition in Chicago, and in 1948 the Barnett-Aden Gallery in Washington, D.C., mounted a one-man exhibition of his works.

COLONIAL SOLDIER

This bust-length portrait of a soldier was probably painted from studies Porter made while in Paris during the 1930s. Senegalese soldiers, for example, frequently visited the homes of Porter's Parisian friends and provided Porter with an opportunity for sketching. This portrait is an effective assimilation of compositional types and the techniques of old and modern masters, combined with Porter's keen observation and perceptive character analysis.

The sitter's broad figure occupies the majority of the picture plane; his head is tilted slightly, and he gazes pensively past the observer to the left. The solid khaki-colored jacket and tall red hat of his uniform are a dramatic contrast to the stippled red plaid background. Executed in broad patches of color, this painting is evidence of Porter's familiarity with Fauvism and expressionism. His forms modeled with color, the soldier is rendered in bold three-dimensionality.

"Painter's Reaction: Africa—A Vivid Continent," *The Evening Star*, 22 Jan. 1965.

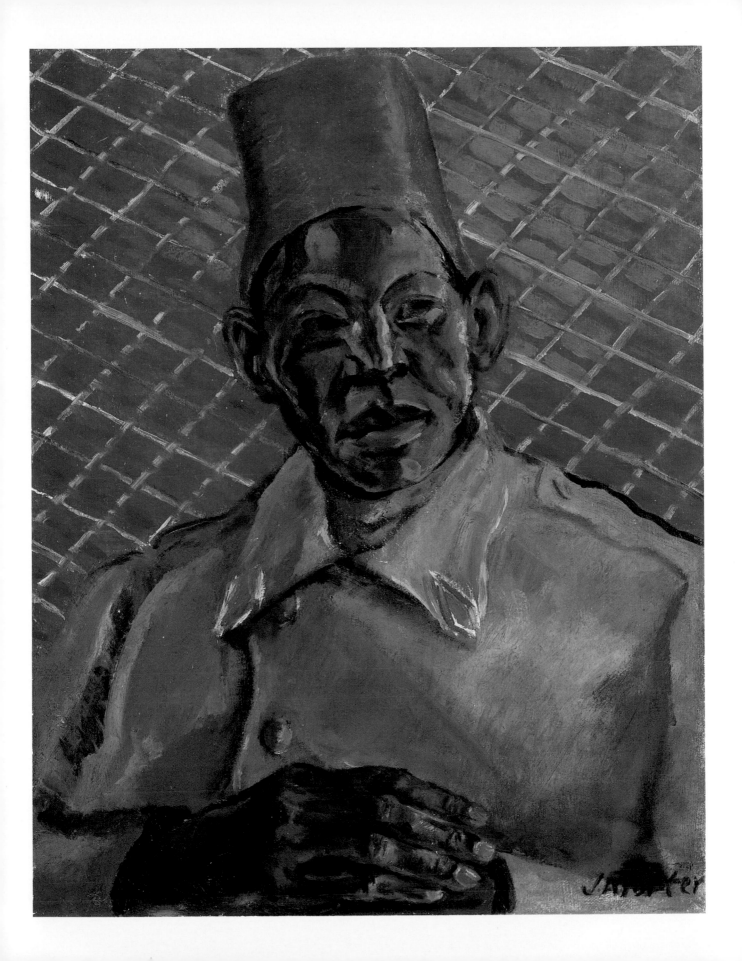

AUGUSTA SAVAGE

1892–1962

I have created nothing really beautiful, really lasting, but if I can inspire one of these young-sters to develop the talent I know they possess, then my monument will be in their work.

The career of Augusta Savage was fostered by the climate of the Harlem Renaissance. During the 1930s, she was well known in Harlem as a sculptor, art teacher, and community art program director. Born Augusta Christine Fells in Green Cove Springs, Florida, on February 29, 1892, she was the seventh of fourteen children of Cornelia and Edward Fells. Her father was a poor Methodist minister who strongly opposed his daughter's early interest in art. "My father licked me four or five times a week," Savage once recalled, "and almost whipped all the art out of me."

In 1907 Savage married John T. Moore, and the following year her only child, Irene, was born. Moore died several years after the birth of their daughter. Around 1915 the widowed artist married James Savage, a carpenter whose surname she retained after their divorce during the early 1920s. In 1923, Savage married Robert L. Poston, her third and final husband, who was an associate of Marcus Garvey. Poston died in 1924.

Savage's father moved his family from Green Cove Springs to West Palm Beach, Florida, in 1915. Lack of encouragement from her family and the scarcity of local clay meant that Savage did not sculpt for almost four years. In 1919 a local potter gave her some clay from which she modeled a group of figures that she entered in the West Palm Beach County Fair. The figures were awarded a special prize and a ribbon of honor. Encouraged by her success, Savage moved to Jacksonville, Florida, where she hoped to support herself by sculpting portrait busts of prominent blacks in the community. When that patronage did not materialize, Savage left her daughter in the care of her parents and moved to New York City.

Gamin, ca. 1930, painted plaster, 9 x 5 5/8 x 4 1/4 in.

Savage arrived in New York with $4.60, found a job as an apartment caretaker, and enrolled at the Cooper Union School of Art where she completed the four-year course in three years. During the mid-1920s when the Harlem Renaissance was at its peak, Savage lived and worked in a small studio apartment where she earned a reputation as a portrait sculptor, completing busts of prominent personalities such as W. E. B. Du Bois and Marcus Garvey. Savage was one of the first artists who consistently dealt with black physiognomy. Her best-known work of the 1920s was *Gamin*, an informal bust portrait of her nephew, for which she was awarded a Julius Rosenwald Fellowship to study in Paris in 1929. There she studied briefly with Felix Benneteau at the Académie de la Grand Chaumière. She had two works accepted for the Salon d'Automne and exhibited at the Grand Palais in Paris. In 1931 Savage won a second Rosenwald fellowship, which permitted her to remain in Paris for an additional year. She also received a Carnegie Foundation grant for eight months of travel in France, Belgium, and Germany.

Following her return to New York in 1932, Savage established the Savage Studio of Arts and Crafts and became an influential teacher in Harlem. In 1934 she became the first African-American member of the National Association of Women Painters and Sculptors. In 1937 Savage's career took a pivotal turn. She was appointed the first director of the Harlem Community Art Center and was commissioned by the New York World's Fair of 1939 to create a sculpture symbolizing the musical contributions of African Americans. Negro spirituals and hymns were the forms Savage decided to symbolize in *The Harp*. Inspired by the lyrics of James Weldon Johnson's poem *Lift Every Voice and Sing*, *The Harp* was Savage's largest work and her last major commission. She took a leave of absence from her position at the Harlem Community Art Center and spent almost two years completing the sixteen-foot sculpture. Cast in plaster and finished to resemble black basalt, *The Harp* was exhibited in the court of the Contemporary Arts building where it received much acclaim. The sculpture depicted a group of twelve stylized black singers in graduated heights that symbolized the strings of the harp. The sounding board was formed by the hand and arm of God, and a kneeling man holding music represented the foot pedal. No funds were available to cast *The Harp*, nor were there any facilities to store it. After the fair closed it was demolished as was all the art.

Upon returning to the Harlem Community Art Center, Savage discovered that her position had been assumed by someone else. This initiated a series of frustrations that virtually forced Savage to end her career. The Harlem Community Art Center closed during World War II when federal funds were cut off. In 1939 Savage made an attempt to reestablish an art center in Harlem with the opening of the Salon of Contemporary Negro Art. She was founder-director of the small gallery that was the first of its kind in Harlem. That venture closed shortly after its opening due to lack of money. During the spring of 1939, Savage

held a small, one-woman show at the Argent Galleries in New York.

Depressed by the loss of her job and the collapse of both of her attempts to establish art centers, Savage retreated to the small town of Saugerties, New York, in the Catskill Mountains in 1945 and reestablished relations with her daughter and her daughter's family. Although her artistic production decreased, she found peace and seclusion in Saugerties. Savage visited New York occasionally, taught children in local summer camps, and produced a few portrait sculptures of tourists. During her years in Saugerties, Savage also explored her interest in writing children's stories, murder mysteries, and vignettes, although none were published. In 1962 Savage moved back to New York and lived with her daughter. She died in relative obscurity on March 26, 1962, following a long bout with cancer.

GAMIN

This small sculpture is one of several surviving plaster versions of Savage's life-size bronze bust *Gamin* of 1929. "Gamin" is a term that was applied to street urchins who were often the subjects of paintings and literature in the nineteenth century. Here, the casually attired, street-wise boy about twelve years old is reputedly the sculptor's nephew, Ellis Ford, who lived in Harlem. Although *Gamin* represents a specific individual, the subject convincingly fits the profile of hundreds of preadolescent urban ghetto youths during rebellious and frequently uncomfortable stages in their lives. Girl-shy and uncertain of the rites of passage into young manhood, this young resident of Harlem, nevertheless, appears ready and willing to face the future.

Savage effectively captured the essence of her subject's personality in this diminutive bust. Wearing a "be-bop" cap with its wide brim cocked jauntily to the side, the figure tilts his head in the same direction and looks past the observer with a slightly sullen expression of typical boyhood defiance. The sculpture was modeled in clay, cast in plaster, and painted to resemble the award-winning version. Savage's facility in handling the clay medium is clearly demonstrated in her sensitive modeling of the boy's broad features, deeply set eyes, and prominent ears. In addition, the open collar of his wrinkled shirt and crumpled cap contribute to the sculpture's informality and immediate appeal.

T. R. Poston, "Augusta Savage," *Metropolitan Magazine*, Jan. 1935, n.p.

HENRY OSSAWA TANNER
1859–1937

My effort has been to not only put the Biblical incident in the original setting . . . but at the same time give the human touch "which makes the whole world kin" and which ever remains the same.

The most distinguished African-American artist of the nineteenth century, Henry Ossawa Tanner was also the first artist of his race to achieve international acclaim. Tanner was born on June 21, 1859, in Pittsburgh, Pennsylvania, to Benjamin Tucker and Sarah Miller Tanner. Tanner's father was a college-educated teacher and minister who later became a bishop in the African Methodist Episcopalian Church. Sarah Tanner was a former slave whose mother had sent her

north to Pittsburgh through the Underground Railroad. Tanner's family moved frequently during his early years when his father was assigned to various churches and schools. In 1864 Tanner's family settled in Philadelphia where his early artistic interests were developed. At age thirteen, Tanner decided to become an artist when he saw a painter at work during a walk in Fairmount Park near his home. Throughout his teens, Tanner painted and drew constantly in his spare time and tried to look at art as much as possible in Philadelphia art galleries. He also studied briefly with two of the city's minor painters.

Eager to discourage his son's interest in art, Bishop Tanner apprenticed him to a friend to learn the milling business. For Tanner, a frail young man whose health was never strong throughout his life, the work in the flour mill proved too strenuous and he became seriously ill. His parents encouraged his painting during his recuperation, and Tanner lived at home during the next few years except for several trips to the Adirondack Mountains and Florida for his health. In 1880, when Tanner was twenty-one, he enrolled in the prestigious Pennsylvania Academy of the Fine Arts. There he studied with a group of master professors including Thomas Eakins. It was Eakins who exerted the greatest influence on Tanner's early style. Tanner left the Pennsylvania Academy prior to graduating to pursue the idea of combining business with art. In 1888 he

The Savior, ca. 1900–05, oil on wood, 29 1/8 x 21 7/8 in.

moved to Atlanta, Georgia, and established a modest photography gallery where he attempted to earn a semiartistic living by selling drawings, making photographs, and teaching art classes at Clark College. In spite of his combined efforts, Tanner's Atlanta venture barely profited enough to provide living expenses.

In Atlanta, Tanner met Bishop and Mrs. Joseph Crane Hartzell, who became his primary white patrons over the next several years. In the summer of 1888 Tanner sold his small gallery and moved to Highlands, North Carolina, in the Blue Ridge Mountains where he hoped to study and earn a living by his photography. He also felt that the mountains would be good for his delicate health. While there, Tanner may have made many sketches and photographs of the region and its African-American residents, some of which were later used as subjects in his most important early paintings.

In the fall of 1888, Tanner returned to Atlanta and taught drawing for two years at Clark College. After discussing his ambitions to travel abroad with Bishop and Mrs. Hartzell, they arranged an exhibition of Tanner's works in Cincinnati in the fall of 1890. When no paintings were sold, the Hartzells bought the entire collection. This endowment allowed Tanner to sail for Rome in January 1891. After brief stays in Liverpool and London, Tanner arrived in Paris. He was so impressed by this center of art and artists that he abandoned his plans to study in Rome.

In Paris, Tanner enrolled in the Académie Julian where the painters Jean Paul Laurens and Jean Joseph Benjamin-Constant were among his teachers. It was not long before he painted two of his most important works depicting African-American subjects, *The Banjo Lesson* of 1893 and *The Thankful Poor* of 1894. During the summers of 1892 and 1893, Tanner left Paris and lived in isolated rural areas in Brittany. His best-known paintings from that period are *The Bagpipe Lesson* of 1894 and *The Young Sabot Maker* of 1895. Both depict French peasants, and Tanner assimilated the inhabitants of his rural French environment into his works as he had done previously in the mountains of Highlands, North Carolina.

In 1895, Tanner painted *Daniel in the Lion's Den*, which won an honorable mention in the Paris Salon the same year. Two years later he completed *Resurrection of Lazarus*, which so impressed Rodman Wanamaker, a Philadelphia merchant in Paris, that he decided to finance the first of Tanner's several trips to the Holy Land. Before leaving, Tanner sent his *Resurrection of Lazarus* to the Paris Salon where it was awarded a third class medal and was purchased by the French government for exhibition at the Luxembourg Gallery and eventually entered the collection of the Louvre.

Spurred by his newly found acclaim, Tanner visited Philadelphia for several months in 1893. The visit, however, convinced him that he could not fight racial prejudice. Tanner returned to Paris and focused on painting religious subjects and landscapes. In 1899 Tanner married Jessie Olssen, a white opera singer from

Salome, ca. 1900, oil on canvas, 46 x 35 1/4 in.

San Francisco, whom he had met in Paris. The couple's only child, Jesse Ossawa, was born in New York in 1903. Their marriage may have influenced Tanner's decision to settle permanently in France, where the family divided its time between Paris and a farm near Étaples in Normandy.

During the final decades of Tanner's career he enjoyed consistent acclaim. In 1900, his 1895 painting, *Daniel in the Lion's Den*, was awarded a silver medal at the Universal Exposition in Paris; the following year it received a silver medal at the Pan American exhibition in Buffalo.

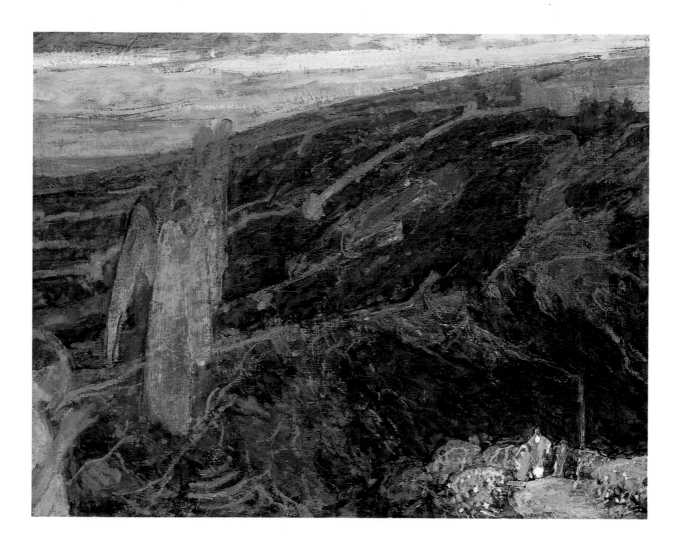

Angels Appearing Before the Shepherds, ca. 1910, oil on canvas, 25 5/8 x 32 in.

In 1908 his first one-man exhibition of religious paintings in the United States was held at the American Art Galleries in New York. Two years later, Tanner was elected a member of the National Academy of Design. In 1923 he was made an honorary chevalier of the Order of the Legion of Honor, France's highest honor, and in 1927 he became a full academician of the National Academy of Design, the first African American to receive that honor. In his later years, Tanner was a symbol of hope and inspiration for African-American leaders and young black artists, many of whom visited him in Paris. On May 25, 1937, Tanner died at his home in Paris.

MARY

After 1895 Tanner specialized in religious subjects, perhaps because of his religious upbringing and his own intense personal faith. Mary, the mother of Christ, appears frequently in Tanner's religious paintings, and probably repre-

Mary, ca. 1914,
oil on canvas, 40 x 36 in.

sented for Tanner a symbol of strength and courage. After experiencing the particular brutality of World War I living in France, he painted Mary as a solitary figure in contemplative poses several times. These paintings are basically devoid of narrative and depict the Virgin in melancholic moods.

This version was probably completed around 1914 since it was exhibited at the Salon des Artistes Françaises during the summer of 1914 and illustrated in *International Studio* in November of the same year. Mary is seated on a couch in a small space defined by a wall hanging, to the left behind the slotted backrest, and a broad barrel-vault ceiling in the shallow foreground space. Placed to the left of the painting, Mary gazes toward an unknown subject at the right.

The painting's predominant muted blues and mauves are the colors that characterize Tanner's late works. So too are the layers of thick impasto that render details in this painting indistinct. Tanner's loose brushwork and tonal palette were influenced respectively by French Symbolist and Impressionist painting.

Here, Tanner's dramatically handled light comes from two sources—the lamp that Mary holds on her lap and a vertical shaft of light at the left that comes from a doorway or corridor that is not visible. The model for Mary was probably Tanner's wife, Jessie Olssen, who frequently served as the model for female subjects in his religious paintings.

The apparent absence of the Christ Child, or even the suggestion of His presence by a halo, is unusual. The *International Studio* essay of November 1914 noted that Mary "is waiting, lamp in hand, ready to render service to her beloved Lord," suggesting that Tanner has chosen a meditative moment before the Annunciation. Mary is shown as pure and spiritual, yet unaware of her future role as the mother of Christ.

On the back of this painting is an unfinished oil sketch of two men and a woman; the subject matter is currently unknown. In the interest of economy, Tanner often worked on both sides of his canvases and on occasion even painted over earlier works. This sketch provides an excellent example of Tanner's academically instilled method of constructing figures and facial expressions.

Lynda Roscoe Hartigan, *Sharing Traditions: Five Black Artists in Nineteenth-Century America* (Washington D.C., published for National Museum of American Art by the Smithsonian Institution Press, 1985), 106.

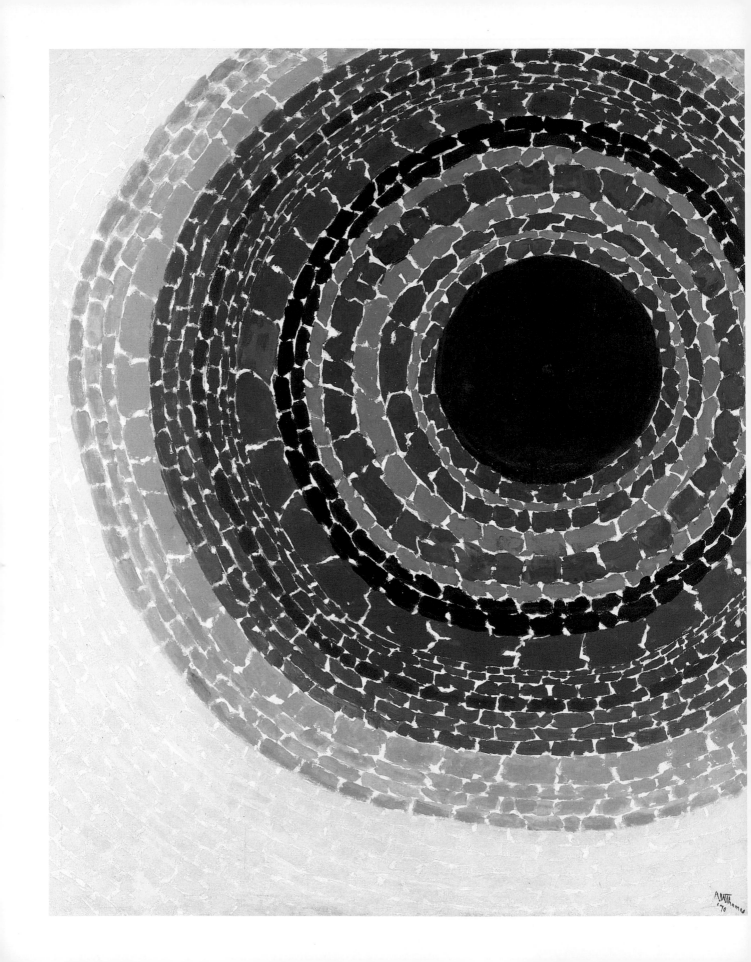

ALMA THOMAS

—— 1891–1978 ——

Man's highest aspirations come from nature. A world without color would seem dead. Color is life. Light is the mother of color. Light reveals to us the spirit and living soul of the world through colors.

A lma Thomas began to paint seriously in 1960, when she retired from her thirty-eight year career as an art teacher in the public schools of Washington, D.C. In the years that followed she would come to be regarded as a major painter of the Washington Color Field School.

Born on September 22, 1891, in Columbus, Georgia, Thomas was the eldest of four daughters. Her father worked in a church and her mother was a seamstress and homemaker. Thomas's family was well respected in Columbus, and she and her sisters grew up in comfortable surroundings. The family lived in a large Victorian house high on a hill overlooking the town where Thomas spent her childhood observing the beauty and color of nature. In 1907, when Thomas was fifteen years old, her father moved the family to Washington, D.C. She enrolled in Howard University, and in 1924 became the first graduate of its newly formed art department. Thomas's teacher and mentor, James V. Herring, granted her use of his private art library, from which she gained a thorough background in art history. A decade later, she earned a Master of Arts degree in education from Columbia University.

During the 1950s Thomas attended art classes at American University in Washington. She studied painting under Joe Summerford, Robert Gates, and Jacob Kainen, and developed an interest in color and abstract art. Throughout her teaching career she painted and exhibited academic still lifes and realistic paintings in group shows of African-American artists. Although her paintings were competent, they were never singled out for individual recognition.

Suffering from the pain of arthritis at the time of her retirement, she considered giving up painting. When Howard University offered to mount a retrospec-

The Eclipse, 1970, acrylic on canvas, 62 x 49 3/4 in.

Arboretum Presents White Dogwood, 1972, acrylic on canvas, 68 x 55 in.

tive of her work in 1966, however, she wanted to produce something new. From the window of her house she enjoyed watching the ever-changing patterns that light created on her trees and flower garden. So inspired, her new paintings passed through an expressionist period, followed by an abstract one, to finally a nonobjective phase. Many of Thomas's late-career paintings were watercolors in which bold splashes of color and large areas of white paper combine to create remarkably fresh effects, often accented with brush strokes of India ink.

Although Thomas progressed to painting in acrylics on large canvases, she continued to produce many watercolors that were studies for her paintings. Thomas's personalized mature style consisted of broad, mosaic-like patches of

Elysian Fields, 1973, acrylic
on canvas, 30 1/8 x 42 1/8 in.

vibrant color applied in concentric circles or vertical stripes. Color was the basis
of her painting, undeniably reflecting her life-long study of color theory as well
as the influence of luminous, elegant abstract works by Washington-based
Color Field painters such as Morris Louis, Kenneth Noland, and Gene Davis.

Thomas was in her eighth decade of life when she produced her most
important works. Earliest to win acclaim was her series of "Earth" paintings—
pure color abstractions of concentric circles that often suggest target paintings
and stripes. Done in the late 1960s, these works bear references to rows and
borders of flowers inspired by Washington's famed azaleas and cherry blossoms.
The titles of her paintings often reflect this influence. In these canvases, brilliant
shades of green, pale and deep blue, violet, deep red, light red, orange, and yellow
are offset by white areas of untouched raw canvas, suggesting jewel-like Byzan-
tine mosaics.

Man's landing on the moon in 1969 exerted a profound influence on Thomas,
and provided the theme for her second major group of paintings. In 1969 she
began the "Space" or "Snoopy" series so named because "Snoopy" was a term
astronauts used to describe a space vehicle used on the moon's surface. Like the

"Earth" series these paintings also evoke mood through color, yet several allude to more than a color reference. In *Snoopy Sees a Sunrise* of 1970, she placed a circular form within the mosaic patch of colors and accented it with curved bands of light colors. *Blast Off* depicts an elongated triangular arrangement of dark blue patches rising dramatically and evocatively against a background of pale pinks and oranges. The majority of Thomas's "Space" paintings are large sparkling works with implied movement achieved through floating patterns of broken colors against a white background.

In her last paintings, Thomas employed her characteristic short bars of color and impasto technique. The tones, however, became more subdued, and the formerly vertical and horizontal accents of Thomas's brush strokes became more diverse in movement, and included diagonals, diamond shapes, and asymmetrical surface patterns. During the artist's final years, the crippling effects of arthritis prevented her from painting as often as she wanted.

Alma Thomas never married, and lived in the same house her father bought in downtown Washington in 1907. The final years of her life brought awards and recognition. In 1972 she was honored with one-woman exhibitions at the Whitney Museum of American Art and at the Corcoran Gallery of Art; that same year one of her paintings was selected for the permanent collection of the Metropolitan Museum of Art in New York City. Before her death in 1978, Thomas had achieved national recognition as a major woman artist devoted to abstract painting.

RED SUNSET, OLD POND CONCERTO

This large, brilliantly colored painting is a splendid example of Thomas's "target and stripe" series. Arranged vertically on the surface, its bold irregularly shaped mosaic of reds shimmers. The painting is entirely nonrepresentational, yet Thomas has successfully evoked the mood of a hot sun setting over a pond on a summer day. Areas of raw white canvas as well as black background stripes and touches of gray provide a foil for the pulsating reds and accentuate the work's atmospheric effects.

The Eclipse of 1970 also conveys Thomas's ability to imply movement and form in an abstract work, inspired by natural phenomenon that she witnessed. Concentric circular patterns of yellow, gold, red, orange, purple, blue, and green are organized around a central blue vortex that represents the sun. The off-center compositional arrangement and the circle's arbitrarily cut off right edge create a design that appears ready to slide off the canvas at the very moment of the sun's total eclipse.

Press Release, Columbus Museum of Arts and Sciences, 1982, for an exhibition entitled *A Life in Art: Alma Thomas 1891–1978*, Vertical File, Library, National Museum of American Art, Smithsonian Institution, Washington, D.C.

BOB THOMPSON

1937–1966

I paint many paintings that tell me slowly that I have something inside of me that is just bursting, twisting, sticking, spilling over to get out. Out into souls and mouths and eyes that have never seen before. The Monsters are present now on my canvas as in my dreams...

Between 1958 and 1966, Bob Thompson was a talented, bohemian artist as well as one whose success in the New York art world was nothing short of phenomenal. Tragically, his life was cut short by his dissipated habits but more importantly, Bob Thompson produced an innovative body of metaphoric paintings at a time when both "classical" art historical sources and figurative styles were scorned.

Thompson's rather unremarkable early years were spent in Louisville, Kentucky, where he was born on June 26, 1937. Thompson's mother was a school teacher who instilled in her children the value of education.

When Thompson was thirteen his father was killed in an automobile accident. Young Robert became deeply depressed, and his mother sent him to Boston to live with his older sister and her husband. Thompson's mother wanted her son to become a doctor, and Thompson enrolled in a pre-med program at Boston University in 1955. He quickly, however, became bored with the program and his depression continued. Robert Holmes, his brother-in-law, remembered Thompson's childhood love of art and encouraged him to develop his talents as a means of alleviating his grief. Thompson returned home and in September 1956 enrolled as an art student at the University of Louisville. Soon he became involved with an intellectual art circle that held regular meetings and discussions.

During Thompson's junior year at the University of Louisville, one of his teachers, Mary N. Spencer, suggested that he would benefit from a summer in Provincetown, Massachusetts. There were two important art schools in the old fishing village of Provincetown—the Seong Moy Art School and an older, more

Descent from the Cross, 1963, oil on canvas, 84 x 60 1/8 in.

established institution under the direction of Hans Hofmann, the innovative
abstract expressionist painter. One of Hofmann's students at that time was the
young artist Jan Müller, who departed from Hofmann's aesthetic principles of
nonobjective painting in favor of a figurative style.

Provincetown was an exciting environment for Thompson, and he was
especially attracted to Müller's figural paintings and the works of Red Grooms,
from Nashville, Tennessee. Grooms was also involved in performances that were
later called "Happenings" and represented a new aesthetic concept. Thompson
was an active participant in many of Grooms' productions.

During the fall of 1958 Thompson returned to the University of Louisville and
developed a keen interest in Italian Renaissance painting. He began copying
works by Masaccio, Fra Angelico, and Piero della Francesca to develop his own
visual vocabulary. He would later reinvent these images in his own personalized
manner. Following his invigorating experiences in Provincetown, Thompson
realized that his environment in Louisville could never fulfill his artistic needs.
In the middle of the fall semester of his senior year Thompson moved to New
York.

Upon his arrival in New York, Thompson discovered that his Provincetown
cohorts, Christopher Lane, Red Grooms, and Jay Milder, had opened the City
Gallery. Thompson moved in with Milder, joined the City Gallery, and began
experimenting with the scientific perspective techniques of the Italian Renais-
sance. These experiments were subsequently transformed into contemporary
reinterpretations of biblical themes.

Thompson rose quickly among the ranks of New York artists. His first one-
man exhibition was held at the Delancey Street Museum, a space created by his
friend Red Grooms. Next was a two-man exhibition with Jay Milder at the
influential Zabriskie Gallery. In December 1960 Thompson married Carol
Penda, whom he had met in Provincetown, and he was seen frequently at
openings, night clubs, and other social gatherings.

In 1961 Thompson and his wife traveled to Europe and settled in Glacière,
France, with the help of a Walter Gutman Foundation grant. He was awarded
a John Hay Whitney grant in 1962 to continue his European work. In 1963
Thompson moved to Ibiza, Spain, and returned to New York late that year with
a large body of new paintings. An old friend, Lester Johnson, arranged a meeting
between Thompson and gallery owner Martha Jackson that resulted in a one-
man exhibition and invitation to join the stable of artists shown by Jackson's
gallery.

Representation by the influential Martha Jackson Gallery assured Thompson's
recognition in the art world. His paintings began appearing in exhibitions
around the country, and critics proclaimed the genius of the new, young,
African-American master of Renaissance themes with a contemporary focus.
Thompson's paintings were large, figurative, bright, raw, and unorthodox in

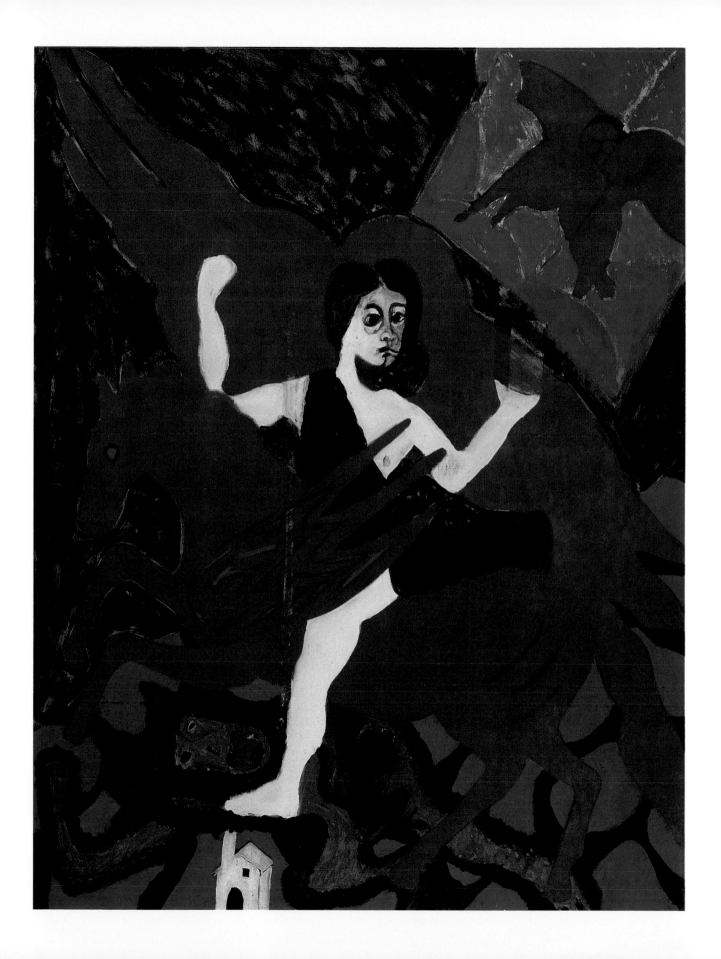

their use of color, with birds and other winged creatures appearing as ubiquitous symbols. Some of Thompson's paintings were autobiographical, and many reflect his longstanding interest in music.

By 1964, when he was only twenty-eight years old, Thompson had experienced unprecedented success for an African-American artist. He painted incessantly and lived extravagantly. He longed to return to Europe, specifically to Rome, to study Renaissance art. With proceeds from his exhibition at the Martha Jackson Gallery, Thompson financed a trip to Rome in November 1965. In March 1966, Thompson underwent emergency gall bladder surgery in Rome. His doctors suggested a long period of recuperation but Thompson resumed his hectic lifestyle almost immediately. On May 30, 1966, less than a month before his twenty-ninth birthday, he died in Rome of lung complications. During a remarkably short career Thompson produced more than one thousand paintings as testimony to his unfaltering albeit meteoric commitment to his art.

THE SPINNING, SPINNING, TURNING, DIRECTING

Inspired by Goya's *Los Caprichos*, Thompson reinterpreted the early nineteenth-century Spanish master's imagery in this painting, which at once suggests balance and imbalance, chaos and calm. Thompson's colors are flat, bright, raw, emotive, and recall Matisse and the Fauves. Each area of color is energetic and dependent upon the other for an overall harmony. In its sensual swirl of figures, forms, and color, the work evokes the atmosphere of a bacchanalia. A large, enigmatic green-and-orange standing figure strikes a pose not unlike that of an orchestra conductor. Other seated figures in the painting's foreground stabilize the upside down floating nude female. An enormous green winged creature hovers as a foil in the middle ground.

Descent from the Cross, painted the same year, is a contemporary representation of a traditional biblical event. Bright colors unexpectedly heighten the tragedy of the scene, and mourning angels are represented here as fantastic winged creatures conjured from Thompson's imagination.

Gylbert Coker, *The World of Bob Thompson*, (New York: The Studio Museum in Harlem, 1979), 21–22.

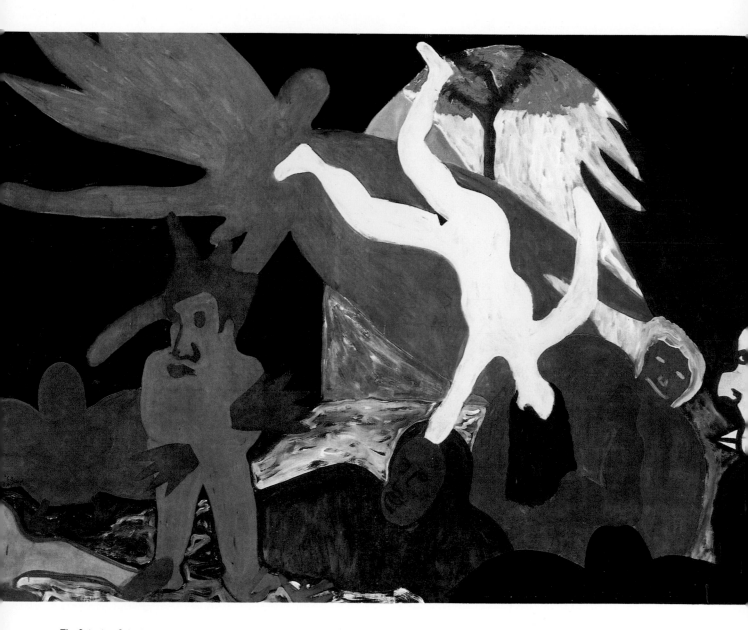

The Spinning, Spinning,
Turning, Directing, 1963, oil
on canvas, 62 7/8 x 82 7/8 in.

BILL TRAYLOR

——— 1854–1947 ———

. . . it jes' come to me.

When Bill Traylor was born in 1854 on the plantation of George Traylor near Benton, Alabama, the Emancipation Proclamation was still almost a decade away. He recalled little about his childhood during slavery, and he remained on the Traylor plantation until 1938, when he was eighty-four years old.

Traylor worked as a sharecropper for descendants of George Traylor for over eight decades, and during that period he raised some twenty children during his marriage. In 1938, after the death of Traylor's wife, he moved to Montgomery where he was employed briefly in a shoe factory until rheumatism and old age forced him to retire. Traylor's final years in Montgomery were almost entirely lacking in physical comforts. He had no fixed address, slept in the back room of a funeral parlor, and spent his days seated on downtown Montgomery's Monroe Street, where he was known by almost everyone.

In 1939, when he was eighty-five, Traylor's artistic impulses erupted suddenly and unexpectedly. More remarkable is the degree to which his style emerged fully developed and the even quality of his enormous output. Employing only pencils, a straight-edge, and a lap-sized drawing board, Traylor often began his works by applying a simple geometric form to any material at hand—paper, cardboard, or shirt cardboard. With crayons he then colored his simple geometric shapes, which became the basis of animals, human figures, and architectural structures. Animals are prominent among Traylor's forms, and include large red-tongued dogs, spotted cats, green goats, yellow birds, purple rabbits, and opossums. Other scenes depict dancers, drinkers, men driving mules, and women milking cows. Whether featuring single or multiple pictorial

Man on Crutch and Woman with Umbrella, ca. 1939–42, crayon and tempera on paperboard, 11 1/4 x 17 in.

elements, Traylor's compositions reflect the experiences of his childhood and adult life.

Shortly after Traylor began drawing, his works were noticed by a young Montgomery artist, Charles Shannon, who immediately recognized the elderly man's talents. The two men developed a friendship; Shannon began to collect his drawings and provided him with simple materials. Traylor was extremely prolific and drew constantly, almost obsessively, as if to compensate for his late beginning.

Traylor's artistic activities were interrupted in 1942 when he moved north to live with some of his children during World War II. He lived for a while in Detroit, Chicago, Philadelphia, and Washington, D.C., and, while he may have drawn during that period, no surviving works are known. In 1946 Traylor returned to Montgomery, but his desire and ability to draw had abated. About a year later Traylor became ill. He lived briefly with one of his daughters in Montgomery. He died in a nursing home in 1947.

Traylor's drawings reveal the memories and experiences of a man who enjoyed life's vigor and its humor in the face of hardship. Although Traylor had little awareness of himself as an artist, his drawings were exhibited twice during his lifetime. In 1940 they were shown at New South, an art center in Montgomery, and the following year at the Fieldston School in New York. It was not until almost forty years later that Traylor's works were exhibited publicly again at the Oosterom Gallery in New York.

Concerning the impact and mere survival of Traylor's drawings, the critic Allen Rankin wrote in 1946, "Will it live, this bizarre stuff which is primitive and Thurberish at the same time? Will it blow down the gutters of a little town when Bill is gone? Or will it have some little part of the permanence enjoyed by the rock-immortalized cave pictures which it resembles?" Rankin could not have imagined how prophetic his questions were, nor could he have foreseen the immortality of Traylor's drawings.

DANCING MAN, WOMAN, AND DOG

In this animated composition the simple rectangles, triangles, and trapezoids that form the nucleus of Traylor's figures are clearly discernible beneath the lightly painted surfaces. Suspended in flattened spatial zones, the figures sport electrified, manelike masses of hair that were probably meant to suggest tremendous energy. Although shown in profile, the woman's face sports two eyes seen full front. The shaded repetitions of the dog's wagging tail and female's right leg (which might be the result of erasures) are engaging suggestions of movement.

In *Man on Crutch and Woman with Umbrella* of 1939–42, both of the figures are shown in profile with full-front eyes. An observer of daily life, Traylor has composed a scene that suggests an animated confrontation between the irate umbrella-bearing woman and the one-legged man who leans on his crutch and

Dancing Man, Woman, and Dog,
1939–42, crayon and pencil on
paperboard, 22 x 14 in.

tosses up both arms in feigned innocence. Sometime between 1942 and 1946,
Traylor's left leg was amputated because of gangrene. Although this work and
others picturing men on crutches have previously been described as self-
portraits, Traylor drew these images prior to the amputation of his leg.

Allen Rankin, "He Lost 10,000 Years," *Collier's,* 22 June 1946, n.p.

Afro Emblems, 1950, oil on
linen, 18 x 22 in.

HALE WOODRUFF

———— 1900–1980 ————

It's very important to keep your artistic level at the highest possible range of development and yet make your work convey a telling quality in terms of what we are as people.

Born in Cairo, Illinois, Woodruff grew up in Nashville, Tennessee. In the early 1920s, he studied at the John Herron Art Institute in Indianapolis, where he lived for a number of years. He later studied at Harvard University, the School of The Art Institute of Chicago, and the Académie Moderne and Académie Scandinave in Paris. He spent the summer of 1938 studying mural painting with Diego Rivera in Mexico, an experience that greatly affected Woodruff's evolving style until the early 1940s.

Woodruff's earliest public recognition occurred in 1923 when one of his paintings was accepted in the annual Indiana artists' exhibition. In 1928 he entered a painting in the Harmon Foundation show and won an award of one hundred dollars. He bought a one-way ticket to Paris with the prize money, and managed to eke out four years of study with an additional donation from a patron.

In 1931, Woodruff returned to the United States and began teaching art at Atlanta University. It was Woodruff who was responsible for that department's frequent designation as the "École des Beaux Arts" of the black South in later years. As he excelled as chairman of the art department at Atlanta University, his reputation also grew as one of the most talented African-American artists of the Depression era.

Woodruff's figurative style of the 1930s was bold and muscular. Southern lynchings of blacks stirred his conscience deeply, and inspired him to design a series of block prints that were as impressive as his oils and watercolors. His best-known and most widely acclaimed works at this time were the *Amistad* murals he painted between 1939 and 1940 in the Savery Library at Talladega College in Alabama. These murals were commissioned in celebration of the one-hun-

dredth anniversary of the mutiny by African slaves aboard the slave ship *Amistad* in 1849, their subsequent trial in New Haven, Connecticut, and return to West Africa following acquittal.

The curvilinear rhythms of Woodruff's Mexican muralist-inspired works such as the *Amistad* murals were absent in his productions of the 1940s. His Georgian landscapes of the 1940s are simpler in concept and dominated by diagonal accents and bold contrasts in darks and lights. Whether in oil or watercolor, many of Woodruff's landscapes of the 1940s depict tarpaper shanties, community wells, and outhouses to the extent that he frequently referred to this group of landscapes as the "Outhouse School." These subjects were handled accurately and sensitively but without sentimentality.

During the 1940s Woodruff also completed a series of watercolors and block prints dealing with black themes related to the state of Georgia. In the September 21, 1942, issue of *Time*, Woodruff stated, "We are interested in expressing the South as a field, as a territory, its peculiar run-down landscape, its social and economic problems—the Negro people."

In 1946 Woodruff moved to New York where he taught in the art department at New York University from 1947 until his retirement in 1968. During the mid-1960s Woodruff and fellow artist Romare Bearden were instrumental in starting the "Spiral" organization, a collaboration of African-American artists working in New York. Woodruff's New York works were greatly influenced by abstract expressionism and the painters of the New York School who were active during the late 1940s and 1950s. Among his associates were Adolf Gottlieb, Mark Rothko, Franz Kline, and Jackson Pollock. Following a long and distinguished career that took him from Paris to New York via the Deep South, Woodruff died in New York in 1980.

GEORGIA LANDSCAPE

In addition to Woodruff's acclaimed "Outhouse School" works, he painted a number of landscapes inspired by scenes near his Atlanta home during the 1930s. Here, two groups of trees form parentheses around a large gnarled oak; serpentine limbs and leafy boughs are visually and psychologically related to its curvilinear neighbors. The twill-like brushstrokes echo the techniques of Cézanne while the swirling masses of color recall the emotionalism of Van Gogh's late landscapes. Woodruff undoubtedly became familiar with the works of these modern European masters during his Paris sojourn, yet this landscape has a decidedly original and American flavor. By the 1950s, works such as *Afro Emblems* establish the degree to which Woodruff had moved to a nonfigural style once he was exposed to abstract painting trends in New York. His emblematic forms temptingly suggest symbols based on African motifs.

Albert Murray et al., *Hale Woodruff: 50 Years of His Art* (New York: The Studio Museum in Harlem, 1979), 76.

Art Linkletter's Ranch near
Darwin Australia, June 2,
1966, crayon, pastel, and
ball-point pen on paper,
11 7/8 x 17 7/8 in.

JOSEPH E. YOAKUM

1886–1972

I tell you—There's few places I haven't been—of any size that is. And there's nothing I haven't suffered to see things first hand.

Although Joseph Yoakum gave vastly different accounts of his background, he was, throughout his life, classified as an African American. Sometimes Yoakum claimed that he was a full-blooded "Nava-joe" Indian, one of twelve or thirteen children born to a farmer on an Indian reservation in Window Rock, Arizona. At other times he insisted that he was of African-American descent. He described his mother as a strong woman who was a doctor and knowledgeable in the use of herbal medicines. Yoakum's family moved to Kansas City, Missouri, during his early childhood. His father was employed briefly in the railroad yards prior to settling permanently on a farm in nearby Walnut Grove in southwest Missouri. Although Yoakum said that his formal schooling consisted of only three or four months, the character of the notations on his drawings suggests greater exposure to formal training.

The early years of Yoakum's life were apparently nomadic. He claimed to have run away from home during his early teens to join a circus. He also claimed to have worked with Buffalo Bill before 1903, when he became the personal valet of John Ringling of the Ringling Brothers Circus. Between 1905 and 1910, Yoakum may have visited Europe, Russia, Mexico, the Middle East, China, Siberia, Canada, Central America, and South America. His first marriage occurred around 1910 and produced five children. He married again in 1929.

Yoakum served in the Unites States Army during World War I and was stationed at one time in France. The specific location and nature of his activities after his military discharge until his artistic career began in the early 1960s are uncertain. Yoakum said that he worked at a variety of jobs throughout the United States. In the early 1940s, he and his wife operated an ice cream parlor

Mt. Cortezo; in Hureto Provience near Mexico City Mexico., ca. 1960–70, crayon and ball-point pen on paper, 12 x 18 1/16 in.

on Chicago's South Side. By the late 1950s, however, Yoakum was widowed, retired, and living in a housing project for the elderly in Chicago. In 1966, Yoakum moved from the project to a storefront on the South Side. He lived there until he was hospitalized and placed in a nursing home in 1971; he died there the following year.

According to Yoakum, he was motivated to draw as the result of a dream around 1962. He described his process of working as a "spiritual enfoldment," meaning that his imagery was revealed as he worked. Yoakum's earliest drawings were done on small pieces of white or Manila paper with pen or pencil and little or no color. He graduated to larger pieces of paper and applied more color to his drawings as he drew with greater frequency.

Although Yoakum enjoyed doing celebrity-oriented portraits, the majority of his drawings are landscapes. In his hundreds of variations, real or imagined, mountains and water are the major themes. Between 1965 and 1970, Yoakum drew constantly and sometimes completed several pictures a day, often similar in theme, yet distinctly different in design. He kept an assortment of travel books, an atlas, and the *Encyclopedia Britannica* and took great pains to include inscriptions that name geographical details ranging from valleys to continents. Nonetheless, the scenes in Yoakum's landscapes are generally not identifiable. Yoakum usually signed and dated his landscapes in the upper left corner. Occasionally he used a rubber stamp to indicate the date—adding what he called a "touch of class." Yoakum's world was intensely private. His religious beliefs were rooted in the view that God and nature were the same thing. He expressed this belief in hundreds of drawings that are delicate, sensitive, and poetic—in contrast to the bold, if not brash, character of most contemporary folk art.

MT. CORTEZO; IN HURETO PROVIENCE NEAR MEXICO CITY MEXICO

Conveying mood and defining form, sinuous, rhythmic line is the most important element in Yoakum's drawings such as *Mt. Cortezo* and *Art Linkletter's Ranch near Darwin Australia*. Pastel colors, used as tints and highlights, enrich the evocative atmosphere of each drawing, in part because his choice and combination of colors often do not correspond to those of Nature.

Christine Ramberg, diary excerpts, 29 May 1969, Whitney Halstead Papers: 2 (Archives of American Art, Smithsonian Institution, Washington, D.C.)

BIBLIOGRAPHY

Identifying the parameters and emphases of a select bibliography is always a challenge. This is especially true when the scholarly activities and public awareness of a field undergo exponential growth, as has been the case with African-American art and its parent, African-American culture, during the past ten years. This publication was conceived with several audiences in mind—the general public, educators from the primary to college levels, and a community of scholars and collectors. While the bibliography emphasizes publications devoted to African-American art, it also includes complementary resources on African-American culture and history. Factors such as ready availability, diversity of subject, period, and interpretation, and relevance to the museum's permanent collection have all played a part. A cross section of public archival resources establishes their widespread geographical distribution. Sources pertaining to individual artists relate only to those artists whose works are discussed in this publication. The intentionally brief selection of periodicals targets patterns of public and professional awareness and serial publications that have regularly featured information pertinent to this field. I would like to thank Maricia Battle, Spencer Crew, Regenia A. Perry, and Richard J. Powell for their careful review of the bibliography and NMAA curatorial staff members Lara Scott and Susan Haase for their industrious assistance.

Lynda Roscoe Hartigan
Associate Curator
National Museum of American Art

ARCHIVAL RESOURCES

Afro-American Studies Collection, Firestone Library, Princeton University, Princeton, New Jersey

Amistad Research Center, Tulane University, New Orleans, Louisiana

Archives of American Art, Smithsonian Institution, Washington, D.C., with regional offices in Boston, Detroit, Los Angeles, and New York

Beulah Davis Room, Soper Library, Morgan State University, Baltimore, Maryland

Black Studies Division, Martin Luther King Memorial Library, District of Columbia Public Library, Washington, D.C.

Evans-Tibbs Collection, Washington, D.C.

George C. Hall Branch, Chicago Public Library, Chicago, Illinois

George Foster Peabody Collection and the Hampton University Archives, Gills P. Huntington Memorial Library; and Hampton University Museum, Hampton University, Hampton, Virginia

H. T. Sampson Library, Jackson State University, Jackson, Mississippi

Harmon Foundation Papers, Manuscript Division, Library of Congress, Washington, D.C.

Hatch-Billops Collection, Inc., New York, New York

James Weldon Johnson Collection, Beinecke Rare Book and Manuscript Library, Yale University, New Haven, Connecticut

Julius Rosenwald Fund Archives, the Negro Collection, Archives Collection, and Black Oral History Collection, University Library; and Fisk University Museum of Art, Fisk University, Nashville, Tennessee

Langston Hughes Memorial Library, Lincoln University, Lincoln University, Pennsylvania

Library, The Museum of African American Art, Los Angeles, California

Moorland-Spingarn Research Center, Founder's Library, Howard University, Washington, D.C.

National Archives, Washington, D.C.

National Museum of American Art, Curatorial Division and Library, Smithsonian Institution, Washington, D.C.

Research Library, California Afro-American Museum, Los Angeles, California

Robert W. Woodruff Library, Atlanta University Center, Inc., Atlanta, Georgia

Schomburg Center for Research in Black Culture, New York Public Library, New York, New York

Texas Black History and Texas Black Women's Archives, Museum of African-American Life and Culture, Dallas, Texas

The Washington Collection and Archives, Dr. Hollis Burke Frissell Library, Tuskegee University, Tuskegee, Alabama

The W. E. B. Du Bois Institute for Afro-American Research, Harvard University, Cambridge, Massachusetts

Whitney Halstead Papers, Department of Prints and Drawings, The Art Institute of Chicago, Chicago, Illinois

BOOKS

Anderson, Jarvis. *This Was Harlem.* New York: Farrar Straus Giroux, 1982.

Baker, Houston A., Jr. *Modernism and the Harlem Renaissance.* Chicago and London: The University of Chicago Press, 1987.

Bastin, Bruce. *Red River Blues: The Blues Tradition in the Southeast.* Urbana: University of Illinois Press, 1986.

Bearden, Romare, and Harry Henderson. *Six Black Masters of American Art.* New York: Zenith Books, Doubleday and Company, 1972.

Berry, Mary Frances, and John Blassingame. *Long Memory: The Black Experience in America.* New York: Oxford University Press, 1982.

Biggers, John Thomas. *Ananse, the Web of Life in Africa.* Austin: University of Texas Press, 1962.

Biggers, John Thomas, Carroll Simms, and John Edward Weems. *Black Art in Houston: The Texas Southern University Experience.* College Station and London: Texas A & M Press, 1978.

Boime, Albert. *The Art of Exclusion: Representing Blacks in the Nineteenth-Century.* Washington, D.C.: Smithsonian Institution Press, 1990.

Branch, Taylor. *Parting the Waters: America in the King Years.* New York: Touchstone, 1988.

Bugner, Ladislas, gen. ed. *The Image of the Black in Western Art.* vol. 4. Karen C. C. Dalton, associate ed. *From the American Revolution to World War I.* Cambridge: Harvard University Press for The Menil Foundation, Inc., 1989.

Butcher, Margaret Just. *The Negro in American Culture.* New York: Alfred A. Knopf, 1969.

Campbell, Mary Schmidt, et al. *Harlem Renaissance: Art of Black America.* New York: The Studio Museum in Harlem and Harry N. Abrams, Inc., 1987.

Cederholm, Theresa Dickerson, ed. *Afro-American Artists: A Bibliographical Dictionary.* Boston: Trustees of the Boston Public Library, 1973.

Chase, Judith Wragg. *Afro-American Art and Craft.* New York: Van Nostrand Reinhold Company, 1971.

Clifford, James. *The Predicament of Culture: Twentieth-Century Ethnography, Literature, and Art.* Cambridge: Harvard University Press, 1988.

Crew, Spencer. *Field to Factory: Afro-American Migration, 1915–1940.* Washington, D.C.: Smithsonian Institution Press for the National Museum of American History, 1987.

Crite, Alan Rohan. *Were You There When They Crucified My Lord?: A Negro Spiritual in Illustrations.* Cambridge: Harvard University Press, 1944.

Cruse, Harold. *The Crisis of the Negro Intellectual.* 1967. Reprint. New York: Quill, 1984.

Cunard, Nancy, ed. *Negro Anthology, Made by Nancy Cunard, 1931–1933.* 1934. Reprint. New York: Negro Universities Press, 1969.

DeCarava, Roy, and Langston Hughes. *The Sweet Flypaper of Life.* 1955. Reprint. Washington, D.C.: Howard University Press, 1984.

Dewhurst, C. Kurt, Betty Macdowell, and Marsha Macdowell. *Religious Folk Art in America: Reflections of Faith.* New York: E. P. Dutton and Co., Inc., 1983.

Dictionary Catalog of the Arthur Spingarn Collection of Negro Authors. Boston: G. K. Hall, 1970.

Dictionary Catalog of the Jesse E. Moorland Collection of Negro Life and History. Boston: G. K. Hall, 1970. Supplement, 1977.

Dictionary Catalog of the Negro Collection of Fisk University Library. Boston: G. K. Hall, 1974.

The Dictionary Catalog of the Schomburg Collection. Boston: G. K. Hall, 1962–1975.

Dover, Cedric. *American Negro Art.* 1960. Reprint. Greenwich, Conn.: The New York Graphic Society, 1969.

Driskell, David C. *Amistad II: Afro-American Art.* Nashville, Tenn.: Department of Art, Fisk University, 1975.

Driskell, David C., and Earl J. Hooks. *The Afro-American Collection, Fisk University.* Nashville, Tenn.: Department of Art, Fisk University, 1976.

Du Bois, W. E. B. *The Souls of Black Folk.* 1903. Reprint. New York: Avon Books, 1965.

———. *Black Reconstruction in America.* 1935. Reprint. New York: Atheneum, 1983.

———. *Dusk of Dawn.* 1940. Reprint. New Brunswick, N. J.: Transaction Publishers, 1984, 1991.

Ellison, Ralph. *Invisible Man.* New York: Random House, 1952.

Fabre, Michel. *La Rive Noire: De Harlem à la Seine.* Paris: Lieu Commun, 1985.

Fax, Elton. *Seventeen Black Artists.* New York: Dodd, Mead and Company, 1971.

Ferguson, Russell, Martha Gerver, Trinh T. Minh-ha, and Cornel West, eds. *Out There: Marginalization and Contemporary Cultures.* New York: New Museum of Contemporary Art; Cambridge: MIT Press, 1990.

Ferris, William. *Blues from the Delta.* New York: Anchor Books, 1979.

———, ed. *Afro-American Folk Arts and Crafts.* Jackson, Miss., and London: University Press of Mississippi, 1983.

Ferris, William, and Charles R. Wilson, eds. *Encyclopedia of Southern Culture.* Chapel Hill: University of North Carolina Press, 1989.

Fine, Elsa Honig. *The Afro-American Artist: A Search for Identity.* 1973. Reprint. New York: Hacker Art Books, 1982.

Franklin, John Hope. *Color and Race.* Boston: Houghton Mifflin, 1968.

———. *Black Literature and Literary Theory.* New York: Methuen, Inc., 1984.

Franklin, John Hope, and Alfred Moss. *From Slavery to Freedom: A History of Negro Americans.* 1947. 6th ed. New York: Alfred A. Knopf, 1988.

Franklin, John Hope, and August Meier, eds. *Black Leaders of the 20th Century.* Urbana: University of Illinois Press, 1982.

Fuller, Edmund L. *Visions in Stone: The Sculpture of William Edmondson.* Pittsburgh, Penn.: University of Pittsburgh Press, 1973.

Gates, Henry Louis, Jr., ed. *"Race," Writing, and Difference.* Chicago and London: The University of Chicago Press, 1986.

Goldwater, Robert J. *Primitivism in Art.* 1938. Reprint. Cambridge: The Belknap Press for Harvard University Press, 1986.

Greene, Carroll, Jr., ed. *American Visions: Afro-American Art—1986.* Washington, D.C.: The Visions Foundation, 1987.

Grimm, Reinhold, and Jost Hermand, eds. *Blacks and German Culture.* Madison: University of Wisconsin Press, 1986.

Hall, Michael D. *Stereoscopic Perspective: Reflections on American Fine and Folk Art.* Ann Arbor, Mich.: UMI Research Press, 1988.

The Harmon Foundation. *Negro Artists: An Illustrated Review of Their Achievements.* New York: Harmon Foundation, 1935.

Hemphill, Herbert Waide, Jr., and Julia Weissman. *Twentieth-Century Folk Art and Artists.* New York: E. P. Dutton and Co., Inc., 1974.

Herskovits, Melville J. *The Myth of the Negro Past.* 1941. Reprint. Boston: Beacon Press, 1958.

Holmes, Oakley N., Jr. *The Complete Annotated Resource Guide to Black American Art.* Spring Valley, N.Y.: Macgowan Enterprises for Black Artists in America, 1978.

Huggins, Nathan Irvin. *The Harlem Renaissance.* New York: Oxford University Press, 1971.

———, ed. "Visual Arts: To Celebrate Blackness," *Voices From the Harlem Renaissance.* New York: Oxford University Press, 1976.

Igoe, Lynn Moody. *Two Hundred Fifty Years of Afro-American Art: An Annotated Bibliography.* New York: R. R. Bowker Company, 1981.

Johnson, Abby, and Ronald Johnson. *Propaganda and Aesthetics: the Literary Politics of Afro-American Magazines in the Twentieth Century.* Amherst: University of Massachusetts Press, 1979.

Johnson, Clifton H., ed. *God Struck Me Dead: Religious Conversion Experiences and Autobiographies of Ex-Slaves*. Philadelphia: Pilgrim Press, 1969.

Johnson, James Weldon. *Black Manhattan*. 1930. Reprint. New York: Da Capo Press, Inc., 1991.

Kellner, Bruce, ed. *The Harlem Renaissance: An Historical Dictionary for the Era*. 1984. Reprint. New York: Routledge, Chapman & Hall, 1987.

Lemann, Nicholas. *The Promised Land: The Black Migration and How It Changed America*. New York: Alfred A. Knopf, 1991.

Lewis, David Levering. *When Harlem Was In Vogue*. 1981. Reprint. New York: Vintage Books, 1982.

Lewis, Samella. *Art: African American*. New York: Harcourt Brace Jovanovich, 1978.

————. *The Art of Elizabeth Catlett*. Claremont, Calif.: Hancraft Studios, 1984.

Lewis, Samella, and Ruth G. Waddy. *Black Artists on Art*, 2 vols. Los Angeles: Contemporary Crafts, Inc., 1976.

Lincoln, C. Eric, and Lawrence H. Mamiya, eds. *The Black Church in the African American Experience*. Durham, N.C.: Duke University Press, 1990.

Linneman, Russell J., ed. *Alain Locke: Reflections on a Modern Renaissance Man*. Baton Rouge: Louisiana State University Press, 1983.

Lippard, Lucy R. *Mixed Blessings: New Art in a Multicultural America*. New York: Pantheon Books, 1990.

Litwack, Leon, and August Meier, eds. *Black Leaders of the Nineteenth Century*. Urbana: University of Illinois Press, 1988.

Locke, Alain LeRoy. *Negro Art: Past and Present*. Washington, D.C.: Associates in Negro Folk Education, 1936.

————, ed. *The Negro in Art: A Pictorial Record of the Negro Artist and the Negro Theme in Art*. 1940. Reprint. New York: Hacker Art Books, 1979.

————, ed. *The New Negro: An Interpretation*. 1925. Reprint. New York: Atheneum Publishers, 1968.

Long, Richard A. *Africa and America: Essays in Afro-American Culture*. Atlanta: Center for African and African-American Studies, Atlanta University, 1981.

Maresca, Frank, and Roger Ricco. *Bill Traylor: His Art, His Life*. New York: Alfred A. Knopf, 1991.

Martin, Tony. *Literary Garveyism: Garvey, Black Arts and the Harlem Renaissance*. Dover, Mass.: The Majority Press, 1983.

McElroy, Guy. *Facing History: The Black Image in American Art, 1710–1940*. San Francisco: Bedford Arts Publishers in Association with The Corcoran Gallery of Art, 1990.

Moutoussamy-Ashe, Jeanne. *Viewfinders: Black Women Photographers*. New York: Dodd, Mead and Company, 1986.

Negro Artists: An Illustrated Review of Their Achievements. New York: The Harmon Foundation, 1935.

Nielson, David. *Black Ethos: Northern Urban Life and Thought, 1890–1930*. Westport, Conn.: Greenwood Press, 1977.

O'Connor, Francis V. *Art for the Millions: Essays from the 1930s by Artists and Administrators of the WPA Federal Arts Project*. Greenwich, Conn.: New York Graphic Society, 1973.

Oliver, Paul. *The New Grove Gospel, Blues and Jazz*. New York: W. W. Norton and Company, 1986.

Ploski, Harry A. *The Negro Almanac: A Reference Work on the African American*. 5th ed. Detroit: Gale Research Inc., 1989.

Porter, James A. *Modern Negro Art*. 1943. Reprint. New York: Arno Press and the New York Times, 1969.

Powell, Richard J. *Homecoming: The Art and Life of William H. Johnson*. New York: Rizzoli International Publications, Inc., for the National Museum of American Art, 1991.

Quimby, Ian M. G., and Scott T. Swank, eds. *Perspectives on American Folk Art*. New York: W. W. Norton and Co., 1980.

Rampersad, Arnold. *The Art and Imagination of W. E. B. Du Bois*. Cambridge: Harvard University Press, 1976.

Reno, Dawn E. *Collecting Black Americana*. New York: Crown Publishers Inc., 1986.

Ritter, Rebecca E. *Five Decades: John Biggers and the Hampton Art Tradition*. Hampton, Va.: Hampton University Museum, 1990.

Schwartzman, Myron. *Romare Bearden: His Life and Art*. New York: Harry N. Abrams, 1990.

Sinnette, Elinor Des Verney. *Arthur Alfonso Schomburg: Black Bibliophile and Collector*. New York and Detroit: The New York Public Library and Wayne State University Press, 1989.

Smith, Jessie Carney, ed. *Notable Black American Women*. Detroit: Gale Research Inc., 1991.

Southern, Eileen. *The Music of Black Americans: A History*. 2nd ed. New York: W. W. Norton and Company, Inc., 1983.

Sowell, Thomas. *Ethnic America: A History*. New York: Basic Books, 1981.

Stewart, Jeffrey, ed. *The Critical Temper of Alain Locke: A Selection of His Essays on Art and Culture*. New York and London: Garland Publishing, Inc., 1983.

Stoetling, Winifred Louis. *Hale Woodruff, Artist and Teacher: Through the Atlanta Years*. Ann Arbor, Mich., and London: University Microfilms International, 1978.

Stuckey, Sterling. *Slave Culture: Nationalist Theory and the Foundations of Black America*. New York: Oxford University Press, 1987.

Sullivan, Charles, ed. *Children of Promise: African-American Literature and Art for Young People.* New York: Harry N. Abrams, Inc., Publishers, 1991.

Thompson, Robert Farris. *Flash of the Spirit: African and Afro-American Art and Philosophy.* New York: Vintage Books, 1984.

Thompson, Vincent. *The Making of the African Diaspora in the Americas 1441–1900.* New York: Longman, Inc., 1987.

Vlach, John Michael. *By the Work of Their Hands: Studies in Afro-American Folklife.* Ann Arbor, Mich.: UMI Research Press, 1990.

Vlach, John Michael, and Simon Bronner, eds. *Folk Art and Art Worlds.* Ann Arbor, Mich.: UMI Research Press, 1986.

West, Cornel. *Prophetic Fragments.* Grand Rapids, Mich.: William P. Eerdsman Publishing Co.; Trenton, N. J.: Africa World Press, Inc., 1988.

Wheat, Ellen Harkins. *Jacob Lawrence: The Harriet Tubman and Frederick Douglass Series of 1938–40.* Seattle and London: University of Washington Press and Hampton University Museum, 1991.

White, John. *Black Leadership in America.* New York: Longman, Inc., 1985.

Willis, Wilda Logan. *A Guide to the Alain L. Locke Papers.* Washington, D.C.: Moorland-Spingarn Research Center, Howard University, 1985.

Willis-Thomas, Deborah. *Black Photographers, 1840–1940: An Illustrated Bio-Bibliography.* New York, London: Garland Publishing, Inc., 1985.

———. *An Illustrated Bio-Bibliography of Black Photographers: 1940–1988.* New York, London: Garland Publishing, Inc., 1989.

Winston, Michael R., and Rayford W. Logan, eds. *Dictionary of American Negro Biography.* 1st ed. New York: Norton, 1982.

Wintz, Cary D. *Black Culture and the Harlem Renaissance.* Houston: Rice University, 1988.

CATALOGUES

Adele, Lynne. *Black History/Black Vision: The Visionary Image in Texas.* Austin: Archer M. Huntington Art Gallery, The University of Texas at Austin, 1989.

Aden, Alonzo. *Exhibition of Fine Arts Productions of American Negro Artists.* New York: Harmon Foundation, 1936.

Afro-American, Mexican-American, Native-American Art Slide Catalog. Mobile, Ala.: Ethnic American Art Slide Library, The College of Arts and Sciences, University of South Alabama, n.d.

American Negro Art: Nineteenth and Twentieth Centuries. New York: Downtown Gallery, 1941.

American Negro Art: Nineteenth and Twentieth Centuries. New York: Downtown Gallery, 1942.

The Art of the American Negro, 1851–1940. Chicago: American Negro Exposition, 1940.

Augusta Savage and the Art Schools of Harlem. New York: Schomburg Center for Research in Black Culture, The New York Public Library, 1988.

The Barnett-Aden Collection. Washington, D.C.: Smithsonian Institution Press for The Anacostia Neighborhood Museum in cooperation with the Barnett-Aden Gallery, 1974.

Beauford Delaney: A Retrospective, 50 Years of Light. New York: Philippe Briet, Inc., 1991.

Beauford Delaney: A Retrospective. New York: The Studio Museum in Harlem, 1978.

Benjamin, Tritobia H. *The World of Lois Mailou Jones.* Washington, D.C.: Meridian House International, 1990.

———. *Lois Mailou Jones: The Passion for Art.* Washington, D.C.: Howard University Libraries, 1988.

Black Artists: Two Generations. Newark, N. J.: The Newark Museum, 1971.

Bontemps, Arna Alexander, ed. *Forever Free: Art by African American Women 1862–1980.* Alexandria, Va.: Stephenson, Inc., 1980.

———, ed. *Choosing: An Exhibit of Changing Perspectives in Modern Art and Art Criticism by Black Americans, 1925–1985.* Washington, D.C.: Museum Press, 1985.

Breeskin, Adelyn D. *William H. Johnson: 1901–1970.* Washington, D.C.: Smithsonian Institution Press for the National Collection of Fine Arts, 1971.

Britton, Crystal, ed. *Selected Essays: Art and Artists from the Harlem Renaissance to the 1980s.* Atlanta, Ga.: National Black Arts Festival, 1988.

Campbell, Mary Schmidt. *Red and Black to "D": Paintings by Sam Gilliam.* New York: The Studio Museum in Harlem, 1982.

Campbell, Mary Schmidt, et al. *Tradition and Conflict: Images of a Turbulent Decade, 1963–1973.* New York: The Studio Museum in Harlem, 1985.

Campbell, Mary Schmidt, and Sharon F. Patton. *Memory and Metaphor: The Art of Romare Bearden, 1940–1987.* New York: The Studio Museum in Harlem and Oxford University Press, 1991.

Coar, Valencia Hollins. *A Century of Black Photographers: 1840–1960.* Providence: Museum of Art, Rhode Island School of Design, 1983.

Coker, Gylbert. *The World of Bob Thompson.* New York: The Studio Museum in Harlem, 1978.

Contemporary Afro-American Photographers. Oberlin, Ohio: Allen Memorial Art Museum, Oberlin College, 1983.

Cubbs, Joanne. *The Gift of Josephus Farmer*. Milwaukee, Wisc.: Burton & Mayer, Inc., for the University of Wisconsin, Milwaukee Art History Gallery, 1982.

The Decade Show: Frameworks of Identity in the 1980s. New York: Museum of Contemporary Hispanic Art, The New Museum of Contemporary Art, and The Studio Museum in Harlem, 1990.

Driskell, David C. *Two Centuries of Black American Art*. New York: Alfred A. Knopf for the Los Angeles County Museum of Art, 1976.

————. *Hidden Heritage: Afro-American Art, 1800–1950*. Bellevue, Wash.: Bellevue Art Museum and The Art Museum Association of America, 1985.

————. *Contemporary Visual Expressions: The Art of Sam Gilliam, Martha Jackson-Jarvis, Keith Morrison, and William T. Williams*. Washington, D.C.: Smithsonian Institution Press for The Anacostia Museum, 1987.

Elizabeth Catlett. New York: The Studio Museum in Harlem, 1972.

Emilio Cruz: Spilled Nightmares, Revelations, and Reflections. New York: The Studio Museum in Harlem, 1987.

The Evolution of Afro-American Artists: 1800–1950. New York: City University of New York, 1967.

Exhibit of Fine Arts by American Negro Artists. New York: The Harmon Foundation, 1930.

Exhibition of Productions by Negro Artists. New York: The Harmon Foundation, 1933.

Fagaly, William A. "Sister Gertrude Morgan," in *Louisiana Folk Paintings*. New York: The Museum of American Folk Art, 1973.

First Annual Exhibition Salon of Contemporary Negro Art. New York: Augusta Savage Studios, 1939.

Fletcher, Georganne, ed. *William Edmondson: A Retrospective*. Nashville: Tennessee State Museum, 1981.

Foresta, Merry A. *A Life in Art: Alma Thomas, 1891–1978*. Washington, D.C.: Smithsonian Institution Press for the National Museum of American Art, 1981.

Friedman, Martin, et al. *Naives and Visionaries*. New York: E. P. Dutton and Co., Inc., for Walker Art Center, 1974.

Gaither, Edmund Barry. *Afro-American Artists: New York and Boston*. Boston: Museum of Fine Arts, 1970.

————. *Massachusetts Masters: Afro-American Artists*. Boston: Museum of Fine Arts in cooperation with the Museum of the National Center of Afro-American Artists, 1988.

Gilliam/Edwards/Williams: Extensions. Hartford, Conn.: Wadsworth Atheneum, 1974.

Gordon, Allan M. *Echoes of Our Past: The Narrative Artistry of Palmer C. Hayden*. Los Angeles: Museum of African American Art, 1988.

Hall, Michael D., and Eugene Metcalf. *The Ties That Bind: Folk Art in Contemporary American Culture*. Cincinnati, Ohio: The Contemporary Arts Center, 1986.

Hammond, Leslie King. *Ritual and Myth: A Survey of African American Art*. New York: The Studio Museum in Harlem, 1982.

Hartigan, Lynda Roscoe. *James Hampton: The Throne of the Third Heaven of the Nations Millenium General Assembly*. Montgomery, Ala.: Montgomery Museum of Fine Arts, 1977.

————. *James Hampton and the Throne of the Third Heaven of the Nations' Millennium General Assembly*. Washington, D.C.: National Museum of American Art, 1986.

————. *Made with Passion: The Hemphill Folk Art Collection*. Washington, D.C.: Smithsonian Institution for the National Museum of American Art, 1990.

————. *Sharing Traditions: Five Black Artists in Nineteenth-Century America*. Washington, D.C.: Smithsonian Institution Press for the National Museum of American Art, 1985.

Hemphill, Herbert Waide, Jr., ed. *Folk Sculpture USA*. New York: The Brooklyn Museum, 1976.

Introspectives: Contemporary Art by Americans and Brazilians of African Descent. Los Angeles: The California Afro-American Museum, 1989.

Jacobs, Joe. *Since the Harlem Renaissance: 50 Years of African-American Art*. Lewisburg, Penn.: The Center Gallery of Bucknell University, 1985.

James Porter: Recent Paintings and Drawings. Washington, D.C.: Barnett-Aden Gallery, 1948.

Jus' Jass: Correlations of Painting and Afro-American Classical Music. New York: Kenkelaba Gallery, 1983.

Kahan, Mitchell D. *Heavenly Visions: The Art of Minnie Evans*. Raleigh: North Carolina Museum of Art, 1986.

Keith Morrison: Recent Painting. New York: The Alternative Museum, 1990.

Kingsley, April. *Afro-American Abstraction*. San Francisco: The Art Museum Association, 1982.

Laura Wheeling Waring. In Memoriam: An Exhibition of Paintings. Washington, D.C.: The Gallery of Art, Howard University, 1949.

LeFalle-Collins, Lizzetta, ed. *Novae: William H. Johnson and Bob Thompson*. Los Angeles: The California Afro-American Museum, 1990.

LeFalle-Collins, Lizzetta, and Cecil Fergerson. *19 Sixties: A Cultural Awakening Re-evaluated, 1965–1975*. Los Angeles: The California Afro-American Museum Foundation, 1989.

Livingston, Jane, John Beardsley, and Regenia Perry. *Black Folk Art in America, 1930–1980*. Jackson: University Press of Mississippi and Center for the Study of Southern Culture for The Corcoran Gallery of Art, 1982.

Locke, Alain. *Contemporary Negro Art*. Baltimore: The Baltimore Museum of Art, 1939.

Lois Mailou Jones: Retrospective Exhibition. Washington, D.C.: The Gallery of Art, Howard University, 1972.

Long, Richard A. *William H. Johnson, Afro-American Painter.* Atlanta: Spelman College, 1970.

———. *Highlights from the Atlanta University Collection of Afro-American Art.* Atlanta: High Museum of Art, 1973.

Manley, Roger. *Signs and Wonders: Outsider Art Inside North Carolina.* Raleigh: North Carolina Museum of Art, 1989.

The Many Facets of Palmer Hayden. New York: Just Above Midtown Gallery, 1977.

McElroy, Guy C., Richard J. Powell, and Sharon F. Patton. *African-American Artists 1880–1987: Selections from the Evans-Tibbs Collection.* Seattle and London: University of Washington Press in association with Smithsonian Institution Traveling Exhibition Service, 1989.

McWillie, Judith. *Another Face of the Diamond: Pathways Through the Black Atlantic South.* New York: INTAR Latin American Gallery, 1989.

Montgomery, Evangeline J. *Sargent Johnson: Retrospective.* Oakland, Calif.: The Oakland Museum, 1971.

Morrison, Keith. *Art in Washington and Its Afro-American Presence: 1940–1970.* Washington, D.C.: Washington Project for the Arts, 1985.

Mosby, Dewey F., Darrel Sewell, and Rae Alexander-Minter. *Henry Ossawa Tanner.* Philadelphia: Philadelphia Museum of Art, 1991.

Mules and Mississippi. Jackson, Miss.: Department of Archives and History, 1980.

Nasisse, Andy, and Maude Southwell Wahlman. *Baking in the Sun: Visionary Images from the South.* Lafayette, La.: University Art Museum, University of Southwestern Louisiana, 1987.

The Negro Comes of Age: A National Survey of Contemporary American Artists. Albany, N.Y.: Albany Institute of History and Art, 1945.

The Negro in American Art. Los Angeles: UCLA Art Galleries and California Arts Commission, Dickson Art Center, 1966. (Essay by James Porter. "One Hundred and Fifty Years of Afro-American Art.")

New York/Chicago: WPA and the Black Artist. New York: The Studio Museum in Harlem, 1978.

North, Percy. *Abstractions from the Phillips Collection, Part I.* Fairfax, Va.: George Mason University, 1983 (Sam Gilliam).

Palmer Hayden: Southern Scenes and City States. New York: The Studio Museum in Harlem, 1974.

The Permanent Collection of The Studio Museum in Harlem, Volume I, 1983. New York: The Studio Museum in Harlem, 1983.

Perry, Regenia A. *What it is: Black Folk Art from the Collection of Regenia Perry.* Richmond: Anderson Gallery, Virginia Commonwealth University, 1982.

———. *Selections of Nineteenth-Century Afro-American Art.* New York: The Metropolitan Museum of Art, 1976.

Porter, James A. *Ten Afro-American Artists of the Nineteenth Century.* Washington, D.C.: The Gallery of Art, Howard University, 1967.

Powell, Richard J. *Impressions/Expressions: Black American Graphics.* New York: The Studio Museum in Harlem, 1979.

Powell, Richard J., et al. *The Blues Aesthetic: Black Culture and Modernism.* Washington, D.C.: Washington Project for the Arts, 1989.

Rambling on My Mind: Black Folk Art of the Southwest. Dallas, Tex.: The Museum of African-American Life and Culture, 1987.

Reynolds, Gary A., and Beryl S. Wright, *Against the Odds: African-American Artists and the Harmon Foundation.* Newark, N.J.: The Newark Museum, 1989.

Richard Hunt: Sculptures and Drawings. Los Angeles: The Museum of African American Art, Los Angeles, 1986.

Rubin, William, ed. *"Primitivism" in Twentieth Century Art: Affinity of the Tribal and Modern.* New York: The Museum of Modern Art, 1984.

The Sculpture of Richard Hunt. New York: The Museum of Modern Art, 1971.

Simon, Janice. *Discriminating Images: Depictions of the African-American in the Collections of the University of Georgia.* Athens: The Georgia Museum of Art, The University of Georgia, 1991.

Sims, Lowery S., and Adrian Piper. *Next Generation: Southern Black Aesthetic.* Winston-Salem, N.C.: Southeastern Center For Contemporary Art, 1990.

Smith, Edward D. *Climbing Jacob's Ladder: The Rise of Black Churches in Eastern American Cities, 1740–1877.* Washington, D.C., and London: Smithsonian Institution Press for The Anacostia Museum, 1988.

Spirits or Satire: African-American Face Vessels of the 19th Century. Charleston, S.C.: The Gibbes Art Gallery, 1985.

Stigliano, Phyllis. *Bill Traylor.* New York: Luise Ross Gallery, 1990.

Stoetling, Winfred L., Mary Schmidt Campbell, and Gylbert Coker. *Hale Woodruff: Fifty Years of His Art.* New York: The Studio Museum in Harlem, 1979.

Sweeney, James Johnson, ed. *African Negro Art.* 1935. Reprint. New York: Arno Press, 1969.

Thompson, Robert Farris, and Joseph Cornet. *The Four Moments of the Sun: Kongo Art in Two Worlds.* Washington, D.C.: The National Gallery of Art, 1981.

Vlach, John Michael. *The Afro-American Tradition in Decorative Arts.* 1978. Reprint. Athens: The University of Georgia Press, 1990.

Wardlaw, Alvia J. *John Biggers: Bridges.* Los Angeles: California Museum of Afro-American History and Culture, 1983.

Wardlaw, Alvia J., et al. *Black Art—Ancestral Legacy: The African Impulse in African-American Art.* Dallas, Tex.: Dallas Museum of Art, 1989.

Weekley, Carolyn J., et al. *Joshua Johnson: Freeman and Early American Portrait Painter.* Williamsburg, Va.: The Abby Aldrich Rockefeller Folk Art Center, The Colonial Williamsburg Foundation, and the Maryland Historical Society, The Museum and Library of Maryland History, 1987.

Wheat, Ellen. *Jacob Lawrence: American Painter.* Seattle: University of Washington Press for the Seattle Art Museum, 1986.

Wood, Peter H., and Karen C. C. Dalton. *Winslow Homer's Images of Blacks: The Civil War and Reconstruction Years.* Austin, Tex.: University of Texas Press and The Menil Collection, 1988.

Wright, Beryl. *The Appropriate Object.* Buffalo, N.Y.: The Albright-Knox Gallery, 1989.

Zeidler, Jeanne. *The Countee Cullen Art Collection from the Hampton University Museum.* Hampton, Va.: Hampton University, 1987.

PERIODICALS

Adams, Russell. "Intellectual Questions and Imperatives in the Development of Afro-American Studies." *The Journal of Negro Education* 53 (Summer 1984): 201–25.

Allen, Cleveland G. "Our Young Artists." *Opportunity* 1 (June 1923): 24–25.

"American Negro Art Given Full Length Review in New York Show." *Art Digest* 16 (15 Dec. 1941): 5, 16.

Artist and Influence. Yearly volumes of transcripts of interviews with minority artists of all disciplines. Published by Hatch-Billops Collection, Inc., New York City, since 1981.

"The Arts and the Black Revolution." *Arts in Society* (Summer–Fall 1968): 395–531.

Auerbach-Levy, William. "Negro Painters Imitate Whites." *New York World* (5 Jan. 1930): 1M.

Baker, James H. "Art Comes to the People of Harlem." *The Crisis* (March 1939): 78–80.

Barnes, Albert C. "Negro Art and America." *Survey Graphic* 6 (March 1925): 668–69.

Bearden, Romare. "The Negro Artist and Modern Art." *Opportunity* 12 (Dec. 1934): 371–72.

———, moderator. "The Black Artist in America: A Symposium." *The Metropolitan Museum of Art Bulletin* 7 (Jan. 1969): 245–60.

Bowling, Frank. "It's Not Enough to Say 'Black Is Beautiful'." *Art News* (April 1971): 53–55, 82.

Brenson, Michael. "Black Artist: A Place in the Sun." *New York Times* (12 March 1989): H2.

Burrows, Carlyle. "Notes and Comments on Events in Art: Negro Life." *New York Herald Tribune* (11 May 1941): sec. 6, 5.

Chalmers, F. Graeme. "The Study of Art in a Cultural Context." *Journal of Aesthetics and Art Criticism* 32 (Winter 1973): 249–55.

Cobbs, Price M. "Valuing Diversity: The Myth and the Challenge." *The State of Black America 1989.* Washington, D.C.: The National Urban League, 1989, 151–59.

Conwill, Kinshasha Holman. "In Search of an 'Authentic' Vision." *American Art* 5 (Fall 1991): 2–9.

Davis, Douglas. "What Is Black Art?" *Newsweek* (22 June 1970): 89–90.

Donaldson, Jeff. "10 in Search of a Nation." *Black World* 19 (Oct. 1970): 80–99.

Du Bois, W. E. B. "Criteria of Negro Art." *The Crisis* (May 1926): 290–97.

Ellison, Ralph. "Modern Negro Art." *Tomorrow* 4 (Nov. 1944): 92–93.

"Ethnic and Folk Art: Tradition and Transition." *Artspace: Southwestern Contemporary Arts Quarterly.* (Spring 1987): issue devoted to the topic.

Fine, Elsa Honig. "The Afro-American Artist: A Search for Identity." *Art Journal* (Summer 1971): 374–75.

Fire!! A Quarterly Devoted to Younger Negro Artists. Westport, Conn.: Negro University Press, 1970.

Gaither, Edmund B. "A New Criticism is Needed." *New York Times* (12 June 1970): II, 21.

Getlein, Frank. "Combining the Root with the Reach of Black Aspiration: Richard Hunt." *Smithsonian* 21 (July 1990): 60–71.

Ghent, Henri. "Notes to the Young Black Artist: Revolution or Evolution?" *Art International* (June 1971): 33–36.

Glueck, Grace. "America Has Black Art on Her Mind." *New York Times* (27 Feb. 1969).

Henderson, Rose. "First Nation-Wide Exhibit of Negro Artists." *The Southern Workman* 58 (March 1928): 121–26.

Herring, James V. "The American Negro as Craftsman and Artist." *The Crisis* (April 1942): 116–18.

Jefferson, Margo. "The Image Culture." *Vogue* (March 1988): 122, 127.

Kagan, Andrew. "Improvisations: Notes on Jackson Pollock and the Black Contribution to American High Culture." *Arts* 53 (March 1979): 96–99.

Kramer, Hilton. "Black Art and Expedient Politics." *New York Times* (7 June 1970).

———. "Black Art or Merely Social History." *New York Times* (25 June 1977): D19.

Kuspit, Donald. "The Appropriation of Marginal Art in the 1980s." *American Art* 5 (Winter/Spring 1991): 133–41.

LaDuke, Betty. "The Grande Dame of Afro-American Art: Lois Mailou Jones." *Women's Art Journal* 8 (Fall 1987–Winter 1988): 28–32. reprinted in *SAGE* 4 (Spring 1988): 53–58.

Locke, Alain LeRoy. "A Note on African Art." *Opportunity* 2 (May 1924): 134–38.

———. "The Concept of Race As Applied to Social Culture." *Howard (University) Review* (June 1924): 290–99.

———. "The American Negro as Artist." *American Magazine of Art* 23 (Sept. 1931): 210–20.

———. "Advance on the Art Front." *Opportunity* 17 (May 1939): 132–36.

Major, Clarence. "Jacob Lawrence, Expressionist." *The Black Scholar* 9:3 (Nov. 1977): 23–34.

Metcalf, Eugene. "Black Art, Folk Art and Social Control." *Winterthur Portfolio* 18 (Winter 1983): 271–89.

Mitchells, K. "The Work of Art in Its Social Setting and Its Aesthetic Isolation." *Journal of Aesthetics and Art Criticism* 25 (Summer 1967): 369–74.

"Negro Artists: Their Works Win Top U.S. Honors." *Life* (22 July 1946): 62–65.

Porter, James A. "Negro Art on Review." *American Magazine of Art* 27 (Jan. 1934): 33–38.

Porter, Dorothy. "James Porter—Artist." *Opportunity* (Feb. 1933): 46–47.

Powell, Richard J. "I, Too, Am America." *Black Art: An International Quarterly* 2 (no. 3 1978): 4–25.

———. "In My Family of Primitiveness and Tradition: William H. Johnson's *Jesus and the Three Marys*." *American Art* 5 (Fall 1991): 21–33.

Rose, Barbara. "Black Art in America." *Art in America* (Sept.–Oct. 1970): 53–54.

Survey Graphic 6 (March 1925): issue devoted to African-American culture and art.

Tate, Greg. "Cult-Nats Meet Freaky-Deke." *Voice Literary Supplement* 51 (16 Dec. 1986): 5–8.

Ten.8 24 (1987) Special Issue: Afro-American Photography.

Thompson, Robert Farris. "Hip-Hop 101." *Rolling Stone* 470 (27 March 1986): 95–100.

Watrous, Peter. "Harlem of the 20's Echoes in America Today." *New York Times* (22 Jan. 1989): N5, 36.

Williams, Charles. "Harlem at War." *The Nation* (16 Jan. 1943): 86–88.

Wilson, Judith. "Optical Illusions: Images of Miscegenation in Nineteenth- and Twentieth-Century Art." *American Art* 5 (Summer 1991): 89–107.

LIST OF ARTWORKS

(p. 22) Edward Mitchell Bannister, *Newspaper Boy*, 1869, oil on canvas, 30 1/8 x 25 in.; Gift of Frederick Weingeroff 1983.95.85

(p. 24) Edward Mitchell Bannister, *Woman Walking Down Path*, 1882, oil on canvas, 20 x 30 in.; Gift of Joseph Sinclair 1983.95.156

(p. 25) Edward Mitchell Bannister, *Tree Landscape,* 1877, oil on canvas, 20 x 30 in.; Gift of H. Alan and Melvin Frank 1984.147

(pp. 26–27) Edward Mitchell Bannister, *Approaching Storm*, 1886, oil on canvas, 40 1/4 x 60 in.; Gift of William G. Miller 1983.95.62

(p. 28) Romare Bearden, *Family*, 1988, collage on wood, 28 x 20 in.; Transfer from the General Services Administration, Art-in-Architecture Program 1990.37

(p. 31) Romare Bearden, *The Return of Ulysses,* serigraph on paper, 18 1/2 x 22 1/2 in.; Gift of the Brandywine Graphic Workshop 1976.106.1 © 1976 Romare Bearden/Brandywine Workshop

(p. 33) Romare Bearden, *Golgotha*, ca. 1945, watercolor on charcoal paper, 26 x 20 in.; Gift of International Business Machines Corporation 1969.132 © The Estate of Romare Bearden

(p. 35) Romare Bearden, *Pepper Jelly Lady (Presidential Portfolio)*, 1980, color lithograph on paper, 25 15/16 x 21 3/16 in.; Gift of Democratic National Committee 1981.174.2

(pp. 36–37) John Biggers, *Shotgun, Third Ward #1,* 1966, oil on canvas, 30 x 48 in.; Museum purchase made possible by The Anacostia Museum, Smithsonian Institution 1987.56.1

(p. 40) Frederick Brown, *Junior Wells,* 1989, oil on linen, 36 x 30 in.; Museum purchase made possible by William Cost Johnson, George Story, Robert J. Oliver and Grete Wagnor-Barwig 1990.31

(pp. 42–43) Frederick Brown, *Stagger Lee,* 1983, oil on canvas, 90 x 140 in.; Museum purchase 1991.40 © 1984 Frederick J. Brown

(p. 46) Elizabeth Catlett, *Sharecropper,* 1970, linoleum cut on paper, 17 13/16 x 16 15/16 in.; Museum purchase 1981.97.1 © 1970 Elizabeth Catlett

(p. 49) Elizabeth Catlett, *Singing Head,* 1980, black Mexican marble, 16 x 9 1/2 x 12 in.; Museum purchase 1989.52

(pp. 50–51) Allan Rohan Crite, *School's Out,* 1936, oil on canvas, 30 1/4 x 36 1/8 in.; Transfer from The Museum of Modern Art 1971.447.18

(p. 53) Allan Rohan Crite, *Shadow and Sunlight,* 1941, oil on board, 25 1/4 x 39 in.; Museum purchase 1977.45

(pp. 54–55) Beauford Delaney, *Can Fire in the Park,* 1946, oil on canvas, 24 x 30 in.; Museum purchase 1989.23

(p. 61) Robert Scott Duncanson, *Pompeii,* 1871, oil on canvas, 10 1/4 x 18 in.; Gift of Lawrence Koffler 1983.95.166

(p. 62) Robert Scott Duncanson, *Loch Long,* 1867, oil on canvas, 7 x 12 in.; Gift of Donald Shein 1983.95.171

(p. 62) Robert Scott Duncanson, *Mountain Pool,* 1870, oil on canvas, 11 1/4 x 20 in.; Gift of Dr. Richard Frates 1983.95.173

(p. 63) Robert Scott Duncanson, *Landscape with Rainbow*, 1859, oil on canvas, 30 1/8 x 52 1/4 in.; Gift of Leonard Granoff 1983.95.160

(p. 64) William Edmondson, *Crucifixion,* ca. 1932–37, carved limestone, 18 x 11 7/8 x 6 1/4 in.; Gift of Elizabeth Gibbons-Hanson 1981.141

(p. 66) William Edmondson, *Rabbit,* ca. 1940, carved limestone, 12 5/8 x 5 x 8 in.; Gift of Herbert Waide Hemphill, Jr., and museum purchase made possible by Ralph Cross Johnson 1986.65.241

(p. 71) Minnie Evans, *Design Made at Airlie Garden,* 1967, oil and mixed media on canvas mounted on paperboard, 19 7/8 x 23 7/8 in.; Gift of the artist 1972.44

(p. 72) Sam Gilliam, *Art Ramp Angle Brown,* 1978, acrylic and oil enamel on canvas and nylon, 242 1/4 X 35 7/8 in.; Transfer from the General Services Administration, Art-in-Architecture Program 1979.159.41

(p. 74) Sam Gilliam, *April 4*, 1969, acrylic on canvas, 110 x 179 3/4 in.; Museum purchase 1973.115

(p. 75) Sam Gilliam, *In Celebration*, 1987, serigraph on paper, 30 1/2 x 38 1/4 in.; Gift of Smithsonian Resident Associate Program 1987.54

(p. 77) Sam Gilliam, *G.D.S.*, 1978, serigraph on paper, 25 15/16 x 24 1/8 in.; Gift of Donald A. Brown 1978.168.39 © 1978 Sam Gilliam

(p. 79) Sam Gilliam, *Open Cylinder,* 1979, oil on canvas, diptych: 81 x 35 1/2 in. and 80 3/4 x 46 in.; Gift of Mr. and Mrs. Albert Ritzenberg 1981.165A and B

(pp. 82–83) James Hampton, *The Throne of the Third Heaven of the Nations Millenium General Assembly,* ca. 1950–64, gold and silver tinfoil, Kraft paper, and plastic over wood furniture, paperboard and glass, 180 pieces in overall configuration: 10 1/2 x 27 x 14 1/2 ft.; Gift of anonymous donors 1970.353.1

(p. 86) Palmer Hayden, *The Janitor Who Paints,* ca. 1937, oil on canvas, 39 1/8 x 32 7/8 in.; Gift of the Harmon Foundation 1967.57.28

(p. 90) Richard Hunt, *"The greatest obstacle to being heroic is the doubt whether one may not be going to prove one's self a fool; the truest heroism, is to resist the doubt; and the profoundest wisdom, to know when it ought to be resisted, and when to be obeyed." from the series, Great Ideas,* 1975, chromed steel, cut, formed and welded, 32 x 50 5/8 x 33 3/4 in.; Gift of the Container Corporation of America 1984.124.122

(p. 92) Richard Hunt, *Study for Richmond Cycle,* 1977, soldered, bolted, and burnished copper with wood edging, 19 x 60 3/4 x 24 3/4 in.; Transfer from the General Services Administration, Art-in-Architecture Program 1977.47.14

(p. 93) Richard Hunt, *Untitled—Bones,* ca. 1964–70, lithograph on paper, 24 x 34 1/2 in.; Transfer from the National Endowment for the Arts 1988.18.59

(p. 94) Joshua Johnson, *Portrait of Adelia Ellender,* ca. 1803–05, oil on canvas, 26 1/4 x 21 1/8 in.; Gift of Mr. and Mrs. Norman B. Robbins 1983.95.55

(p. 96) Joshua Johnson, *Portrait of Mrs. Barbara Baker Murphy (Wife of a Sea Captain),* ca. 1810, oil on canvas, 21 3/4 x 17 5/8 in.; Gift of Sol and Lilian Koffler 1983.95.56

(p. 97) Joshua Johnson, *Portrait of Sea Captain John Murphy,* ca. 1810, oil on canvas, 21 1/2 x 17 1/2 in.; Gift of Leonard and Paula Granoff 1983.95.57

(p. 100) Sargent Johnson, *Untitled,* ca. 1940, terra cotta, 10 1/2 x 3 1/4 x 2 3/8 in.; Gift of an anonymous donor 1991.133.1

(p. 103) Sargent Johnson, *Lenox Avenue,* ca. 1938, lithograph, 12 1/2 x 8 9/16 in.; Transfer from the D.C. Public Library 1967.72.124

(p. 105) Sargent Johnson, *Mask,* ca. 1930–35, copper on wood base, 15 1/2 x 13 1/2 x 6 in.; Gift of International Business Machines Corporation 1966.27.4

(p. 106) William H. Johnson, *Cafe,* ca. 1939–40, oil on fiberboard, 36 1/2 x 28 3/8 in.; Gift of the Harmon Foundation 1967.59.669

(p. 108) William H. Johnson, *Self-Portrait with Pipe,* ca. 1937, oil on canvas, 35 x 28 in.; Gift of the Harmon Foundation 1967.59.913

(p. 109) William H. Johnson, *Harbor, Svolvær, Lofoten,* ca. 1937, oil on burlap, 26 x 35 1/4 in.; Gift of the Harmon Foundation 1967.59.893

(p. 111) William H. Johnson, *Going to Church,* ca. 1940–41, oil on burlap, 38 1/8 x 45 1/2 in.; Gift of the Harmon Foundation 1967.59.1003

(p. 112) William H. Johnson, *Swing Low, Sweet Chariot,* ca. 1944, oil on paperboard, 25 5/8 x 26 1/2 in. Gift of the Harmon Foundation 1983.95.52

(p. 113) William H. Johnson, *Dr. George Washington Carver,* ca. 1945, oil on fiberboard, 35 1/2 x 28 1/2 in.; Gift of the Harmon Foundation 1967.59.1142

(p. 114) Frank Jones, *Indian House,* ca. 1968–69, colored pencil on paper mounted on paperboard, 22 5/8 x 22 5/8 in.; Gift of Herbert Waide Hemphill, Jr., and museum purchase made possible by Ralph Cross Johnson 1986.65.175

(p. 120) Lois Mailou Jones, *Les Fétiches,* 1938, oil on linen, 21 x 25 1/2 in.; Museum purchase made possible by Mrs. N. H. Green, Dr. R. Harlan, and Francis Musgrave 1990.56

(pp. 124–25) Lois Mailou Jones, *Jardin du Luxembourg,* ca. 1948, oil on canvas, 23 3/4 x 28 3/4 in.; Gift of Gladys P. Payne in honor of Alice P. Moore 1990.7

(p. 126) Jacob Lawrence, *Dreams No. 2,* 1965, tempera on fiberboard, 35 3/4 x 24 in.; Gift of the Sara Roby Foundation 1986.6.95

(p. 128) Jacob Lawrence, *Captain Skinner,* 1944, gouache on paperboard, 29 1/8 x 21 1/8 in.; Gift of Carlton Skinner 1990.65

(pp. 130–31) Jacob Lawrence, *The Library,* 1960, tempera on fiberboard, 24 x 29 7/8 in.; Gift of S. C. Johnson and Son, Inc. 1969.47.24

(p. 133) Jacob Lawrence, *"In a Free Government, the Security of Civil Rights Must Be the Same as That for Religious Rights. It Consists in the One Case in the Multiplicity of Interests, and in the Other, in the Multiplicity of Sects.",* 1976, opaque watercolor and pencil on paper mounted on fiberboard, 30 x 22 1/8 in.; Gift of the Container Corporation of America 1984.124.170

(p. 134) Edmonia Lewis, *Hagar,* 1875, carved marble, 52 5/8 x 15 1/4 x 17 in.; Gift of Delta Sigma Theta Sorority, Inc. 1983.95.178

(p. 137) Edmonia Lewis, *Old Arrow Maker,* 1872, carved marble, 21 1/2 x 13 5/8 x 13 3/8 in.; Gift of Joseph Sinclair 1983.95.182

(p. 139) Edmonia Lewis, *Anna Quincy Waterston,* ca. 1866, carved marble, 11 7/8 x 7 1/4 x 5 1/8 in.; Gift of Dr. Richard Frates 1983.95.181

(p. 140) Sister Gertrude Morgan, *Let's Make a Record,* ca. 1978, tempera, acrylic, and pencil on paperboard album cover with long-playing record, 12 3/8 x 12 1/2 in. and 11 7/8 in. (diam.); Gift of Chuck and Jan Rosenak 1981.136.5A and B

(pp. 142–43) Sister Gertrude Morgan, *Jesus Is My Airplane,* ca. 1970, tempera, ball-point pen and ink, and pencil on paper, 18 x 26 3/8 in.; Gift of Herbert Waide Hemphill, Jr., and museum purchase made possible by Ralph Cross Johnson 1986.65.187

(p. 144) Sister Gertrude Morgan, *Come in my Room, Come on in the Prayer Room,* ca. 1970, tempera, acrylic, ball-point pen, and pencil on paperboard, 12 1/8 x 23 in. (irregular); Gift of Herbert Waide Hemphill, Jr., and museum purchase made possible by Ralph Cross Johnson 1986.65.186

(pp. 146–47) Keith Morrison, *Zombie Jamboree,* 1988, oil on canvas, 62 x 69 1/8 in.; Museum purchase through the Catherine Walden Myer Fund and the Director's Discretionary Fund 1990.76

(p. 153) James A. Porter, *Colonial Soldier,* ca. 1937, oil on canvas, 18 1/4 x 14 1/8 in.; Museum purchase made possible by The Anacostia Museum, Smithsonian Institution 1987.56.2

(p. 154) Augusta Savage, *Gamin,* ca. 1930, painted plaster, 9 x 5 5/8 x 4 1/4 in.; Gift of Benjamin and Olya Margolin 1988.57

(p. 158) Henry Ossawa Tanner, *The Savior,* ca. 1900–05, oil on wood, 29 1/8 x 21 7/8 in.; Gift of Mr. and Mrs. Norman B. Robbins 1983.95.191

(p. 161) Henry Ossawa Tanner, *Fishermen at Sea,* ca. 1913, oil on canvas, 46 x 35 1/4 in.; Gift of Jesse O. Tanner 1983.95.215

(p. 162) Henry Ossawa Tanner, *Salome,* ca. 1900, oil on canvas, 46 x 35 1/4 in.; Gift of Jesse O. Tanner 1983.95.207A

(p. 163) Henry Ossawa Tanner, *Angels Appearing Before the Shepherds,* ca. 1910, oil on canvas, 25 5/8 x 32 in.; Gift of Mr. and Mrs. Norman B. Robbins 1983.95.195

(p. 165) Henry Ossawa Tanner, *Mary,* ca. 1914, oil on canvas, 40 x 36 in.; Gift of Mrs. Dorothy L. McGuire 1991.102

(p. 166) Alma Thomas, *The Eclipse,* 1970, acrylic on canvas, 62 x 49 3/4 in.; Gift of Alma W. Thomas 1978.40.3

(p. 168) Alma Thomas, *Arboretum Presents White Dogwood,* 1972, acrylic on canvas, 68 x 55 in.; Bequest of Alma W. Thomas 1980.36.6

(p. 169) Alma Thomas, *Elysian Fields,* 1973, acrylic on canvas, 30 1/8 x 42 1/8 in.; Bequest of Alma W. Thomas 1980.36.8

(p. 171) Alma Thomas, *Red Sunset, Old Pond Concerto,* 1972, acrylic on canvas, 68 1/2 x 52 1/4 in.; Gift of the Woodward Foundation 1977.48.5

(p. 172) Bob Thompson, *Descent from the Cross,* 1963, oil on canvas, 84 x 60 1/8 in.; Gift of Mr. and Mrs. David K. Anderson, Martha Jackson Memorial Collection 1977.16

(p. 175) Bob Thompson, *Enchanted Rider,* 1961, oil on canvas, 62 3/4 x 46 7/8 in.; Gift of Mr. and Mrs. David K. Anderson, Martha Jackson Memorial Collection 1975.21

(p. 177) Bob Thompson, *The Spinning, Spinning, Turning, Directing,* 1963, oil on canvas, 62 7/8 x 82 7/8 in.; Gift of Mr. and Mrs. David K. Anderson, Martha Jackson Memorial Collection 1980.137.104

(p. 178) Bill Traylor, *Man on Crutch and Woman with Umbrella,* ca. 1939–42, crayon and tempera on paperboard, 11 1/4 x 17 in.; Gift of Herbert Waide Hemphill, Jr. 1991.96.7

(p. 181) Bill Traylor, *Dancing Man, Woman, and Dog,* ca. 1939–42, crayon and pencil on paperboard, 22 x 14 in.; Gift of Herbert Waide Hemphill, Jr., and museum purchase made possible by Ralph Cross Johnson 1986.65.199

(pp. 182–83) Hale Woodruff, *Afro Emblems,* 1950, oil on linen, 18 x 22 in.; Gift of Mr. and Mrs. Alfred T. Morris, Jr. 1984.149.2

(p. 185) Hale Woodruff, *Georgia Landscape,* ca. 1934–35, oil on canvas, 21 1/8 x 25 5/8 in.; Gift of Alfred T. Morris, Jr. 1986.82.2

(pp. 186–87) Joseph E. Yoakum, *Art Linkletter's Ranch near Darwin Australia, June 2,* 1966, crayon, pastel, and ball-point pen on paper, 11 7/8 x 17 7/8 in.; Gift of Herbert Waide Hemphill, Jr., and museum purchase made possible by Ralph Cross Johnson 1986.65.222

(pp. 188–89) Joseph E. Yoakum, *Mt. Cortezo; in Hureto Provience near Mexico City Mexico,* ca. 1960–70, crayon and ball-point pen on paper, 12 x 18 1/16 in.; Gift of Herbert Waide Hemphill, Jr., and museum purchase made possible by Ralph Cross Johnson 1986.65.224

(p. 191) Joseph E. Yoakum, *Imperial Valley in Imperial County Near Karboul Mounds California,* 1966, crayon and ball-point pen on paper, 11 7/8 x 17 7/8 in.; Gift of Herbert Waide Hemphill, Jr., and museum purchase made possible by Ralph Cross Johnson 1986.65.223

(p. 191) Joseph E. Yoakum, *Sullivan Brothers Coal Mine near Fort Scott Bourbon County Kansas,* 1968, pastel, ball-point pen, ink, pen and ink, and pencil on paper, 17 5/8 x 23 1/2 in.; Gift of Herbert Waide Hemphill, Jr., and museum purchase made possible by Ralph Cross Johnson 1986.65.225

PHOTO CREDITS

Edward Mitchell Bannister, ca. 1875,
The National Portrait Gallery,
Smithsonian Institution

Romare Bearden, 1948,
courtesy of Sam Shaw

John Biggers, 1987,
photograph by Early Hudnall, courtesy
of John Biggers

Frederick Brown, 1991,
National Museum of American Art,
Smithsonian Institution, photograph
by Gene Young

Elizabeth Catlett, 1985,
photograph by Sid Fridkin, courtesy of
Elizabeth Catlett

Allan Rohan Crite, 1985,
photograph by Marie Cosinda,
courtesy of Allan Rohan Crite

Beauford Delaney, 1969,
courtesy of Ed Clark

Robert Scott Duncanson, 1864,
Notman Photographic Archives

William Edmondson, ca. 1935,
The Fine Arts Center, Cheekwood,
Tennessee; Louise Dahl-Wolfe:
William Edmondson in Profile; 64.3.3;
Gift of Louise Dahl-Wolfe

Minnie Evans, n.d.,
courtesy *Morning Star*, Wilmington,
North Carolina

Sam Gilliam, 1984,
photograph by Carol Harrison ©

James Hampton, early 1950s,
National Museum of American Art,
Smithsonian Institution

Palmer Hayden, 1950,
Palmer Hayden Papers, Archives of
American Art, Smithsonian Institution

Richard Hunt, ca. 1980,
photograph by Cal Kowal, courtesy of
Richard Hunt

Joshua Johnson, advertisement,
"Portrait Painting," *Baltimore
Intelligencer,* 19 Dec. 1789, courtesy of
The American Antiquarian Society,
Worcester, Mass.

Sargent Johnson, n.d.,
Schomburg Center for Research in
Black Culture, The New York Public
Library, Astor, Lenox, and Tilden
Foundations

William H. Johnson, ca. 1931,
National Archives, Washington, D.C.

Frank Jones, before 1969,
Curatorial files, National Museum of
American Art, Smithsonian Institution

Lois Mailou Jones, 1986,
Collection of the Moorland-Spingarn
Research Center, Howard University,
photograph by Robert Scurlock

Jacob Lawrence, n.d.,
Peter A. Juley and Son Collection,
National Museum of American Art,
Smithsonian Institution

Edmonia Lewis, ca. 1865,
Boston Athenaeum, photograph by
Henry Rocher

Sister Gertrude Morgan, 1974,
photograph by Samuel G. Banks ©

Keith Morrison, 1991,
photograph by Jarvis Grant, courtesy of
Keith Morrison

James A. Porter, ca. 1969,
courtesy of the Prints and Photographs
Department, Moorland-Spingarn
Research Center, Howard University

Augusta Savage, ca. 1920s,
Schomburg Center for Research in
Black Culture, The New York Public
Library, Astor, Lenox, and Tilden
Foundations

Henry Ossawa Tanner, ca. 1935,
Henry O. Tanner Papers, Archives of
American Art, Smithsonian Institution

Alma Thomas, 1976,
National Museum of American Art,
Smithsonian Institution, photograph
by Michael Fischer

Bob Thompson, early 1960s,
photograph by Dorothy Breskind,
National Museum of American Art,
Smithsonian Institution, photograph
by Dorothy Breskind

Bill Traylor, ca. 1940,
courtesy of Hirschl and Adler Modern,
photograph by Charles Shannon

Hale Woodruff, 1966,
courtesy of the New York University
Archives

Joseph E. Yoakum, 1960s, courtesy of
Phyllis Kind Gallery

AFRICAN-AMERICAN ARTISTS
IN THE COLLECTION OF THE NATIONAL MUSEUM OF AMERICAN ART

Leroy Almon
Emma Amos
Benny Andrews
Steve Ashby
Edward Mitchell Bannister
Romare Bearden
Ed Bereal
John Biggers
Wendell T. Brooks
Frederick Brown
Samuel Joseph Brown
Vivian E. Browne
Richard Burnside
Elizabeth Catlett
Claude Clark
Houston Conwill
Eldzier Cortor
Allan Rohan Crite
Emilio Cruz
William Dawson
Hilliard Dean
Roy DeCarava
Beauford Delaney
Joseph Delaney
Richard Dempsey
Arthur "Pete" Dilbert
John Edward Dowell, Jr.
Robert Scott Duncanson
William Edmondson
Melvin Edwards
Mae Engron
Minnie Evans
Frederick Eversley
Josephus Farmer
Walter Flax

Roland L. Freeman
Herbert Gentry
Sam Gilliam
Paul T. Goodnight
Russell T. Gordon
James Hampton
William Hawkins
Palmer Hayden
Felrath Hines
Lonnie Holley
Margo Humphrey
Richard Hunt
Mr. Imagination (Greg Warmack)
Keith Jenkins
Joshua Johnson
Malvin Gray Johnson
Sargent Johnson
William H. Johnson
Frank Jones
Lois Mailou Jones
Jacob Lawrence
Larry Francis Lebby
Edmonia Lewis
Norman Lewis
Edward Loper
Richard Mayhew
Eric Calvin McDonald
Lloyd McNeill
Robert McNeill
Sister Gertrude Morgan
Keith Morrison
Inez Nathaniel-Walker
Joseph Norman
Leslie Payne
Elijah Pierce

Howardena Pindell
Michael Platt
James A. Porter
Earle Richardson
John N. Robinson
Nellie Mae Rowe
Charles Sallee
Augusta Savage
Charles Searles
Charles Sebree
Frank Smith
Edgar Sorrells-Adewale
Henry Speller
Raymond Steth
Lou Stovall
Jimmie Lee Sudduth
Henry Ossawa Tanner
Alma Thomas
Bob Thompson
Mildred Thompson
Dox Thrash
Mose Tolliver
Bill Traylor
Laura Wheeler Waring
James W. Washington, Jr.
Edward B. Webster
James Lesesne Wells
Charles White
Franklin A. White
George W. White, Jr.
Ellis Wilson
Hale Woodruff
Richard Yarde
Joseph E. Yoakum
Kenneth Young

Project Director: Lynda Roscoe Hartigan; Chief of Publications: Steve Dietz; Editor: Richard Carter; Educational Programs Assistant: Julia Beth Hackman; Editorial Assistant: Deborah M. Thomas

Designed by Steve Bell; Typeset in Adobe Minion™ with display lines in Casablanca and Monotype Gill Sans by General Typographers, Washington, D.C.; Printed and bound by South China Printing Co. (1988) Ltd., Hong Kong